EDINBURGH BIBLIOGRAPHICAL SOCIETY
OCCASIONAL PUBLICATION

LITHOGRAPHIC PRINTERS
OF SCOTLAND

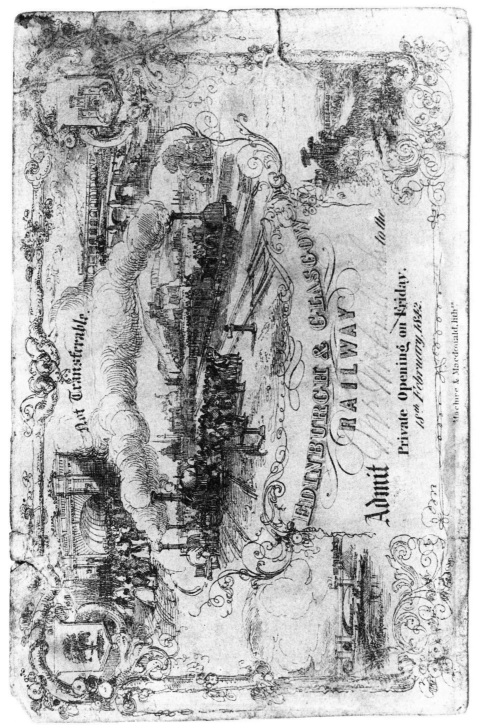

PLATE 1. A 'Railway Ticket' lithographed by the Glasgow firm MacLure & MacDonald (see p.77) to commemorate the inauguration of the Edinburgh & Glasgow Railway on 18 February 1842. Bearing in mind that tickets for this historical journey were primarily restricted to persons of some distinction, it is interesting to speculate whether the MacCulloch whose name appears on this ticket might have been the renowned artist Horatio McCulloch. Enlarged from 85 x 129 mm. (Collection of M.G. & E. Stewart.)

DIRECTORY OF THE
LITHOGRAPHIC PRINTERS
OF SCOTLAND
1820–1870

THEIR LOCATIONS, PERIODS, AND A GUIDE
TO ARTISTIC LITHOGRAPHIC PRINTERS

BY DAVID H.J. SCHENCK

EDINBURGH BIBLIOGRAPHICAL SOCIETY
& OAK KNOLL PRESS
IN ASSOCIATION WITH
THE NATIONAL LIBRARY OF SCOTLAND

1999

First published 1999 by Edinburgh Bibliographical Society
c/o The National Library of Scotland, George IV Bridge, Edinburgh EH1 1EW

Published in North and South America by Oak Knoll Press
310 Delaware Street, New Castle DE 19720

ISBN 1 872116 29 9 (UK) ISBN 1 884718 85 X (USA)

British Library Cataloguing-in-Publication Data

Schenck, David H. J.
 Directory of the lithographic printers of Scotland, 1820–1870 : their locations, periods and a guide to artistic lithographic printers. – (Edinburgh Bibliographical Society occasional publication)
 1. Lithographic workshops – Scotland – History – 19th century – Directories 2. Lithography – Printing – Scotland – History – 19th century – Directories
 I. Title II. Edinburgh Bibliographical Society III. National Library of Scotland
 338.4'7'6862315'025411
 ISBN 1872116299

Library of Congress Cataloguing-in-Publication Data

Schenck, David H. J.
Directory of the lithographic printers of Scotland : 1820–1870 : their locations, periods, and a guide to artistic lithographic printers / by David H. J. Schenck.
 p. cm. – (Occasional publication / Edinburgh Bibliographical Society)
 Includes bibliographical references and index.
 ISBN 1–884718–85–X (USA). – ISBN 1–872116–29–9 (UK)
 1. Lithography – Printing – History – 19th century – Directories. 2. Lithography – Scotland – Directories. 3. Lithography – 19th century – Scotland – Directories. 4. Printers – Scotland – History – 19th century – Directories. I. Title II. Title: Lithographic printers of Scotland. III. Series: Occasional publication (Edinburgh Bibliographical Society)
NE2860.S34 1999
769.9411–dc21 99–37595
 CIP

Printed in Scotland by Polestar AUP Aberdeen Ltd, Hareness Road, Aberdeen AB12 3LE

The cover is based on a trade advertisement published *c.*1845 by Friedrich Schenck, of Edinburgh, reproduced in full as Plate 5 on p.101. It is used here by permission of the National Gallery of Scotland.

ACKNOWLEDGEMENTS

Scotland

During the first of my research visits to Scotland, I had the good fortune to meet John Morris, until his recent retirement an Assistant Keeper at the National Library of Scotland in Edinburgh. His encouragement and assistance both at that time, and subsequently, has contributed greatly to the compilation, content and final form of this *Directory,* and is deeply appreciated.

I gratefully acknowledge the enduring help and warmth of support given by Helen Smailes and Katrina Thomson, Assistant Keepers of the National Gallery of Scotland; Rachel Benvie, Curator of Montrose Museum & Art Gallery; Karen Cunningham, Art Department, Mitchell Library, Glasgow; Tricia Burke, Local Studies Library, Paisley Central Library; Hugh Stevenson, Curator of the Art Gallery, Kelvingrove, Glasgow; Robin Rodger, Principal Officer, Fine & Applied Art, Perth Museum and Art Gallery; Iain Beavan, Humanities Research Support Unit, Aberdeen University Library; Peter Milne, Map Library, National Library of Scotland; J.C. Keppie, Hon. Secretary of the Scottish Printing Archival Trust; and Andrew Bethune, Edinburgh Room, Edinburgh Central Library, who has borne with great patience and fortitude the brunt of my innumerable enquiries concerning events in that city. Although too numerous to mention by name, I am also most grateful to the many Librarians, Curators, Keepers, Archivists, and others in the cities, towns and islands of Scotland, for their wonderful spirit of helpfulness, without which my task would have been far more onerous.

Warm appreciation is also due to W.T. Johnston, compiler of the on-going series of computerised directories published by *Officina,* Livingston, under the comprehensive title *Dictionary of Scottish Artists.* Special mention must also be made of the Buckhaven writer, A.J. Campbell, current Chairman of the Fife Family History Society, and compiler and publisher of eight bibliographies in the series *Fife Bibliography: The Presses of Fife* (1992). Although none of these works deal specifically with lithography, I am most grateful to Andrew Campbell for having so generously provided a substantial part of the background histories of printing businesses in Cupar and Kirkcaldy.

England

Special thanks are due to Michael Twyman, Professor in the Department of Typography and Graphic Communication at the University of Reading, not only for his expert advice but also for the warmth of his encouragement. His kind agreement to my using statistical information from his *Directory of London Lithographic Printers 1800–1850* (Printing Historical Society, 1976) has made possible the comparisons which appear in the Introduction.

I am also most grateful both to the Librarians of the St. Bride Printing Library, London, for their considerable help, and to the Librarians and Staff of the Guildhall Library, London, who during my frequent visits have repeatedly provided me with Scottish directories in quantities which can surely now be measured in tons!

INTRODUCTION

Objectives and Coverage

Since the discovery of the lithographic process by Aloys Senefelder in 1798, and its subsequent introduction in London at the beginning of the 19th century, many excellent works have been published, documenting the history and development of lithographic printing in Britain. However, with very few exceptions, these have largely focused on lithographic printers whose businesses were located in England. Publication of the present *Directory,* closely following the bicentenary of Senefelder's discovery, is the result of what is believed to be the first analysis of the development of lithographic printing in the cities and provincial areas of Scotland. It is hoped that this will provide a first step in redressing the imbalance, and encourage others to research the printed works of local lithographers, in particular the works of those whose endeavours were directed towards fine art print-making, book illustration, and the making of maps and plans.

One of the major problems facing those interested in early lithographic printing, print-making, and book illustration in Scotland, is the lack of readily accessible information concerning the identities, locations, and periods of the lithographic printers whose businesses were established there. The effect of the problem is not confined to students, researchers and historians of early lithographic printing, but extends alike to the custodians, bibliographers, sellers, and collectors of fine art prints and illustrated books.

To recognise the need for a directory of early lithographic printers in Scotland is one thing; to establish the starting point is quite another. Initial investigation was not encouraging. The Seditious Societies Act of 1799 (39 George III, cap.79) demanded that every person involved in printing should register their business with the local Clerk of the Peace. Had they still existed, these records might have provided vital information, but sadly those for Scotland do not appear to have survived. The requirement for registration was relaxed in 1839, after which however printers were required to append their business title and address on all printed matter.

In his article, 'The Rise and Progress of Lithography in Britain', published in Vol. 1, Part 5 of the 1892 edition of *The British Lithographer,* Philip Butler Watt made a rare reference to Scotland, in which he commented 'How the new art of lithography extended to Scotland and to Glasgow is said to be involved in much obscurity, and much mystery has been thrown round it', and later 'How lithography came to Edinburgh is somewhat shrouded in mystery. The most reliable information that can be obtained shows that it was practised in 1830, by one, Nicol, a teacher of writing in George Street'. Subsequent research revealed the reality of the situation to be somewhat different. Even so, Philip B. Watt, whose name will be found among the entries in this *Directory,* provided some valuable leads.

'In the beginning...'

It seems probable that experiments in lithographic printing were being conducted in Scotland from about 1815, and there is little doubt that interest was further stimulated by an important contribu-

tion describing the process which was published in *Blackwoods Magazine*, May 1817, pp.128–129. However, the earliest lithographic printer traced in the directories of Scotland is John Robertson of Edinburgh, whose listing at 13 South Union Place, appeared in the *Post Office Directory* of 1820. No positive evidence has yet been found to dispute the probability that he was also the founder of the first professional lithographic printing business in Scotland.

In the following year, Robertson commenced the challenging task of using the lithographic process to print a series of *Views of Scenery in Perthshire,* which had been drawn on stone by the distinguished artist David Octavius Hill. In the event, printing of the thirty views was equally divided between John Robertson and the renowned lithographer Charles Hullmandel of London. Robertson's contribution appeared in the first three parts, which were published between October 1821 and January 1822. They are believed to be the earliest series of views produced in Scotland by the lithographic process. It is also probable that a 'Plan shewing Proposed Lines of Railway from the Coal Field of Mid Lothian to the Rivers Tweed and Leeder', printed by Robertson from an 1821 survey by the engineer, Robert Stevenson, was the earliest plan to be reproduced in Scotland by lithography.

Having established the basis for a starting point, this *Directory* has been prepared with the objective of identifying those lithographic printers who established their businesses within the fifty years following the 1820 listing of John Robertson, together with successive structural changes in their businesses, where this is applicable. However, in order to illustrate the late spread of lithography to certain provincial areas, a comparatively small number of firms have been included where lithographic printing was introduced later than 1870. With certain exceptions, the original year of establishment of a lithographic business and subsequent changes in structure, title or partnership etc. are recorded as separate, but cross-referenced, entries. These variations in title, which are sometimes small, and changes of address frequently assist in the more accurate dating of works previously undated or only approximately dated. Whilst coverage of the early lithographic printers of Edinburgh and Glasgow is believed to be largely comprehensive in this *Directory*, it must be said that in the provinces, late introduction, intermittent publication, and even non-availability of trade directories in some areas, has rendered comprehensive coverage less certain.

It should be mentioned that this *Directory* does not include listings of those who were employed specifically in the important Glasgow trade of calico printing by lithography, as apart from the supervisor, this was a trade in which little or no lithographic skill was involved. Only those few who also offered a wider service, and were classified under 'Lithographic Printers', have been included.

It is important to note that the research for this work was considerably more widespread than is apparent from the cities and towns which appear in this *Directory*. Included among the many locations covered were Airdrie, Ayr, Brechin, Dingwall, Dunblane, East Kilbride, Falkirk, Forfar, Fort William, Hamilton, Huntly, Inverurie, Kirkcudbright, Kirkwall, Lerwick, Nairn, Oban, St. Andrews, Stornoway, Thurso, and Wick. Although interesting examples of artistic lithography are to be found in most of these towns, the reason for their omission from this *Directory* is that no evidence has yet come to light of the existence of any early lithographic businesses in these locations.

The Directories of Scotland

The principal sources for this *Directory* include *Post Office Directories, Gray's Directories, Pigot's* (later *Slater's*) *Commercial Directories, Kelly's Directories,* The *Bon-Accord Directories* for Aberdeen, the *Angus and Mearns Directory* of 1846, the *Post Office* (later *Kelly's*) *Directories of Stationers, Printers, Booksellers, Publishers and Papermakers,* various other regional and local directories, advertisements in regional newspapers, collection catalogues, and inscriptions on lithographed portraits, topographical prints, book illustrations, maps, plans and the like.

The earliest directories containing classified listings of lithographic printers in Scotland were the *Commercial Directories* published intermittently by Pigot in 1820, 1825, and 1837, and later continued by Slater. No lithographic printers were listed in Scotland in *Pigot 1820*. In the *Post Office Directories* for Edinburgh and Glasgow classified trade sections were first introduced in 1834, but in provincial areas their introduction varied considerably, sometimes extending into and beyond the 1860s. Intermittently published from 1872, the *Post Office* (later *Kelly's*) *Directories of Stationers, Printers, Booksellers, Publishers and Papermakers,* are particularly important as a basis for following through the duration of lithographic printing businesses to the end of the 19th century.

Fortunately, because they are unequivocal, the most commonly used headings in classified directories were 'Lithographic Printers', and 'Printers – Lithographic'. However, *Pigot 1837* used the heading 'Lithographers and Lithographic Printers', and other directories simply 'Lithographers'. These headings are liable to misinterpretation, for unlike today the term 'Lithographer' was sometimes used in reference to the artists or draughtsmen who drew the work on stone. As a result, listings under such headings may well include some who were draughtsmen only. In these circumstances the confusion can usually be resolved by referring to the corresponding entry in the unclassified section of the directories. Here it is important to note that in this *Directory* the term 'Lithographer' is used only as an alternative to 'Lithographic Printer': those who drew or engraved the work are referred to variously as 'artist', 'lithographic artist', or 'draughtsman'.

Even more confusing to the researcher is the change which later occurred in the *Post Office Directories* for Edinburgh. Having used 'Printers – Lithographic' from 1834 to 1868, the classification heading was changed to 'Lithographers' in 1869 and 1870, and then, from 1871 onwards, to 'Engravers and Lithographers'. Although those who were 'Engravers only' were indicated with an asterisk, an assumption appears to have been made that all lithographers were also engravers. This was certainly not the case, and here again confusion can only be resolved by reference to the unclassified sections of the directories concerned.

It is almost certainly true to say that the complexities of gathering and recording the information were such that in varying degrees all directories contained inaccuracies by the time they were published. However, probably due to the smaller urban populations, those of Scotland appear to have been generally less prone to error than those of London. Even so, cases occur where lithographic printers were listed in the unclassified section of the directory several years before they appeared in the classified section. A few were never listed at all. The firm of James Ballantyne, distinguished as publishers and printers of works by Sir Walter Scott, were practising as lithographic printers in the early 1830s, yet do not appear to have been listed as such in any directory. However, the most likely area of inaccuracy is attributable to the time delay incurred while col-

lecting information for inclusion in the directories, and there is evidence to suggest that in some cases lithographic printers were practising for at least a year before they were listed in the directories, whilst others continued to be listed for at least a year after they had ceased trading. Again, although the reason is unknown, the numbers of lithographic businesses recorded in the unclassified section of a directory frequently exceeded the numbers listed in the classified section of the same directory. This was particularly apparent in Edinburgh, where the classified section of the *Post Office Directory* for 1846 listed only 11 of the 29 firms actually in business. Although the *Directory* of 1847 showed great improvement, listing 23 of the 28 firms then in business, this type of discrepancy still persisted in later years.

Types of Lithographic Work and Trade Advertisements

There is no doubt at all that the majority of the lithographic printers whose names appear in this *Directory* confined their activities to commercial jobbing work such as circulars, business forms, invitations, display cards, and funeral notices etc., which had been drawn on stone by skilled calligraphers. In the smaller businesses, this was frequently the work of the lithographer himself. Understandably, few examples of such ephemeral work are to be found in Scottish libraries and museums, and it is likely that those that remain are to be located amongst archival records held by such institutions as The Scottish Record Office and County Archives. Reference is made in the entries to any such works thought to be of particular interest. However, the principal interest surely lies in the minority of those lithographic printers who, in addition to commercial work, directed their activities towards the reproduction of highly artistic work such as topographical views, portraits, book illustrations, embellishments, military prints and map making, of which many fine examples are to be seen in the collections of the art galleries, museums, and larger libraries of Scotland. Where such examples of a lithographer's work have been found, the types of artistic work have been indicated in the relevant entry.

In some entries reference is made to trade advertisements. These usually provide valuable information regarding the types of work undertaken, changes to locations or partnerships, and occasionally include important announcements concerning artistic publications.

The Statistics of Lithographic Printing Businesses in Scotland

At the end of this Introduction are four Tables designed to illustrate the numbers, rates of growth, durations, and broad distribution of lithographic businesses in Scotland, and to make comparisons with lithographic businesses in London and other major centres of lithographic printing in the provinces of England. Before studying the Tables, it is necessary to explain the significance of italicised entries and certain other entries, which, although included in the *Directory,* are not *individually* reflected in the numbers and durations shown in the Tables. Although the *Directory* contains more than 700 entries, many of these are not individually represented in the Tables, as their inclusion would be misleading.

Italics are used to indicate entries such as alternative names for firms, misspelling of names in directories, comments regarding secondary partners, and references to one or two amateur litho-

graphers whose works were of specific interest to this study. Where applicable, italicised entries are cross-referenced to the main entries, and, to avoid duplication, are omitted from the statistics.

Although many lithographic businesses retained their original title throughout their existence, others included in the Directory were subject to subsequent (and sometimes frequent) changes in title and restructure. In order to present a more realistic picture of the numbers and durations of *different* lithographic printing businesses in Scotland, the statistics included in Tables 2 and 3 reflect the figures which result from combining the individual 'durations' of two or more listed firms, because they were a restructure and continuation of the original business. For example, let us assume that after five years trading a firm titled James Black became Black and Son, then after eight years changed to Black and Smith, and then after another four years ceased to trade. In this *Directory,* the three stages of the firm's development would have been grouped together by cross-referencing as [Entry 1/3], [Entry 2/3] and [Entry 3/3], but for the statistical tables would be considered as *one* business having a total duration of seventeen years and classified in the 15 to 19 year category of the Tables.

Where doubt exists and successions or connections are unconfirmed, an asterisk has been included in the relevant entries, for example [Entry 1/2*]. In such cases the firms have been treated as separate businesses, and the individual durations have not been accumulated. Also, in other cases, arbitrary decisions have been made, due to the particular nature of the restructure, or relocation, but the effect on the statistics is minimal. In order to provide continuity of entries which have been connected in this way, chronological order has been given precedence over the strict alphabetical order of forenames, initials, and names of second partners etc., for example Smith, Wm. 1830–1835 [Entry 1/2] would precede Smith & Adam 1835–1840 [Entry 2/2].

Table 1 Growth in Lithographic Printing Businesses 1820–1870

This combined table and chart shows the growth in numbers of lithographic printing businesses in Edinburgh compared with that of Glasgow. It will be seen that from the earliest listing in 1820 until 1830 the growth rate of lithographic printing businesses in Edinburgh was virtually identical to that of Glasgow. Thereafter, the higher level of industrialisation and the on-going development of the railways led to a far stronger increase in the numbers of new businesses in Glasgow. It is important to note that even after 1870 these numbers continued to increase substantially, in both cities, up to and beyond 1900.

Table 2 Analysis of Lithographic Printing Businesses in Scotland

Table 2 reflects the numbers, durations, and general distribution of lithographic businesses founded in Scotland within the period covered by this *Directory*. The individual existences of those firms which still survived in 1870, have been followed through to the end of the 19th century, so that even a lithographer who started as late as 1870, and continued for 30 years, qualifies for inclusion in the '25 years or over' category of 'Durations'.

In studying the analysis in Table 2, it is immediately apparent that more than 50% of the 573 businesses listed in Scotland ceased trading in less than ten years. Even more revealing is the fact that no less than 80 (13.9%) of these firms ceased trading, or failed, in the first year of operation. Of these, 12 (9.2%) of the 130 businesses listed in Edinburgh ceased trading in the first year.

Lithographic printers in Glasgow were even more vulnerable, for of the 330 businesses listed there, the first year failure rate reached the remarkably high level of 55 (16.7%.)

It is certain that the previously mentioned industrialisation and the development of the railways had led to a strong and rapid increase in the numbers of new lithographic printers in Glasgow, and it is probable that many of these lacked the training and experience necessary to provide an acceptable standard of quality and service. However, it is even more likely that the rate of growth in Glasgow was so strong that the resulting capacity frequently exceeded the demand for lithographic work. The higher level of premature failure may also be attributed, at least in some measure, to the tendency of early Glasgow lithographers to group closely together in the vicinity of Trongate and Argyle Street, sometimes even sharing the same building; whereas in Edinburgh the lithographic printers appear to have followed the example of the book trade which preceded them, and spread themselves more effectively over the city. As may be seen from lithographs and engravings of the time, Trongate was a bustling area of activity. Its attraction as an ideal location for lithographic printers was understandable, for it contained many tenement blocks, consisting of small workshops, and was adjacent to the commercial and legal centre of Glasgow, which in the 18th and early 19th centuries lay to the east of George Square. There was also the added bonus that Trongate was closely sited to the centre of the book trade in Saltmarket.

Table 3 Comparisons with Lithographic Businesses in London

In his *Directory of London Lithographic Printers 1800–1850* (Printing Historical Society 1996), Professor Michael Twyman lists nearly four hundred firms which were established in London within the fifty year period 1800–1850, and includes interesting information as to the relative durations of these businesses. In London growth in the numbers of lithographic printing businesses was negligible between 1800 and 1820. In Scotland growth was very rapid during the period 1850 to 1870. Professor Twyman suggested that a more realistic picture is therefore obtained by comparing the figures for Scotland for the thirty year period 1820–1850 with those of London for the fifty year period 1800–1850. This comparison may be seen in Table 3.

As the 'duration' figures quoted for London were restricted to the upper limit of the study, i.e. 1850, the 'durations' of those Scottish firms which continued beyond 1850 have been similarly restricted in Table 3, in order to make meaningful comparison. For example, a firm which was established in 1842, and ceased trading in 1865, would be considered as having a duration ending in 1850, and classified under the 'Less than 10 years' category.

It is immediately apparent from Table 3 that up to 1850 the number of lithographic printing businesses in Scotland was just over half that of London. It will also be seen that although the percentages applicable to the All-Scotland 'duration' categories are almost identical to those of London, there are some striking regional differences. Especially noticeable is the high percentage of Glasgow lithographers listed under the 'less than 10 years' category. The reasons for this have been detailed in the notes relating to Table 2.

In his directory Michael Twyman comments that one of the practices exercised by lithographers in London was to move 'quite frequently' from one address to another. He also comments on the practice of some lithographers to share premises, and lists a number of addresses in London which were occupied by two or more lithographic printers, either at the same time or suc-

cessively. All of these characteristics were apparent in the lithographic businesses of Scotland, but seemingly to a greater degree. Both in Edinburgh and Glasgow the comment about moving 'quite frequently' would be an understatement, for some changed their location almost every year, and to such an extent that it is difficult to imagine how they ever retained effective contact with their customers. While some of these moves resulted from the need to expand the business, it was noticeable that such rapid successive changes of address were often a precursor to a firm going out of business.

Again, Scottish lithographic printers frequently shared premises, especially in Glasgow. A classic example is the premises at 62 Argyle Street. This address was occupied by the following lithographic businesses: David MacClure, 1836–97 (& Son from 1853); Daniel F. Duncan 1845–79; John Wright; 1856–58; Thomas Murdoch 1858–61; John Brock 1860–61; James Hay 1860–61; William Franklin 1863–66; Franklin & Jack 1866–68; and Jack & Carrick 1868–20thC. It will be seen that throughout much of this period the premises were occupied concurrently by three different businesses, and that during the year 1860–61 there were as many as five lithographic businesses sharing this address. In Edinburgh, 30 Hanover Street was a popular location, and one which, at least in the earlier years, appeared to hold special appeal to lithographers interested in artistic work. These premises were successively occupied by R.H. Nimmo 1827–34; Leith & Smith 1835–40; John Smith 1840–48; William Nichol, 1848–49; J.W. Menzies 1860–82; and Powell & Auld 1867–72.

Table 4 Comparisons with major provincial cities of England

Although substantially below the level for London, the significance of Glasgow and Edinburgh as major centres of lithographic printing should not be underestimated. This is clearly demonstrated in Table 4, in which the numbers of lithographic printers in these cities are compared with four major cities of lithographic importance in provincial England.

The Distaff side of Lithographic Printing in Scotland

It is interesting to note that lithographic printing in Scotland was not exclusively a male occupation. Mrs Robert Hughes of Aberdeen, Mrs George Veni of Edinburgh, Mrs Agnes Gibb of Paisley, Mrs John Wright of Glasgow, and Mrs Robert Bryson of Kirkcaldy, who was particularly successful, all managed professional lithographic printing businesses, while the distinguished water colour artist Jemima Wedderburn (later Mrs Hugh Blackburn) actually printed, in the atelier of the Edinburgh artist and lithographer Friedrich Schenck, some of the many works which she had drawn, or engraved, on stone. Examples of her highly imaginative engraved lithography are to be found in the charming plates which appear in *The White Cat* and *Fortunio,* both of which were published by William Blackwood & Sons in 1847.

Seeing Lithographed Prints in Scotland

For those who wish to see examples of works produced by lithographic printers in Scotland, the following notes will be of interest.

Historically, prints held in institutional collections have been principally listed by subject or by artist, and only rarely by the name of the engraver or lithographic printer. Fortunately, a sub-

stantial amount of work is now being done in Scotland to computerise the listing of these collections. Not only does this provide a means of selecting prints by subject, artist, executor, and nation of origin, but the system also allows selection by process, making it possible to separately identify and select the etchings, engravings, aquatints, and lithographs in a particular collection. Understandably, progress in the computerised listing of Scottish collections varies considerably: in some cases it is well on the way to completion, in others it has not commenced, and sadly there are some collections for which computerisation has not yet been planned.

Edinburgh The Edinburgh Room of Edinburgh Central Library has a wonderful and easily accessible collection of prints, drawings and water-colours of Edinburgh and its environs. This collection was beautifully catalogued in 1951 by the former Principal Librarian, R. Butchart, and the Edinburgh Room staff, in a 270–page work under the title *The Edinburgh Scene.* In this publication the collection is catalogued by subject, by artist, and by executor, and also contains Butchart's own fascinating commentary on a range of selected works, in addition to providing a variety of excellent illustrations in monochrome and colour. The Scottish Room of the same library holds a further collection of prints relating to all other areas of Scotland: these are catalogued on a card index system.

As may be expected, the Scottish National Portrait Gallery holds a superb collection of lithographed and engraved portraits, the cataloguing of which has been fully computerised within the last two years. Of those drawn on stone, by far the major proportion were printed by lithographers in Scotland.

The collection of The National Gallery of Scotland includes some very fine examples of French and English lithography, but sadly very few examples of work by Scottish lithographers. An excellent collection of military prints is held by the United Services Museum in Edinburgh Castle. The collection includes more than seven hundred lithographs, but as yet very few of the computerised listings include the names of the artists or the lithographic printers.

A superb collection of maps is to be found in the Map Library of the National Library of Scotland. Many of these were printed by Scottish lithographers, the earliest traced dating to 1821. The Scottish Record Office, where the magnificent facilities are matched by the wonderful spirit of helpfulness which prevails within its walls, also holds a collection of some 100,000 maps and plans, produced by a variety of processes. Analysis of the records of some 6000 of these showed that approximately 5% were lithographs produced by printers whose businesses were established in Scotland. These include many early examples of lithographed plans of railways, rivers, estates, public works, and similar developments, and provide a fascinating hunting ground for researchers. Computerisation of the records of these maps and plans is making good progress, and they are now becoming progressively accessible to the public.

Other important collections are to be seen in The National Museums of Scotland, The City Art Centre, and Huntly House Museum. Collections may also be found in the University Library, and the libraries of some of the professional colleges.

Glasgow The Hunterian Art Gallery is presently involved in the process of computerising their important collection of some 25,000 prints. The print collection of Glasgow Museums is currently available, by prior appointment, to specialists only. The Mitchell Library, said to be the largest reference library in Europe, has a wonderful collection of books and albums containing lithographed illustrations of old buildings and scenes in and around the city, and, separately, a substantial mixed collection of uncatalogued prints, produced by a variety of processes.

Provincial Cities and Towns The majority of examples mentioned in this *Directory* are to be found in the local libraries, museums and art galleries of the cities and towns under which they are listed. In the libraries these collections are mostly located in the Local Studies Department. The collections to be found in the cities of Aberdeen, Dundee, Montrose, Perth and Kirkwall are of particular interest.

Dates on Prints, Maps and Plans

A word of warning to those for whom the study of lithographed prints may be a new interest. Dates inscribed on prints should not always be taken at face value. Particular caution is necessary when the date appears within the image area, as it is likely to refer to the year in which the work was drawn by the artist, and does not necessarily reflect the date of printing. As an example of this, one need look no further than the series of views, held in Edinburgh Central Library, of ancient buildings in that city, drawn by the artist Daniel Somerville and printed by the distinguished Scottish lithographer, Samuel Leith. Many of these prints are dated between 1815 and 1818, and are listed as such in the catalogue, yet Leith first started as a lithographic printer in Banff in 1830, before moving to Edinburgh in 1835. Although the dates reflect the year in which the views were originally drawn by Somerville, it is unlikely that they were printed by Leith until the 1840s at the earliest.

Similar caution needs to be exercised in accepting the dates on maps and plans. Here, inscribed dates normally reflect the date of completion of the survey, and may well differ from the year of printing. Fortunately, this problem is sometimes resolved by the inclusion of the year of publication in the inscriptions on the print.

Conclusion

In terms of numbers, the measure of Scotland's contribution to the history of lithographic printing in Britain is evident from the statistics. But what of Scotland's contribution to the more important aspects of that history? Within this *Directory* will be found the names of those who contributed greatly both to the development and history of lithography in Britain by their specialisation in the highest forms of fine art printing; by their involvement in the lithographic colour-printing of maps and plans; by their inventions and innovations; by their authorship of treatises; and by the teaching and encouragement which they gave to others. There is little doubt that the remarkable history of printing in Britain was considerably enriched by the largely unheralded contributions made by the 19th-century lithographic printers of Scotland.

TABLE 1

Comparative Growth in Lithographic Printing Businesses in Edinburgh and Glasgow 1820–1870

Number of Lithographic Printing Businesses											
YEAR	1820	1825	1830	1835	1840	1845	1850	1855	1860	1865	1870
EDIN	1	6	6	11	18	29	27	37	48	48	60
GLAS	0	5	6	15	24	39	51	80	105	114	122

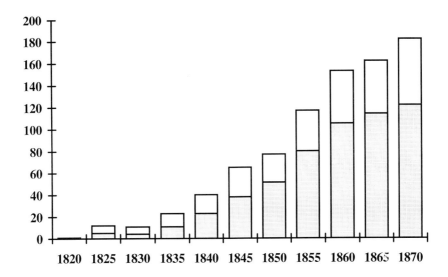

NOTES

See the explanatory notes above, pp.9–12. It will be seen that during the ten year period between 1820 and 1830 the growth in the numbers of lithographic businesses in Glasgow was virtually identical to that of Edinburgh. However, due to the substantially higher level of industrialisation, and the development of the railways in the West of Scotland, the comparative figures for Glasgow had virtually doubled by 1850. The listings in the above Table are approximate.

TABLE 2

Numbers, Durations and General Distribution of
Lithographic Businesses established in Scotland 1820–1870

Durations	Glasgow 1820–70		Edinburgh 1820–70		Provincial 1820–70		All-Scotland 1820–70	
Years	No.	% ↓	No.	% ↓	No.	% ↓	No.	% ↓
1 to 9	192	58.2	62	47.7	39	34.5	293	51.1
10 to 14	31	9.4	19	14.6	16	14.2	66	11.5
15 to 19	19	5.8	6	4.6	11	9.7	36	6.3
20 to 24	18	5.4	9	6.9	12	10.6	39	6.8
25 & over	70	21.2	34	26.2	35	31.0	139	24.3
Total Businesses	330	100	130	100	113	100	573	100
% of Businesses by Area →	330	57.6	130	22.7	113	19.7	573	100
1 Year Duration	55	—	12	—	13	—	80	—
% of Businesses	16.7	—	9.2	—	11.5	—	13.9	—

NOTES

Statistical Basis: The numbers and durations listed in the above Table refer to **'Businesses'** and do not relate directly to every individual entry in this *Directory*. See the explanatory notes above, pp.9–12. The number and percentage of businesses which did not continue beyond their first year of operation are shown as **1 Year Duration,** but are also included in the 1 to 9 Years category.

Duration: In Table 2 'Duration' means duration within the period 1820 to 1900; duration after 1900 does not qualify. The listings in the above Table are approximate.

TABLE 3

**Comparison between numbers and durations of Lithographic
Printing Businesses founded in Scotland within the 30 year period
1820–1850, and in London within the 50 year period 1800–1850**

Duration of Businesses	London 1800–50		Glasgow 1820–50		Edinburgh 1820–50		Provincial 1820–50		All-Scotland 1820–50	
Years	No.	%	No.	%	No.	%	No.	%	No.	%
1 to 9	297	76.5	83	84.7	42	72.4	24	61.5	149	76.4
10 to 14	49	12.6	8	8.2	11	19.0	8	20.5	27	13.8
15 to 19	21	5.4	5	5.1	4	6.9	3	7.7	12	6.2
20 to 24	13	3.4	2	2.0	1	1.7	3	7.7	6	3.1
25 & over	8	2.1	0	0	0	0	1	2.6	1	0.5
Total Businesses	388	100	98	100	58	100	39	100	195	100

NOTES

Statistical Basis: The numbers and durations listed in the above Table refer to **'Businesses'** and do not relate directly to every individual entry in this *Directory*. See the explanatory notes above, pp.9–12. The listings in the above Table are approximate.

Duration: In Table 3 'Duration' means duration within the period 1820 to 1850, i.e. duration after 1850 does **not** qualify for inclusion.

Source of Statistics for London: Michael Twyman, *Directory of London Lithographic Printers 1800–50* (London: Printing Historical Society, 1976).

Basis for Comparison: In London, growth in the numbers of lithographic printing businesses was negligible between 1800 and 1820. In Scotland, growth was very rapid during the period 1850 to 1870. Therefore in the above Table a more realistic picture has been presented by comparing the figures for Scotland for the thirty year period 1820–1850 with those of London for the fifty year period 1800–1850.

TABLE 4

Numbers of Lithographic Printing Businesses in Glasgow and Edinburgh compared with those in the main centres of Lithography in provincial England

City	1820	1825	1830	1841	1851	1861	1871
Manchester	0	3	3	17	69	110	[1] 199
Glasgow	0	5	6	29	47	109	126
Liverpool	0	2	2	10	12	[2] 38	69
Edinburgh	1	6	6	18	28	50	68
Birmingham	0	0	2	7	[3] 17	36	40
Bristol	0	0	3	3	7	12	[4] 21

NOTES

See the explanatory notes above, pp.9–12. With the exception of the cases listed in the following notes, the years 1841, 1851, 1861, and 1871, have been chosen in preference to those of 1840, 1850, 1860 and 1870, due to the availability of the more comprehensive Slater's commercial directories. The listings in the above Table are approximate.

[1] In *Slater's Directory for Manchester* 1871, 'Engravers only' were listed under one heading. Those who were both 'Engravers and Lithographic Printers' were combined under a separate heading, and totalled 199. This may have led to errors, for only 121 of these were positively confirmed as Lithographers from checks in other directories.

[2] Liverpool 1862. This was the closest Directory available in Liverpool Central Library.

[3] Birmingham 1850.

[4] *Bristol and Suburban Commercial Directory* 1871 has 13 listings only under the heading 'Lithographic and Copperplate only'. However, another heading refers to 'Letterpress, Lithographic & General' and lists 42 entries. It is extremely unlikely that all of these were lithographers. A total of 21 firms were positively identified as lithographic printers, but it is possible that this is a conservative figure.

BIBLIOGRAPHY[1]

Works having relevance to lithographic printing in Scotland

R. Butchart, *Prints and Drawings of Edinburgh* (Edinburgh, 1955)

The Edinburgh Scene: *Catalogue of Prints and Drawings in the Edinburgh Room, Central Public Library* (Edinburgh, 1951)

B. Gascoigne, *Milestones in Colour Printing* (Cambridge, 1997)
 Includes commentary and bibliography of colour printing by Thos. Nelson & Sons of Edinburgh

T. Murdoch, *The Early History of Lithography in Glasgow* (Glasgow, 1902)

G. Wakeman & G.D.R. Bridson, *A Guide to 19th Century Colour Printers* (Loughborough, 1975)

P.B. Watt, 'The Rise and Progress of Lithography in Britain', *The British Lithographer,* 1891, Vol. 1, No. 2, pp. 21–23; and 1892, Vol. 1, No. 2, pp. 29–31

General

J.R. Abbey, *Scenery of Great Britain and Ireland in Aquatint and Lithography 1770–1860 from the Library of J.R. Abbey* (London, 1952)

J.R. Abbey, *Travel in Aquatint and Lithography 1770–1860 from the Library of J.R. Abbey.* 2 vols. (London, 1956–1957)

G.D.R. Bridson & G. Wakeman, *Printmaking & Picture Printing* (Loughborough, 1984)

B. Gascoigne, *How to Identify Prints* (London, 1986)

R.T. Godfrey, *Printmaking in Britain* (Oxford, 1978)

R. Lister, *Prints and Printmaking* (London, 1984)

R. McLean, *Victorian Book Design and Colour Printing* (London, 1972)

J. Pennel, *Lithography & Lithographers* (London, 1915)

A. Senefelder, *A Complete Course of Lithography* (1819; reprinted New York, 1977)

R. V. Tooley, *Tooley's Dictionary of Mapmakers* (Tring, 1979)

M. Twyman, *Lithography 1800–1850* (London, 1970)

M. Twyman, *A Directory of London Lithographic Printers 1800–1850* (London, 1976)

M. Twyman, *Early Lithographed Books* (London, 1990)

G. Wakeman, *19th Century Illustrations* (Loughborough, 1970)

G. Wakeman, *Aspects of Victorian Lithography* (Wymondham, 1970)

G. Wakeman, *Victorian Book Illustration* (Newton Abbott, 1973)

[1] Details of published histories relating to individual businesses will be found under their specific entries.

ABBREVIATIONS &c.

Post Office and Commercial Directories

Pigot	Pigot & Co.'s *Commercial Directory for Scotland* (later succeeded by Slater's)
Slater	Slater's *Commercial Directory for Scotland*
POD(s)	*Post Office Directory* relevant to the city/town of the entry
PTD(s)	*Post Office* (Kelly's after 1876) *Directory of Stationers, Printers, Booksellers, Publishers and Paper Makers* (rare; may be consulted at St. Bride Printing Library)

Abbreviations used in this Directory

RHP	Precedes reference numbers of plans held in Scottish Record Office
O.S.	Ordnance Survey
C or -C	Commercial jobbing work, and indicates a traced or known example.
Art	A general indication that the lithographer was involved in some form of artistic work *during the period of the entry.* Normally followed by a hyphen and one or more of the following symbols denoting the types of material traced:
-T	Topographical and architectural views, landscapes etc.
-P	Portraits
-Mil	Military prints or illustrations
-M	Maps and plans
-O	Other types of artistic work
-ms	Denotes existence of manuscripts relating to the lithographer
-Inv	Lithographer known to have introduced invention/innovation
-Tre	Lithographer known to be author of treatise or technical work
-Adv	Lithographer's advertisement in newspaper, directory etc.
Abbey, *Scenery*	Abbey, J.R. *Scenery of Great Britain and Ireland in Aquatint and Lithography 1770–1860 from the Library of J.R. Abbey* (London, 1952)
Abbey, *Travel*	Abbey, J.R. *Travel in Aquatint and Lithography 1770–1860 from the Library of J.R. Abbey.* 2 vols. (London, 1956–1957)

Other conventions

In the notes which follow the entries, the appearance of names in bold type is indicative of a cross reference to another entry. Explanations of those entries which are italicised and of references such as [Entry 1/3], [Entry 1/3*], etc., will be found in the *Introduction*, pp.9–10.

Directory of the
Lithographic Printers of Scotland 1820–1870

Adamson & M'Queen [Entry 1/2]
1873–1874
Edinburgh
 1873–74 1 St James Square
Engravers and Lithographers. William Adamson, former partner in **Melville & Adamson**. When the partnership ended, the business was continued by **Adamson, William** [2/2].

Adamson, William [Entry 2/2]
1874–20th C
Edinburgh
 1874–94 1 St James Square
 1894–20thC 25 St James Square
Also Engraver. Former partner **Adamson & M'Queen** [1/2] and, previously, **Melville & Adamson**.

Aikman, George (& Son †)
1867–1876
Edinburgh
 1867–74 29 North Bridge
 1874–75 no directory entry
 1875–76 14 West Preston Street
Already established as an engraving business for more than ten years. Added Lithographic and Letterpress Printing in 1867.
† Having served apprenticeship with his father, George Aikman *junior* (1831–1905) trained as an artist under Robert Scott Lauder, R.S.A. Around 1865 he became a partner in his father's business, and shortly afterwards the firm introduced lithography, being listed in Slater 1867. George Aikman *junior* left the business in 1872, thereafter following a prolific artistic career during which he produced etchings and landscapes in oils and in watercolours. He was elected A.R.S.A. in 1880. George Aikman *senior* continued the business until 1876.
Art-O 1867: Illustrations in James Brown, *The Epitaphs and Monumental Inscriptions in Greyfriars Churchyard, Edinburgh* (Edinburgh, 1867).

Aikman, John
1856–1857

Edinburgh
 1856–57 39 South Bridge
POD 1856: 'Lithographer and Ticket Writer'. **Aikman, John B.** was at same address in 1866.

Aikman, John B.
1866–1872
Edinburgh
 1866–66 39 South Bridge †
 1866–72 3 Allison Place, Leith Walk
Also Letterpress Printer, and window ticket writer.
† Moved during 1866. Listed Slater 1867 as Aikman, John, and may be same as, or son of, **Aikman, John**.

Aitken & Farie
1855–1899
Glasgow
 1855–57 62 Buchanan Street
 1857–59 62 Buchanan Street & 35 Mitchell Street
 1859–61 51 Buchanan Street
 1861–70 4 Stormont Street
 1870–88 116 St Vincent Street
 1888–99 177 West George Street
Engineering Lithographers, and Draughtsmen. Engravers from 1855. Letterpress by *c.*1860. Listed Slater 1860, 1867, and PTDs 1872–1893.
Art-M-Adv 1872: Plan: 'City of Glasgow – Street improvements' [RHP.307]. 1881: 'Plan of Glasgow in 1783' – a reproduction of an original engraving by **James Lumsden**. 1885: Advertisement in POD.

Alexander, David
1860–1863
Glasgow
 1860–62 68 Glassford Street
 1862–63 7 Argyle Street
Listed Slater 1860: Engraver and Lithographer. No positive trace after 1863, but may connect with **Alexander & M'Nabb** (1869–1871).

Alexander & M'Nabb
1869–1871

Glasgow
1869–71 11 St Vincent Place
Lithographic and Letterpress Printers.

Alexander, Thomas
1836–1853
Glasgow
1836–37 11 Virginia Road
1837–46 179 Argyle Street
1846–49 120 Buchanan Street
1849–53 2 Howard Street
Engraver, Lithographer, Printer. Listed Pigot 1837.

Allan, David [Entry 1/2]
1832–1835
Glasgow
1832–35 187 Trongate
Artist, Engraver and Lithographer. 1835: Entered partnership **Allan & Ferguson** [2/2].
Art-T-O 1832: Dr M. S. Buchanan, *History of Glasgow Infirmary* (Glasgow: Lumsden & Son, 1832). 1834: Frontispiece of POD, view of 'Royal Exchange'. 1835: 'Haggs Castle'. 1835: 'Views in Glasgow & Neighbourhood', artist anonymous, but known to be ex-Allan apprentice James Anderson; descriptive text by John M. Leighton (Abbey, *Scenery*, 501).

Allan & Ferguson [Entry 2/2]
1835–20thC
Glasgow
1835–36 187 Trongate
1836–44 57 Argyle Street
1844–48 87 Argyle Street
1848–49 74 Buchanan Street
1849–52 70 Buchanan Street
1852–75 74 Buchanan Street
1875–20thC 126 Renfield Street
Formerly **Allan, David** [1/2]. Now in partnership with William Ferguson. Lithographic and Copperplate Printers and Engravers. Added Letterpress c.1867. Amongst the most distinguished of the early lithographic businesses in Scotland, producing several fine artists and lithographers, including William 'Crimea' Simpson, Robert Carrick, and James Anderson. Listed Pigot 1837, Slater 1860, 1867. When David Allan died in 1875, he was succeeded by his son James.
Art-T-P-O-M-Adv 1839: Advertised in Glasgow POD. 1846: Plan – 'Lands on banks of River Clyde' [RHP.1329]. 1848: 'Feuing Plan for Ardenadam Bay'

[RHP.3116/1–5]. 1848: 'Views and Notices of Glasgow in former Times' (see PLATE 2 opposite): 43 views drawn (anonymously) by the artist, now known to be William Simpson, of which one, 'The Ruins of the Archbishop's Palace. 1780', is after an original etching by the Glasgow colour merchant and competent amateur artist, James Brown. 'Royal Exchange, Glasgow' (n.d.). 'Glasgow Bridge' (n.d.). 1848: 'View of Loch Lomond'. *c.*1848: 'Glasgow Cathedral' (inscribed '74 Buchanan St.'). *c.*1854: Map of 'Glasgow'.

Allan, Thomas & Co.
*c.*1845–1862
Edinburgh
*c.*1845–62 265 High Street (Craig's Close)
Printer and Publisher of *Caledonian Mercury*. Shown in POD 1813 at Old Fishmarket Close, and from 1815 at 285 High Street. Listed as Letterpress and Stereotyper in PODs. Similarly listed in Slater 1860. However, early photograph of fascia board also showed firm to be lithographic printers. The location of the printing office is described in Kay's *Edinburgh Portraits* (1877) as being 'in Craig's Close, fourth storey, first stair, left hand'. Thomas was the son of Robert Allan. Both were bankers, and, following his father's death, Thomas acquired the estate of Lauriston.

Allardyce, Robert
1824–1829
Edinburgh (Leith)
1824–29 15 Tolbooth Wynd †
Bookseller, Stationer, Letterpress Printer and Publisher of chapbooks since 1821. Now added Lithography. Related to bookseller and letterpress printer, Archibald Allardyce, and, up to 1820, was probably partner in the bookselling and printing firm of Ogle, Allardyce and Thomson. After 1829 appears as bookseller and stationer, but listed Pigot 1837 as a letterpress printer, but not as a lithographer.
† In 1825 the actual printing office was sited in Sugar House Close (information from John Morris).

Allison, David
1865–1868
Glasgow
1865–68 44 Union Street
Lithographic and Letterpress Printer. Listed Slater 1867.

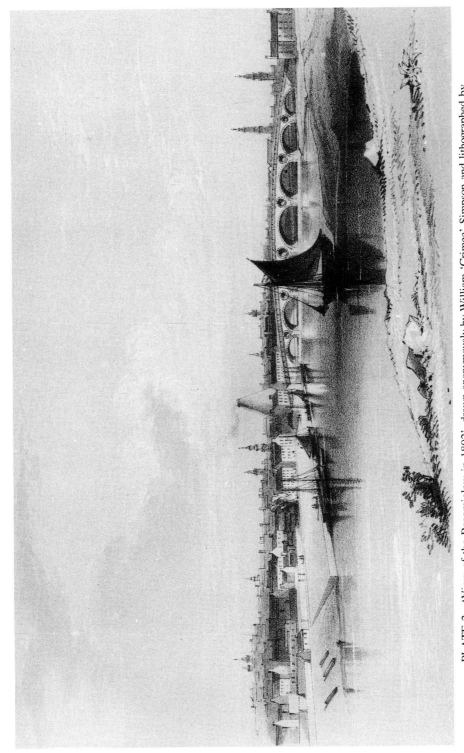

PLATE 2. 'View of the Broomielaw in 1802', drawn anonymously by William 'Crimea' Simpson and lithographed by the Glasgow firm Allan & Ferguson for Robert Stuart, *Views and Notices of Glasgow in Former Times* (Glasgow, 1848). Reduced from 124 x 202 mm. (Mitchell Library, Glasgow.)

Anderson, John
1869–1870
Edinburgh
1869–70 4 N. St Andrew Street
Engraver and Lithographer.

Anderson, William W.
1856–1858
Edinburgh
1856–58 17 St James Square
Listed POD 1856 as 'Lithographer and Teacher of Writing and Arithmetic'.

Annand & Co., Robert Cumming
c.1875–c.1883
Peterhead
c.1875–c.83 11 Love Lane
The earliest lithographic printer traced in Peterhead. Listed PTDs 1876 and 1880.

Armour, Robert
1872–c.1890
Kilmarnock
1872–c.90 32 King Street
Took over premises of **Watson, John** (c.1860–1872). Letterpress Printer and Lithographer. Listed PTDs 1885 and 1889.

Atkinson, Thomas
1836–1841
Glasgow
1836–37 7 Queen Street
1837–41 16 Queen Street
Also Engraver and Copperplate Printer.

Avery, John & Co. (Ltd.)
c.1870–20thC
Aberdeen
c.1870–80 9 St Catherine Wynd
1880–89 20 Netherkirkgate
1889–93 14 Gallowgate
1893–97 14 Gallowgate and
 6 Correction Wynd
1897–20thC 105 King Street and
 6 Correction Wynd
Born Plymouth c.1809, where he trained as a letterpress printer. Following brief period in London, Avery moved to Aberdeen, where in 1838 he established a prosperous Printing and Stationery business at 125 Union Street, subsequently adding engraving. From c.1850, printer and publisher of *Northern Advertiser*. It is probable that Avery introduced lithography when he moved to 9 Catherine Wynd in 1869, although earliest listing was PTD 1872. Also listed PTDs 1876–1900. When John Avery died in June 1871, firm was continued by William Bates Avery, and became a limited liability company from c.1885.
Adv: Advertised POD 1878, and PTDs 1880–1900.

Baird, Hugh (& Co. †)
1853–1872
Glasgow
1853–55 13 Argyle Street and
 45 Albion Street
1855–56 no directory entry
1856–57 51 Gallowgate
1857–58 49 and 51 Gallowgate
1858–72 67 Trongate
Lithographic and Copperplate Printer, Engraver and Stationer. Added Letterpress by 1860.
† Listed as '& Co.' in Slater 1860, but not in 1867.

Baird, Robert A.
1870–20thC
Greenock
1870–72 41 Cathcart Street and
 16 Hamilton Street
1872–85 41 Cathcart Street
1885–89 45 Cathcart Street
1889–20thC Municipal Buildings, in
 Hamilton Street
Listed PTDs 1872–1900.

Ballantine, Walter
1828–1833
Edinburgh
1828–29 18 Greenside Place †
1829–33 14 Leith Terrace
Former partner in **Robertson & Ballantine**. On 25 April 1829, *The Edinburgh, Leith, Glasgow Literary Advertiser* carried an advertisement in which the firm offered for sale supplies of lithographic stones 'just received from Bavaria', and announced their capability of printing maps and estate plans up to 40 x 27 inches. 1834: Premises

taken over by **Smith, William *Jnr***.

† This advertisement confirmed the address as No 18, and also announced the impending move to Leith Terrace.

Art-M-Adv 1827: Robert F. Gourlay's 'Plan for the Improvement of Edinburgh'. *c.*1828: 'Plan of Paisley 1490 to about 1545, from the Abbot's Chartulary' [RHP.543]. This plan is described in the SRO catalogue as 'Lithographed by W. Ballantine, 1820'. However, the last digit is indecipherable, but the date is most likely to be 1828/1829. A similar plan held in the Paisley Museum was printed by **Hay, Robert** of Paisley. 1830: Plan of 'River Leven' by A. Martin [RHP.365]. 1831: Plan of 'Campbell Castle' Estate divided into lots [RHP.1234]. Advertisement in *Glasgow Herald*, 29 January 1828: Estate Plans, jobbing work, sale of lithographic stones.

Ballantyne, James & Co.

*c.*1830–1839 †

Edinburgh

 1831–39 'Head of Leith Walk, Paul's Work'

Well-known firm of publishers and letterpress printers, whose serious financial crisis proved so disastrous for Walter Scott. In the PODs the firm's printing facilities were listed only under 'Letterpress'. Their small-scale use of lithography was known only from the later narrative of their employee **Colin Ross Milne**. Apart from jobbing work, the firm used the process to produce coloured wallpaper in a variety of designs. The product was expensive, and finally discontinued, when it became subject to Government taxation.

† Subsequently, the firm underwent several changes in structure and title: Ballantyne & Hughes (1839–48); Johnstone, Ballantyne & Co. (1848–50); Ballantyne, J.A. (1850–54); Ballantyne & Co. (1854–65); Ballantyne, Roberts & Co. (1865–67); Ballantyne & Co. (1867–80); and Ballantyne, Hanson & Co. (1880–20thC). Under each of these titles the firm was listed as 'Letterpress' only, and it seems that lithography was either abandoned during the first re-structure in 1839, or restricted to in-plant use.

Art-O Coloured wallpaper in a variety of designs.

Banks, William [Entry 1/3]

1852–1858

Edinburgh

 1852–58 26 Waterloo Place

Son of bookbinder Alexander Banks. It is probable that he was originally apprenticed to the distinguished en-gravers, **W. H. Lizars**, where he later rose to be manager from 1824 to 1852, when he left to start his own business as a Lithographer, Engraver, and Copperplate Printer. Apart from J. S. Buist's article 'In Pursuit of Mr Banks' in the *Scots Magazine*, May 1976, Banks' considerable artistic talents have been largely unremarked. Although best known for his steel engravings, Banks also produced some high quality lithographic work. 1858: The firm continued as **Banks, William & Son** [2/3] when Banks' son became a partner.

Art-T-O 1853: Several plates in Charles Roger, *A Week at Bridge of Allan*, 3rd ed. (Edinburgh, 1853) bear Banks' inscription. *c.*1855: 'A General View of Edinburgh from Carlton Hill'. 1885: 'The Great Auk, or Garefowl'.

Banks, William & Son [Entry 2/3]

1858–1864

Edinburgh

 1858–64 26 Waterloo Place

Formerly **Banks, William** [1/3]. Slater 1860 lists as Engravers and Lithographers. 1864: Became **Banks & Co.** [3/3].

Art-M-O-Adv 1860: 'The Beauties of Upper Strathearn' [Crieff]. 1861: Plan: 'Estates of Sheardale' by Archibald Sutter. Advertised in several PODs.

Banks & Co. [Entry 3/3]

1864–20thC

Edinburgh

1864–69	26 Waterloo Place
1869–76	10 N. St Davids Street
1876–81	10 N. St Davids Street and 92 Causewayside
1881–84	10 N. St Davids Street †
1884–20thC	12 George Street †

Formerly **Banks, William & Son** [2/3]. Listed Engravers and Lithographers in Slater 1867. Added Letterpress after move in 1869. Listed PTDs 1872–1900.

† 1881–20thC the firm also occupied Grange Printing Works at 152, Causewayside.

Art-T-M-O-Adv *c.*1870: Produced cards of Glasgow views. 1885: Illustrations in S.Grieve, *The Great Auk* (London, 1885). Plan: 'Footpath East of St Ninians from survey of 1838' by William Legate [RHP.882/1]. Advertised in PODs 1868, 1875 [Plans of Estates]. POD 1891: 4-page colour insert.

Barbour, John *junior*
1865–1881
Paisley

1865–71	99 Causeyside
1871–80	1 Smithfields
1880–83	99 Causeyside

Also Engraver and Stationer. Listed Lithographer in Kelly's 1878, but not trade-listed in any PTDs.
Adv: Advertised in Paisley PODs 1867, 1869, 1872 as 'Practical Engraver and Stationer'.

Barr, John (& Co. †) [Entry 1/2*]
1841–1852 ‡
Glasgow

1841–43	148 Trongate
1843–50	7 Argyle Street
1850–52	40 N. Frederick Street

Engraver and Lithographic Printer. In 1850 entered partnership **Barr & Robin** [2/2] but also continued independently. Possibly related to **Barr, Thomas**.
† '& Co.' from 1850.
‡ John Barr's listing in PODs ended in 1852, but a John Barr, Junior appeared as an engraver only at 41 Howard Street in the PODs of 1864, 1865, and 1866, and a John Barr & Co. as engravers at 3 Enoch Square in the POD of 1866 only. Thereafter POD entries ceased.

Barr & Robin [Entry 2/2*]
1850–1852
Glasgow

1850–52	7 Argyle Street

Senior partner was **Barr, John** [1/2]. Junior partner appears to be **Robin, Thomas** who, when this partnership was dissolved, entered new partnership of **Robin & Logan**.

Barr, Thomas
1849–1850
Glasgow

1849–50	18 Glassford Street

Engraver and Lithographer. Probably related to **Barr, John** [1/2], but appears to be an independent business.

Bartholomew, John (& Co. †)
1866–20thC
Edinburgh

1866–69	4a North Bridge and 135 High Street
1869–76	17 Brown Square
1876–79	17 Chamber Street
1879–88	31 Chamber Street
1888–89	Dalkeith Road
1889–20thC	Park Road, Dalkeith Road

Ex-Lizars engraver. Founded his own business in 1830. The firm achieved international renown as engravers and publishers of maps. Used lithographic transfer process extensively to preserve and extend life of engraved plates, for colouring engraved maps, and for cheque printing. Listed Letterpress Printers in 1870. Listed Slater 1867 and PTDs 1872 to 1889. PTDs for 1893 and 1900 list the address as 'The Edinburgh Geographical Institute'. Following sale of the company in 1980, the business was involved in a number of structural changes, but since 1989 has been trading in Glasgow as part of the Harper Collins organization. The firm's original archival material is now held in the NLS. See Leslie Gardiner, *Bartholomew – 150 Years* (Edinburgh, 1976).
† '& Co.' from 1889.
Art-M-O-Adv 1877: Tinted illustrations in *The British Flora Medica*. Ordnance Survey Plan marked to show 'Proposed works at Fortrose, 1878'. Advertised in POD 1866: Printing of 'Atlases, Maps, Plans, Charts'.

Bell & Co.
1830–1840
Edinburgh

1830–33	13 Shakespeare Square
1833–35	1 West Register Street
1835–40	2 Gabriel's Road

Listed Pigot 1837 as Engravers, Lithographic and Copperplate Printers.
Art-T c.1834: Outline Views 13–30 in E.C.C. [i.e. Mrs Robert Campbell], *Scottish Scenery: Sketches from Nature*, Parts 3, 4, and 5; for other Parts see **Forrester & Nichol, Nimmo, R. H.**, and **Smith, J. & W.**

Bell, J.W.
1832–1834
Edinburgh

1832–33	4 Maryfield
1833–34	10 Hunter Square

'Lithographic Establishment' according to POD 1832/3; 'Stationer & Lithographer', POD 1833/4.

Bell, W.
1861–1866
Glasgow

1861–65	39 Maxwell Street

1865–66 7 Croy Place
Listed Lithographer only.

Bennet Brothers [Entry 1/2]
1865–1867
Glasgow
1865–67 25 Queen Street
Listed Slater 1867 as Lithographic and Letterpress Printers and Engravers. In the same year one of the brothers left the partnership, but **Bennet, William** [2/2] continued the business in the same premises.

Bennet, William [Entry 2/2]
1867–1871
Glasgow
1867–71 25 Queen Street
Lithographic and Letterpress Printer. Previously partner in **Bennet Brothers** [1/2], Glasgow.

Bennett Brothers [Entry 1/2]
c.1870–1880
Dumbarton
c.1870–76 9 & 11 High Street
1876–80 16 High Street
Partnership of Samuel and William Bennett. Following the death of the brothers in 1876 and 1880, the firm became **Bennett & Thompson** [2/2] in 1880. Both firms had a strong working relationship with Samuel Bennett's son-in-law, **Langlands, George**. This was reflected in the designs of their advertisements.
Adv: Advertised on 8 lithographed pages in *Dumbarton Directory* of 1877.

Bennett & Thompson [Entry 2/2]
1880–20thC
Dumbarton
1880–c.97 16 High Street
c.1897–20th Church Street
Formerly **Bennett Brothers** [1/2], Dumbarton. Partnership of Samuel Bennett's daughter, Mary, and William Thomson.
Art-T-P-Adv 1888: Donald MacLeod, *The God's Acres of Dumbarton* (Dumbarton, 1888). 1877: Advertised in POD.

Bertram, Peter [Entry 1/2]
1867–1892
Glasgow
1867–77 202 & 204 Argyle Street

1877–88 355 Argyle Street
1888–92 335 Argyle Street
Listed as Lithographer in Slater 1867, but only as Letterpress Printer, Stationer and Account Book Manufacturer in PODs. 1893: Took sons into partnership as **Bertram, Peter & Sons** [2/2]. Probably related to engraver John Bertram, also sited in Argyle Street.

Bertram, Peter & Sons [Entry 2/2]
1892–20th C
Glasgow
1892–20thC 335 Argyle Street
Previously **Bertram, Peter** [1/2]. POD listed as Letterpress Printer, Stationer and Account Book Manufacturer, but not as Lithographer.

Beveridge, Archibald
[Kirkcaldy Printing Works]
1869–1891
Kirkcaldy
1869–72 Heron's Wynd †
 294 High Street (Lithographic Dept.)
1872–78 276 High Street ‡
1878–91 Townsend Place, Church Lane #
Alternatively known as *Kirkcaldy Printing Works*. Originally apprenticed to **John Crawford** of Kirkcaldy, and from 1863–67, manager of **William Cruikshank**, Edinburgh. In 1867 the enterprising Beveridge founded his own letterpress printing business at Heron's Wynd and also became a co-partner in **W.L. Whyte & Co.**, where he set up and managed the lithographic department (announced in *The Fifeshire Advertiser*, 15 June 1867). His co-partners **William Lindsay Whyte** and **Francis Hislop** were joint proprietors of *The Fifeshire Advertiser*, also located at 294 High Street. Due to Beveridge's ill-health the firm became **Couper & Allen** in 1891. Archibald Beveridge died in May 1892 when only 47 years of age.
† When the partnership was dissolved in 1869 (announced in *Fifeshire Advertiser*, 22 May 1869, and *British Printer*), Beveridge acquired the lithographic printing establishment, which remained on the existing premises until Whyte died in 1871. Beveridge was listed in PTDs 1872–89 inclusive. See J. Harry Allen, *Allen the Lithographers* (Kirkcaldy, 1998).
‡ Possibly due to an erroneous entry, this address was still listed in PTD 1880.
In 1878 the firm also occupied temporary premises at Kirk Wynd.

C-Adv Sample book of Nairn's Linoleum Patterns (private collection).

Bicket, John

*c.*1846–1851

Kilmarnock

 *c.*1846–51 King Street

Originally listed in Pigot 1837 as an engraver at 53 King Street. See note on **Bicket, Thomas**.

Bicket, Thomas

*c.*1846–1851

Kilmarnock

 *c.*1846–51 King Street

Separately listed from **Bicket, John** but occupied same address. They were succeeded by **Merry, Thomas Bicket**, probably a relation through marriage.

Black, James LL.D. [Entry 1/2]

*c.*1870–1882

Elgin

 *c.*1870–76 *Elgin Courant* Office

 1876–82 100 High Street

*b.*1830, *d.*1899. Proprietor/Editor of *Elgin Courant* from 1860. Introduced lithography *c.*1870. Listed PTDs 1872, 1876 and 1880. 1882: Entered partnership **Black, Walker & Grassie** [2/2] at same location.

Black, Walker & Grassie [Entry 2/2]

1882–1892

Elgin

 1882–92 100 High Street

Proprietors of *Elgin Courant*, and formerly **Black, James** [2/2]. In 1892 James Black retired, and business continued as **Walker & Grassie**. Listed PTDs 1885 and 1889.

Blackburn, Mrs. Hugh [Jemima]

Edinburgh and Glasgow

See *Wedderburn, Jemima*.

Blackie, W.G. & Co. [Entry 1/2]

1866–89

Glasgow

 1866–74 50 St James Road

 1872–89 17 Stanhope Street †

Printing division associated with Blackie & Son, the long established publishers, originally founded in 1809 by John Blackie, Archibald Fullarton and William Somerville. Letterpress printing was introduced in 1819, when **Edward Khull**, a former sub-contractor, became a partner. The firm operated as Khull, Blackie & Co., publishers and printers in Glasgow, and as Fullarton, Sommerville, publishers in Edinburgh. Following Khull's resignation in 1826, the firm traded as Blackie, Fullarton & Co. In 1829 Blackie purchased the premises and plant of the Villafield Printing Works, following the failure of the distinguished letterpress printers to the University, A. & J.M. Duncan. Until 1837 the Works were managed by George Brookman, an ex-Duncan employee. The eastern part of the area was rented to Fullarton, who established a printing department there. In 1831 the partnership of Blackie and Fullarton was dissolved, with all aspects of the business being equally divided. Thereafter the Glasgow business continued as Blackie & Son. **Fullarton, A. & Co.** traded as an entirely separate business in Edinburgh, but still maintained the printing unit in Glasgow. Between 1831 and 1874 the floor area of Blackie's printing works was increased from 3,150 to 54,000 square feet. Dr Walter Graham Blackie (1816–1906), who had managed the printing works since 1837, introduced lithography in 1866. The firm is known to have installed a state-of-the-art cylinder press of French manufacture in 1869. At that time the process appears to have been used principally for colour tinting and transferring from engravings to stone. The firm specialised in the production and publication of religious, technical, and educational books, and these included some chromolithographed illustrations. See Agnes A.C. Blackie, *'Blackie & Son' 1809–1959* (London, 1959).

† PODs also listed the following addresses in St James Road, 1885-89 No. 50; and 1889–90 No. 82. The firm was also listed in Slater 1867, and PTDs 1872–1889. From 1890 the printing works operated as **Blackie & Son** [2/2].

Art-T-P-O View of firm's premises in Stanhope Street, in *Pictures & Royal Portraits illustrative of English and Scottish History* (Glasgow: Blackie, 1878). Portrait: 'Robert Blackie', artist: W. L. Leitch.

Blackie & Son [Entry 2/2]

1890–20thC

Glasgow

 1890–20thC 17 Stanhope Street

Formerly **Blackie, W.G. & Co.** [1/2]. 1890: The firm adopted the title of the publishers and parent firm.

Art-O

Blair, Thomas
c.1870–c.1896
Musselburgh
 c.1870–76 125 High Street
 1876–93 131 High Street
 1893–c.1896 143 High Street
Listed PTDs 1872–1893.

Blake, William [Entry 1/2]
1857–1866
Glasgow
 1857–60 11 Renfield Street
 1860–66 64 West Howard Street
Added Letterpress c.1865. 1866: Entered partnership as
Blake & Mackenzie [2/2]

Blake & Mackenzie [Entry 2/2]
1866–1880
Glasgow
 1866–80 64 Howard Street
Formerly **Blake, William** [1/2]. Listed Slater 1867 as
Engravers, Lithographic and Letterpress Printers. In
1865 the firm moved to Liverpool, but continued the
Glasgow office until 1880. The firm specialised in horti-
cultural work, and in later years achieved considerable
distinction.

Blyth, David Wishart [Entry 1/2]
1864–1875
Edinburgh
 1864–75 2 Quality Street
Listed Slater 1867 and PTD 1872. Lithographic and
Copperplate Printer and Engraver. 1875: David Wishart
Blyth moved to a new location where he entered part-
nership as **Blyth, D. & A.** [2/2].

Blyth, D. & A. [Entry 2/2]
1875–1877
Edinburgh
 1875–77 3 Dock Street
Also Engravers. Formerly **Blyth, David W.** [1/2]. Listed
PTD 1876.

Boag, Andrew [Entry 1/3]
1855–1857
Glasgow
 1855–57 18 Hutcheson Street

Previously Engraver only. 1855: Added Lithographic and
Copperplate Printing. 1857: Entered partnership **Boag &
Rowan** [2/3].

Boag & Rowan [Entry 2/3]
1857–1859
Glasgow
 1857–59 18 Hutcheson Street
Formerly **Boag, Andrew** [1/3]. Partnership terminated in
1859 when **Rowan, Alexander** appears to have taken
over Boag's share of the business. **Andrew Boag** [3/3]
started new business.

Boag, Andrew [Entry 3/3]
1859–1866
Glasgow
 1859–60 108 Argyle Street
 1860–66 52 Argyle Street
Engraver and Lithographic Printer. Former partner in
Boag & Rowan [2/3].
Adv: Advertised in POD 1861.

Boston, John
1858–1863
Glasgow
 1858–63 12 Argyle Arcade
Listed Slater 1860 'Engraver and Lithographer'.

Bowie & Glen [Entry 1/2]
1857–1858
Glasgow
 1857–58 123 Vincent Street
John Bowie and William Glen. Formerly Letterpress
Printers only. When this partnership ended, the business
continued at the same address under the new partnership
of **John & Robert Bowie** [2/2].

Bowie, John & Robert [Entry 2/2]
1858–1860
Glasgow
 1858–59 123 Vincent Street
 1859–60 112 Hope Street
Formerly in partnership of **Bowie & Glen** [1/2].

Boyle, James
1845–1846 and 1850–1853
Glasgow
 1845–46 156 Saltmarket

1846–50 not trade listed
1850–52 14 Merchant Street
1852–53 22 East Clyde Street
Listed Engraver and Lithographer.

Boyle, John [Entry 1/3]
1842–1845
Edinburgh
 1842–43 20 Bank Street
 1843–45 142 High Street
Boyle appears to have ceased trading from 1845 to 1847, when he re-appeared at the same address in partnership **Boyle & Mann** [2/3].

Boyle & Mann [Entry 2/3]
1847–1857
Edinburgh
 1847–57 142 High Street
Engravers and Lithographic Printers. Previously **Boyle, John** [1/3]. When the partnership ended, **John Boyle** [3/3] briefly continued the business.

Boyle, John [Entry 3/3]
1857–1858
Edinburgh
 1857–58 142 High Street
Former partner **Boyle & Mann** [3/3].

Brock, John S.
1860–1861
Glasgow
 1860–61 62 Argyle Street
Listed PODs as Engraver and Lithographer, only in 1860–61, but not in 'trades' section. Listed Slater 1860.

Brodie, John [Entry 1/2]
c.1885–c.1887
Arbroath
 c.1885–c.87 Brothock Bridge
Then entered partnership **Brodie & Salmond** [2/2].

Brodie & Salmond [Entry 2/2]
c.1887–20thC
Abroath
 c.1887–20thC *Herald Office* at Brothock Bridge
Formerly **Brodie, John** [1/2]. 'Proprietors of Arbroath Herald'.

Art-? Said to have lithographed reproductions of oil-paintings and map of Abroath, but these not traced.

Brown, David
pre-1870–1895
Kilbirnie and Dalry
 <1870–95 Dennyholme, Kilbirnie
 1889–95 Dennyholme, Kilbirnie
 and Main Street, Dalry
Until 1889 lithographic printing was carried on in Kilbirnie only, but by 1889 seems to have been added to existing engraving facilities in Dalry. Both plants ceased trading shortly after David Brown's death in 1893. The firm also traded in Kilmarnock as **Brown, D. & Co.**
Adv: 'Ardrossan & Saltcoats Herald'. 2 April 1870: Advertised 'having applied Steam to his Lithographic Presses' ... 'Orders for Lithographic Work to be addressed to Kilbirnie'.

Brown, David & Co.
1887–20thC
Kilmarnock
 1887–20thC 2 King Street
'Lithographers, Printers and Stationers'. David Brown, Senior Partner, was also proprietor of the lithographic businesses in Kilbirnie and Dalry. When he died in 1893, the Kilmarnock business was continued by his sons.

Brown, John
1837–1846
Edinburgh
 1837–45 8 North Bridge
 1845–46 16 Keir Street
Previously Engraver and Chapbook Printer at 507 Lawnmarket 1834–35, and at 5 North Bridge 1836–37. Listed POD 1837 as Engraver, Copperplate Printer and Lithographer. Also Listed Pigot 1837. In 1840 he engraved 'View of Nelson's Monument' for the *Pocket Picture of Edinburgh*, and in 1841 printed *The life, trial, and execution of Mary Thompson aged 19, who was executed at Edinburgh 22nd February 1841*. However, no examples of his artistic lithography have been traced. 1843: Admitted to Sanctuary for debt at Holyroodhouse.

Brown, John
1855–20thC
Glasgow
 1855–65 37 Glassford Street
 1865–69 52 Glassford Street

1869–72	48 Gordon Street
1872–79	58 N. Hanover Street
1879–91	11 Miller Street
1891–20thC	8 Gordon Street

Originally apprenticed to **Allan & Ferguson.** Lithographer, 'Writer, Artist & Draughtsman'. Also listed Engraver 1873. Listed Slater 1860, 1867.

Brown, Robert
1870–83
Glasgow

1870–71	3 West Nile Street
1871–78	27 Union Street
1878–83	128 Renfield Street

Lithographic & Letterpress Printer.

Brown, Robert M. [Entry 1/2]
1841–1849
Glasgow

1841–45	10 Jamaica Street
1845–49	29 Jamaica Street

Also Copperplate Printer and Engraver. 1849: Took son into partnership as **Brown & Son** [2/2].

Brown & Son [Entry 2/2]
1849–1853
Glasgow

1849–53	5 King Street
1853 only	56 Trongate and 28/29 Nelson Street

Formerly **Brown, Robert M.** [1/2]. Engravers, Copperplate Printers & Lithographers.

Bruce & Anderson
1837
Glasgow

1837	35 Miller Street

Not listed in PODs. Listed as lithographer only in Pigot 1837, but firm appears to have lasted for less than one year.

Brydone, J. & Son (s †) [Entry 1/3]
1859–1866
Edinburgh

1859–61	17 S. Hanover Street
1861–66	12 Elder Street

Following a publishing partnership with George Thornton between 1836 and 1838, when they published a children's chapbook, *History of Beasts*, James Brydone established his own business as a Letterpress Printer, Publisher and Bookseller at 17 Hanover Street in 1839. Between 1839 and 1858 the firm published a series of Chapbooks. Listed Slater 1860 as Lithographic and Letterpress Printers, Engravers, Publishers, Booksellers. The firm specialised in producing timetables for the railways and horse-drawn coach routes, and were also printers and publishers of *The Scottish Advertiser*. 1866: The business continued as **Brydone, James** [2/3].

† Variously listed in directories as '& Son' and '& Sons'. On balance the latter appears correct.

Art-O 1862: Two-tinted illustrations in *The Clans of the Highlands of Scotland*, second series (Edinburgh, 1862), listed in G. Wakeman & G.D.R. Bridson, *A Guide to 19th Century Colour Printers* (Loughborough, 1975), but not traced.

Brydone, James [Entry 2/3]
1866–1881
Edinburgh

1866–69	Railway Directory Office, 12 Elder Street †
1869–71	no directory entries
1871–81	12 Elder Street

Former partner in **Brydone, J. & Sons** [1/3]. Engraver, Lithographic and Letterpress Printer, Publisher, and Bookseller. Listed Slater 1867. 1867: Listed as having 'Steam Power.' 1881: Entered partnership **Brydone & Luke** [3/3].

† POD 1867/8 incorrectly trade-lists address as 20 Elder Street.

Adv: POD 1867/8 as 'Law and General Printers'.

Brydone & Luke [Entry 3/3]
1881–1894
Edinburgh

1881–94	12 Elder Street

Formerly **Brydone, James** [2/3]. 'Lithographers, Engravers and Letterpress Printers'. Partnership of James Brydone with former wine merchant, Robert Luke. The business was sold to John Stewart in 1894, when Brydone retired. Listed PTD 1885, 1889.

Bryson, Robert Mrs [Entry 1/2]
1857–1870
Kirkcaldy

1857–70	132 & 189 High Street

Lithographers, Bookbinders, Booksellers, Stationers.

Enterprising in the face of adversity, Helen Bryson and her family continued the business of her husband, Robert, following his death in 1848. She added lithographic printing in 1857, and was successful in expanding the business. When she retired, about 1870, she was succeeded by her son, **John Bryson** [2/2]. Helen Bryson died in 1875. See A.J. Campbell, 'Fife Shopkeepers and Traders 1820–1870', 4 vols, 1989 (unpublished work, available in Kirkcaldy Central Library and National Library of Scotland).

Adv-C-O Advertised in *Fifeshire Advertiser* on 9 May 1857 and 19 March 1859.

Bryson, John [Entry 2/2]
1870–1889
Kirkcaldy

1870–81	132 High Street
1881–89	130 High Street

Bookseller, Bookbinder, Letterpress and Lithographic Printer. Originally apprenticed as a bookbinder to his father, Robert Bryson. On returning from the Crimean War about 1857, he re-joined the family firm, then controlled by his mother **Mrs Robert Bryson** [1/2], and succeeded her when she retired. Following Helen Bryson's death in 1875, John Bryson continued to develop the business, and also effected substantial improvements in the *Fifeshire Advertiser*, which he acquired from **Francis Hislop** in 1877. John Bryson retired due to ill-health in 1889, but died in 1890. He was succeeded at the *Fifeshire Advertiser* by the editor, Lachlan Macbean. Listed *Westwood's Directory* 1871, and PTDs 1872, 1876, 1889.

Adv: Advertised in *Fifeshire Advertiser*.

Bryson, Robert M.
1852–1853
Glasgow

1852–53	19 Montrose Street

Listed as Lithographer only.

Art-T-Mil 1856: 'Trezibond' (Abbey, *Travel*, 240). Plates 6 and 10 in Wm. Simpson's 'Seat of War in the East' Series 2 and other military prints produced between 1856 and 1860 are inscribed 'R. M. Bryson'. These suggest he may have moved to England, but not traced.

Buchanan & Pearson
1867–20th C
Glasgow

1867–72	68 Hutcheson Street
1872–93	104 Brunswick Street
1893–99	33 East Howard Street
1899–20thC	11 George Square

Junior partner George Pearson. Trade-listed PODs as Letterpress Printers, but not as Lithographers. 1866: Listed as 'Wholesale Stationers'. 1867: Listed in Slaters as Lithographers. 1872: Also as Paper Bag Manufacturers, and subsequently as Bookbinders and Accounts Book Manufacturers.

Buchanan, David S.
1852–1856
Glasgow

1852–55	7 Argyle Street
1854–56	107 Buchanan Street

Lithographer and Engraver. Former partner in **Miller & Buchanan**.

Buchanan, W. & Co.
1836–1839
Glasgow

1836–39	4 Steel Street

'Lithographer and Lithographic Printer', suggesting he was both artist and lithographer. Listed Pigot 1837.

Burness, William [& Co.]
1828–1900 †
Edinburgh

1828–33	10 St James Square
1833–66	1 N. St Andrew Street
1866–84	2 N. St Andrew Street
1884–89	2 N. St Andrew Street
	18 Clyde Street
1889–96	14, 16, 18 Clyde Street
1896–1900	14, 16, 18 Clyde Street
	(Morrison & Gibb Limited,
	Tanfield and 11 Queen Street)

Listed in POD 1828 as 'Printer', and POD 1833 as 'Law and Lithographic Printer'. 1860: 'Printer to Her Majesty'. From 1868 shared premises with **Scott & Ferguson**, and the two firms later appeared to have amalgamated, for the PTD listing for 1893 shows **Scott & Ferguson & Burness** although this title is not listed in the PODs.

† Between 1896 and 1900 both Scott & Ferguson and Burness & Co. were acquired by Morrison & Gibb, well-known in the 20th century for their book-printing.

Art-M 1831: 'Plan of Keppochhill Road, Glasgow'.

Burnet, Robert A.
1868–1869
Edinburgh
1868–69 2 Street Cuthbert's Place

Burrell & Byers [Entry 1/2]
1858–1877
Edinburgh/Leith
1858–64 3 Baltic Street
1864–66 16 Assembly Close, Leith
1866–67 21 Assembly Street, Leith
1867–77 20 Assembly Street, Leith
Listed as Lithographic and Letterpress Printers in Slater 1860, 1867. Trade-listed in PODs from 1860 as Letterpress Printers, but never as lithographers. 1877: The business was continued by **Alexander Burrell** [2/2] when the partnership ended.

Burrell, Alexander [Entry 2/2]
1877–1880
Edinburgh
1877–80 20 Assembly Street
Previously partner in **Burrell & Byers** [1/2]. Also Letterpress Printer.

Cairns, Daniel, D.
1872–1873
Paisley
1872–73 109 Causeyside
Adv: *Paisley Directory*. Listed PTD 1872.

Cairns, James & Co.
1871–1875
Glasgow
1871–75 35 Gordon Street
Lithographic and Letterpress Printers. Listed PTD 1872. Possibly related to **Walter Cairns**.
Adv: Advertised in POD of 1871.

Cairns, Walter
1858–1872
Glasgow
1858–72 93 Virginia Street
Previously Paper Ruler and Bookbinder. Possibly related to **James Cairns.**

Calder, James Ogilvie [Entry 1/2]
c.1876–c.1887

Fraserburgh
 c.1876–c.87 22 High Street
c.1887: Entered partnership as **Calder Bros.** [2/2].
Listed PTDs 1876–1889.

Calder Brothers [Entry 2/2]
c.1887–c.1891
Fraserburgh
 c.1887–c.91 22 High Street
Formerly **Calder, James O.** [1/2]. Listed PTD 1889.

Caldwell Brothers (Ltd. †)
1860–20thC
Edinburgh
1860–69 15 Waterloo Place
1869–20thC 11, 13, 15 Waterloo Place
William and Thomas Caldwell. Formerly Wholesale Stationers and Publishers, now added Lithography and Engraving. Listed Slater 1860 and 1867. Added Letterpress c.1885.
† 'Ltd.' from 1881.
Adv: Advertised regularly in POD from 1887.

Callow, Frederick
1865–1894
Glasgow
1865–75 46 Maxwell Street
1875–79 7 Argyle Street
1879–94 48 Stockwell Street
POD 1866 and Slater 1867: 'Ticket Writer and Lithographer'. Previously with **Newmarch, Strafford, & Co.**, and succeeded to their business at the same address. Listed PTDs 1872, 1876, 1880, 1885.

Cameron, Clark & Co. [Entry 1/5]
1859–1860
Glasgow
1859–60 12 Enoch Square and 187 Argyle Street
Partnership ended in 1860, but the firm continued business as **Cameron & Co.** [2/5].

Cameron, & Co. [Entry 2/5]
1860–1867
Glasgow
1860–61 12 Enoch Square and
 187 Argyle Street
1861–64 76 Queen Street
1864–67 88 & 94 W. Nile Street

Also Letterpress Printers. Formerly **Cameron, Clark & Co.** [1/5]. In 1867 entered new partnership as **Cameron & Ferguson** [3/5].

Cameron & Ferguson [Entry 3/5]
1867–1890
Glasgow

1867–72	88, 94 W. Nile Street
1872–75	88 W. Nile Street only
1875–76	88 to 94 W. Nile Street
1876–90	88 W. Nile Street only

Also Letterpress Printers. Formerly **Cameron & Co.** [3/5]. Not listed in PTDs. 1890: Title changed to **Cameron, Ferguson & Gullick** [4/5].

Cameron, Ferguson & Gullick [Entry 4/5]
1890–1892
Glasgow

1890–91	59 N. Frederick Street
1891–92	63 N. Frederick Street

Lithographic and Letterpress Printers. Formerly **Cameron & Ferguson** [3/5]. Partnership not listed in PTDs. 1892: Gullick left the firm, and title reverted to **Cameron & Ferguson** [5/5].

Cameron, Ferguson & Co. [Entry 5/5]
1892–20thC
Glasgow

1892–20thC	68 N. Frederick Street

Lithographic and Letterpress Printers. Formerly **Cameron, Ferguson & Gullick** [4/5].

Cameron, James A.
1867–1873
Edinburgh

1867–73	10 Clerk Street

Lithographic & Letterpress Printer, Bookbinder, Publisher and Stationer. Listed Slater 1867.

Cameron, James
1865–70
Glasgow

1865–67	7 Argyle Street
1865–70	31 Argyle Street

'Lithographic & Letterpress Printer.'

Cameron, Kenneth
c.1898–20thC

Motherwell

c.1898–20thC	84 Merry Street (Offices of the *Motherwell Times*)

In 1841 Motherwell was still a village having just 1,000 inhabitants. In spite of industrialization and the development of the railways, it was almost the end of the century before lithography came to Motherwell.

Adv: Printer, Bookbinder, Bookseller and Stationer.

Cameron, Thomas
1866–20thC
Glasgow

1866–70	44 Maxwell Street
1870–71	255 George Street
1871–84	88 John Street
1884–91	63 John Street
1891–97	3 Love Lane, off John Street
1897–20thC	7 Stirling Road

Listed as 'Lithographer only' in Slater 1867, but introduced Letterpress c.1875.

Campbell, A. & Co.
1855–1859
Glasgow

1855–57	5 Hutcheson Street
1857–59	5 Brunswick Street

Engraver and Lithographer.

Campbell, Allan
1864–1874
Glasgow

1864–74	114 Trongate

Campbell, Archibald [& Rae †]
1840–1846
Glasgow

1840–46	21 Argyle Street

'Lithographer and Engraver'. Succeeded to business of **Miller, James.** 1846: Succeeded by **Miller & Buchanan. Campbell, Archibald** (1855–1860) may be a re-appearance of the same Campbell, or possibly related.

† Campbell was said by **Murdoch, Thomas** to have been in partnership as Campbell & Rae, but this title does not appear under trade-listings in PODs.

Campbell, Archibald
1855–1860

Glasgow

1855–60	53 Candleriggs

See note on **Campbell, Archibald** (1840–1846). Pattern Designer and Lithographer.

Campbell, Duncan & Son

1859–1899

Glasgow

1859–64	93 St Vincent Street
1864–68	93 St Vincent Street and 20 Renfield St.
1868–70	93 St Vincent Street
1870–73	96 St Vincent Street
1873–74	no directory entries
1875–99	96 Vincent Street

Lithographic and Letterpress Printer. Listed in PTDs 1872–1900, but seemingly retired in 1899, having completed 40 years in business.

Campbell, M.

1857–1858

Glasgow

1857–58	85 Dundas Street

Previously Stationer only.

Campbell & Tudhope (& Co. †)

1853–20thC

Glasgow

1853–54	75 Argyle Street
1854–56	95 Argyle Street (Craigs Court)
1856–64	6 Union Street
1864–65	6 Union Street and 172 Argyle Street
1865–75	43 Mitchell Street
1875–85	137 W. Campbell Street
1885–20thC	45 Cranston Street

Alexander Campbell and Robert Tudhope. Also Engravers. Added Letterpress c.1875. 1882: POD entry lists as having 'Steam Power'. Listed Slaters 1860, 1867, PTDS 1872–1900.
† Listed as Campbell, Tudhope & Co. 1853 to 1855 only.
Adv: Advertised in PTD 1872.

Campbell, Walter (& Co. †)

1844–1853

Glasgow

1844–53	16 Queen Street

Previously partner in **Johnston & Campbell**. Engraver, Lithographic Printer.
† '& Co.' from 1851.

Campbell, William

1853–1854

Glasgow

1853–54	71 Stockwell

Cargill, J.

1847–1849

Edinburgh

1847–49	16 Dock Street, Leith

POD 1847 lists as 'Lithographic Writer and Printer'.

Carswell & Mather

1861–1862

Glasgow

1861–62	24 Stockwell Street

Carswell possibly related to the **Carswell** family of printers in Paisley.

Carswell, John (& Co. †)

1845–20thC

Paisley

1845–48	100 High Street
1848–67	46 Moss Street
1867–87	4 High Street
1887–92	3 High Street
1892–20thC	14 Causeyside Street

'Lithographer, Printer, Bookbinder and Account Book Manufacturer.' Also Engraver. Listed Slater 1867. By 1867 had added paper-ruling, and by 1876 bookbinding. Several members of Carswell family were involved in the printing trade. Carswell, who died in 1897, was also an active local politician.
† Listed '& Co.' from 1892.
Adv: Advertised POD 1872.

Chalmers, James [Entry 1/3]

1829–1856

Dundee

1829	4 & 5 Castle Street †
1834	4 Castle Street ‡
1840–56	10 Castle Street

Letterpress and Lithographic Printer, Bookbinder, Bookseller, Stationer, and Ink Manufacturer. Originally founded by William Chalmers in 1788 as Booksellers at 10/12 Castle Street. In 1805 William was succeeded by his more enterprising brother James, who introduced letterpress printing and the manufacture of ink. In spite

of variations in listings to Nos. 4, 5, 8, and 12, the principal administrative address, through successive changes of management and into 20th century, is almost invariably listed as 10 Castle Street. From *c.*1840 Chalmers also sold music and musical instruments, but is best (albeit controversially) remembered as the originator, in 1834, of the adhesive postage stamp. When James Chalmers died in 1853, he was succeeded by his son, **Chalmers, Charles D.** [2/3], but the business retained its existing title until 1856. The Edinburgh printer and stationer, **George Stewart,** was an employee of James Chalmers until 1855.

† When, in 1829, Chalmers introduced lithography, the Ink Manufactory was still located at No. 4, and the Printing Office at No. 7 New Inn Entry.

‡ In 1834 Printing Office re-located to Thom's Close, High Street.

Art-M-Adv 'Plan of the Town of Dundee', in the *Dundee Directory and Register for 1829*, 'drawn and engraved on stone by Mr. Sime, Land-Surveyor'. Advertisement in Dundee POD 1837 (text only).

Chalmers, Charles D. [Entry 2/3]

1856–70

Dundee

1856–60	10 Castle Street and
	79 High Street
1860–70	10 Castle Street

Bookseller, Stationer, Printer, and Account Book Manufacturer. Succeeded to business following death of his father, **James Chalmers** [1/3], in 1853. However, title of business remained unchanged until 1856, when he acquired premises at 79 High Street as Printing and Bookbinding Office. In 1870 he entered partnership **Chalmers and Winter** [3/3].

Chalmers & Winter [Entry 3/3]

1870–74

Dundee

1870–74	8 & 10 Castle Street

Booksellers, Stationers, Printers and account book manufacturer. Previously **Chalmers, Charles D.** [2/3]. Partnership of Charles D. Chalmers with James Chalmers's ex-apprentice David Winter. Shortly before Chalmers died in 1877, he was succeeded by partnership **Winter, Duncan & Co.**

Cherry, John

1860–1872

Edinburgh

1860	131 Nicholson Street
1860–65	84 High Street
1865–67	Carrubber's Close
1867–70	no directory entry
1870–72	10 Hill Square

Slater 1860 and 1867: Engraver and Lithographer.

Christie, James

1863–20thC

Glasgow

1863–90	11 Miller Street
1890–92	194c St Vincent Street
1892–94	10 Wellington Street
1894–20thC	5 Oswald Street

Listed Slater 1867 as Lithographer and Engraver. Added Letterpress *c.*1875. Not listed in PTDs until 1900.

Clark & Co., William

1887–1903

Dunfermline

1887–20thC	11 & 15 High Street

Succeeded in 1903 by Mackie, J. B. (not listed here).

Clark & MacDonald

1870–1871

Edinburgh

1870–71	79 George Street

Clark, Robert

1842–1873

Edinburgh

1842–43	14 Clyde Street
1843–58	8 S. St Andrews Street
1858–66	10 Hanover Street
1866–73	15 Elder Street

Listed Slater 1860, 1867, PTD 1872. Previously Engraver and Copperplate Printer.

Adv: Advertised in *Kelly's Directory* 1872.

Cleland, John

1822–1825

Glasgow

1822–25	30 Virginia Street

One of the earliest Lithographic Printers in Scotland, John Cleland, whose father, James, was the author of *The Annals of Glasgow*, is known to have produced good quality commercial work. Listed Pigot 1825. In 1825

Cleland's business was taken over by **Miller, James** (1825–1840) and later continued by other successors.

Clelland & Gibb
1864–1870
Paisley

 1864–70 8 Forbes Place

William Clelland & Thomas Gibb. Listed Slater 1867.
Adv: Advertised commercial work in *Paisley Directory* 1866. After partnership ended in 1870, business was continued by **Gibb, Thomas.**

Clerk, Alexander
1860–1861
Perth

 1860–61 72 High Street

'Lithographer and Copperplate Printer'. Succeeded in 1862 by letterpress printer Robert Whittet.
Adv: Advertised in *Perth Directory* 1860/1.

Cochrane, Peter
c.1825–c.1828
Perth

 c.1825–c.28 Kinfauns Castle

See note under *Kinfauns Press.*

Art-O Peter Cochrane's name appears as the lithographic printer of a wide variety of embellishments which appear in the *The Catalogue of the Gray Library, Kinfauns Castle,* completed in 1828 under the **'Kinfauns Press'** imprint. He worked with **Morison, David.** Cochrane's name has not been traced in any directories of the time, and he does not appear to have had his own business.

Coghill, Thomas
1869–1870
Edinburgh
 1869–70 5 Nicolson Street

Cohen, Emanuel
1852–1894
Glasgow

1852–53	31 Stockwell Street
1853–65	15 Hutcheson Street
1865–66	St Georges Court, Buchanan Street
1866–72	175 Buchanan Street
1872–76	39 N. Hanover Street
1876–86	38 Sauchiehall Street

 1886–94 73 West Nile Street

Engraver, Lithographer, Stationer. Added Letterpress *c.*1860. Listed Slater 1860, 1867.

Collins, William, Sons & Co. [Ltd.]
1853–20thC
Glasgow

1853–61	111 & 113 N. Montrose Street
1861–62	137 Stirling Road
1862–69	75 St James Road
1869–70	139 & 147 Stirling Road
1870–80	79 St James Road
1880–89	75 to 79 St James Road
1889–20thC	139 St James Road

Originally founded in 1819 by William Collins and Charles Chalmers, younger brother of William's close friend and mentor, the renowned orator and reformer, The Rev. Thomas Chalmers, whose works they printed and published. When Charles left the business in 1826, it was continued by William Collins. Under his sound management the firm overcame many early difficulties, and from 1840 achieved spectacular growth. In 1842 the firm was licensed to print and publish the Bible. Around 1846 the sons of William Collins became partners. Lithography was introduced shortly after William's death in 1853, being largely used for producing coloured illustrations, by transfer, from engravings.

1858: The firm produced their first illustrated Bible, for which they engaged the services of distinguished Scottish artist David Roberts R.A. 1862: Appointed 'Printer to the Queen' for Scotland. In 1869 the plant included 16 letterpress and 7 lithographic printing machines, and by 1875 employed more than 1,200 persons. In the same year the firm produced more than 1.3 million printed and bound books. The Collins family were highly respected for their consideration for the welfare of their printers, having reduced their working hours, firstly from 66 to 60, and then, in 1870, to 57 hours. The firm specialised in three distinct areas: educational books, scientific works, and the Scriptures. Examples of the firm's early illustrations seem rare, and none have yet been traced. In 1879 the company partners were bought out. A new 'Limited' company was floated, the Board consisting mainly of members of the family. The firm was listed in PTDs from 1872 to 1900. The firm continued into the 20th century as a great printing and publishing house, but, following a major restructure in 1981, is currently trading as Harper Collins. See D.E. Keir, *The House of Collins* (London, 1952).

Art-O-Adv POD 1890.

Cook, John D.
1858–1861
Glasgow
 1858–61 14 Garthland Street
Listed Slater 1860 as Engraver and Lithographer. Shared address with **Cook, William**.

Cook, William
1842–1863
Glasgow
 1842–63 14 Garthland Street
'Pattern Designers, Print Cutters and Lithographers'. Between 1858 and 1861 William shared this address with **John Cook**. They were separately listed and did not appear to be partners.

Cornwall, George & Sons
1856–20thC
Aberdeen
 1856–80 54 Castle Street
 1880–89 42 Castle Street
 1889–20thC 42 & 45 Castle Street
Originally founded in 1832 by George Cornwall, ex-apprentice of David Chalmers & Co. and ex-employee of William Clowes of Beccles. In spite of title, only one son, Joseph, was actually a partner in this highly progressive and successful firm. Lithography was used extensively in label printing and in the production of many chromo-lithographed calendars etc. By the 1890s the firm had built up a substantial export market in the colonies, the USA and China, and employed more than 250 personnel. Listed Slater 1867 and PTDs 1872, 1876, 1880, 1893, and 1900.
Art-O-M 1882: 'Map of Cullen' in *Reminiscences of the Old Town of Cullen*. 1886: Tinted illustrations in P. Morgan, *Annals of Woodside and Newhills* (Aberdeen, 1886). 1892: 'Great North of Scotland Railway' (Plan and Sections) from survey by Peter May.

Couper & Allen
1891–1900
Kirkcaldy
 1891–1900 Townsend Place, Church Lane
Also occupied premises in Kirk Wynd until 1892. Lithographic and Letterpress Printers. Listed PTDs 1893–1900. Formerly **Beveridge, Archibald**. Due to Beveridge's ill-health, he was succeeded in 1891 by the partnership of Roderick Couper, a businessman, and John

Henry Allen, who, having joined Beveridge in 1872, had risen from apprentice to general manager. When a disastrous fire destroyed the factory in 1900, Couper left the business, and the firm was re-structured, firstly becoming J. H. Allen & Co., and then, after a few months, Allen Lithographic Co., Ltd. The firm is still trading, in 1998, under the title Inglis Allen Limited.
Art-C Sample book of Nairn's Linoleum Patterns in Kirkcaldy Museum.

Cox, William
1868–1877
Edinburgh
 1868–70 2a Greenside Place
 1870–72 39 South Bridge
 1872–73 no directory entry
 1873–77 15 St James Square
Originally listed Lithographer and Envelope Maker, but also Letterpress Printer in POD 1870. PTD 1876.

Crawford & M'Cabe
1866–1888
Edinburgh
 1860–69 7 George Street
 1869–88 15 Queen Street
William Crawford and Matthew M'Cabe. Law and General Printers. Listed Slater 1867 as Lithographic and Letterpress Printers, and Engravers.

Crawford & Merchant
1843–1844
Glasgow
 1843–44 20 St Enoch Square
Also Engravers and Letterpress Printers. Crawford may connect with **Crawford, T.**

Crawford, John [Entry 1/3]
1869–1870
Glasgow
 1869–70 52 Howard Street
1870: Entered partnership **Crawford & Balfour** [2/3].

Crawford & Balfour [Entry 2/3]
1870–1871
Glasgow
 1870–71 15 St Enoch Street
Formerly **Crawford, John** [1/3]. After dissolution of partnership, Crawford moved to a new location where he reverted to trading as **Crawford, John** [3/3].

Crawford, John [Entry 3/3]
1872–20thC
Glasgow
> 1872–80 71 George Street
> 1880–93 66 Mitchell Street
> 1893–99 104 W. George Street
> 1899–20thC 128 Sauchiehall Street

Lithographic and Letterpress Printer. Formerly **Crawford & Balfour** [2/3]. Listed PTDs 1872–89.

Crawford, John [Entry 1/4]
1857–1873
Kirkcaldy
> 1857–73 201 High Street

Also known from inception as 'Kirkcaldy Steam Printing & Lithographic Works'. Originally a bookseller, Crawford started letterpress printing in 1850, and added lithography in 1857. From 1857 to 1877 printed free advertising sheet *Fife Circular*. Listed PTDs 1872. 1873: From 1873 traded as **Crawford, John & Sons** [2/4]. See A.J. Campbell, *Early Kirkcaldy Presses* (Fife Bibliography: The Presses of Fife, 6) (Buckhaven, 1992).

Art-O-Adv *c.*1860: Vignette on front cover of catalogue for 'Links Brick & Tile Works and Pottery, Kirkcaldy'. Advert in *Fife Advertiser*, April 1857.

Crawford, John & Sons [Entry 2/4]
1873–1874
Kirkcaldy
> 1873–74 201 High Street

Previously **Crawford, John** [1/4]. 1873: Entered short-lived partnership with his sons James and William. Following dissolution in 1874, the business continued as **Crawford, John**. See A.J. Campbell, *Early Kirkcaldy Presses* (Fife Bibliography: The Presses of Fife, 6) (Buckhaven, 1992).
Adv: *Fifeshire Advertiser*.

Crawford, John [Entry 3/4]
1874–1877
Kirkcaldy
> 1874–77 201 High Street

Formerly **Crawford, John & Sons** [2/4]. Following termination of partnership with sons, continued on his own. Listed PTDs 1876. In 1877 he entered new partnership as **Crawford & Walker** [4/4]. See A.J. Campbell, *Early Kirkcaldy Presses* (Fife Bibliography: The Presses of Fife, 6) (Buckhaven, 1992).

Crawford & Walker [Entry 4/4]
1877–1881
Kirkcaldy
> 1877–81 201 High Street

Formerly **Crawford, John** [3/4] (Kirkcaldy). The partnership of John Crawford and William Walker continued until 1881, when Crawford retired. He died in 1892. Strangely, only Crawford's name was listed in PTD 1880. See A.J. Campbell, *Early Kirkcaldy Presses* (Fife Bibliography: The Presses of Fife, 6) (Buckhaven, 1992).
Adv: *Fifeshire Advertiser*, 25 April 1857.

Crawford, T. & Co.
1844–1845
Glasgow
> 1844–45 25 Trongate

Lithographic Printer and Engraver.

Crighton [Crichton †], Alexander
1831–1845
Edinburgh
> 1831–41 27 West Register Street
> 1841–45 54 Princes Street

Listed Pigot 1837. Also Copperplate Printer. In 1841 Crighton also became involved in print-selling and the making of picture frames, and continued this business after ceasing to trade as a printer in 1845.
† From 1838 spelling of name changed from Crichton.
Adv: Advertised 'Lithographic Establishment' in *The Scotsman*, 2 August 1834, in which he also offered for sale prints engraved by Joseph Swan and Westall.

Crocket, William Henry
*c.*1878–*c.*1883
Montrose
> *c.*1878–*c.*83 13 Bridge Street

Probably related to **Crockett, William M.**

Crocket, William M.
*c.*1883–*c.*1892
Montrose
> *c.*1883–*c.*92 200 High Street

Probably related to **Crocket, William Henry**, and may well have succeeded him.

Cruikshank, William
1860–20thC

Edinburgh

1860–61	13 East Register Street
1861–62	13 East Register Street and
	21 St James Square
1862–72	18 St James Square
1872–81	23 Elder Street
1881–91	15 Elder Street
1891–1900	7 Elder Street
1900–20thC	21 Elder Street

Also Engraver. Listed Letterpress c.1885. Manager from 1863–67 was **Archibald Beveridge**. In 1867 Beveridge resigned and moved to Kirkcaldy where he became a co-partner in **W. L. Whyte & Co.** Listed Slater 1867 and PTDs 1872–89.

Cumming, Gershom
1842–1854
Dundee

1842–48	37 Reform Street
1848–53	94 Nethergate
1853–54	6 High Street and 5 Panmure Street

b.1810, d.1898. Originally an Artist and Engraver at 21 Reform Street. Expanded to include print selling and stationery in 1840. In 1842 moved to new address and added lithography. Ceased trading in 1854.
Art-T-P-O-M Portrait of 'The Reverend William A. D. Smith'. 'Ancient Tower and Churches, Dundee'. Both drawn and chromolithographed by G. Cumming, but neither is dated. 1843: Plan: 'Turnpike and Statute Labour Roads in the District of Dundee', surveyed by W. Byres (National Library of Scotland, Map Library, EMS.s.683). Plan: 'Estate of Tulloes, Angus' from an 1838 survey by J. Corsar [RHP.2597/2–5].

Currie, Mackay † & Kirkwood [Entry 1/2]
1846–1852
Glasgow

| 1846–52 | 9 South Hanover Street |

Partnership of Duncan T. Currie, Lauchlan M'Kay and Charles Kirkwood. From 1847 Mackay & Kirkwood also operated a separate wholesale stationery business at 135 Ingram Street. 1852: Following dissolution of partnership, **Currie, Duncan T.** [2/2] continued at a new location, while **M'Kay & Kirkwood** added engraving and lithography to their existing stationery business.
† Spelling varied between 'Mackay', 'Mackie' and M'Kay'.
Art-Mil Print: c.1848: 'Glasgow Yeomanry Cavalry', one of a group of lithographed plates listed under Entry

no. 358 'Mercer Grant's Scottish Yeomanry Cavalry' in *Index to British Military Costumes 1500–1914* (Army Museums Ogilby Trust, London, 1972). 1849: Colour lithograph: 'Landing of Her Most Gracious Majesty and Prince Albert at Glasgow'.

Currie, Duncan T. [Entry 2/2]
1852–1855
Glasgow

| 1852–55 | 107 Buchanan Street |

Engraver & Lithographer. Previously in partnership **Currie, Mackay & Kirkwood** [1/2].

Dakers, Alexander
1868–20thC
Aberdeen

1868–77	15 Netherkirkgate †
1877–97	17 & 19 Netherkirkgate
1897–20thC	17 Guestrow

Possibly the 'Dakers' who was **John Henderson**'s competent foreman at time of Henderson's death in 1848/9 or, alternatively, Daker's son.
† PTD 1872 lists an additional address at 6 Queen Street, which Dakers shared with **Stevenson, James**.

Dalglish, W.
1833–1835
Glasgow

| 1833–35 | 56 Trongate |

Davidson, John (& Co. †) [Entry 1/3]
1860–1866
Glasgow

1860–61	38 & 40 St Enoch Square and
	187 Argyle Street
1862–64	40 St Enoch Square
1864–65	50 St Enoch Square
1865–66	170 Buchanan Street

Letterpress added c.1865. May connect with **Davidson, John**, of Edinburgh. In 1866 Davidson entered into short-lived partnership of **Davidson & Muir** [2/3].
† '& Co.' from 1865.

Davidson & Muir [Entry 2/3]
1866–1868
Glasgow

| 1866–68 | 170 Buchanan Street |

Also Letterpress. Formerly **Davidson, John & Co.** [1/3].

Partnership dissolved in second year. **Davidson, John** [3/3] continued at same address.

Davidson, John & Co. [Entry 3/3]
1868–1871
Glasgow

1868–71	170 Buchanan Street

'Lithographic and Letterpress Printer'. Formerly **Davidson & Muir** [2/3].

Davidson, John
1862–20thC
Edinburgh

1862–65	3 Baltic Street
1865–66	13 Mitchell Street
1866–68	16 Mitchell Street
1868–75	25 Bernard Street, Leith
1875–20thC	9 Bernard Street, Leith

Slater 1867: Lithographic and Letterpress Printer. Added engraving *c*.1875. May connect with **Davidson, John** [1/3] of Glasgow.

Davidson, Thomas
1870–1874
Glasgow

1870–72	135 Buchanan Street
1872–74	68 St Vincent Street

Engraver and Lithographer. Listed PTD 1872.

Dawson, William
1858–1869
Edinburgh

1858–69	21 Nicolson Street

Slater 1860 and 1867: Engraver and Lithographer.

Deaf & Dumb Institution
c.1824–1832
Aberdeen

*c.*1824–32	53 School Hill

See entries for **Robert Taylor,** Teacher at the Institution *c*.1824–32, and **Taylor & Co.**, Aberdeen 1832–41. See Iain Beavan, '19th Century Book Trade in Aberdeen' (Aberdeen University Ph.D. thesis, 1992).

Denovan, James [Entry 1/3]
1869–1870
Glasgow

1869–70	3 St Enoch Street

No directory entry for 1871. Then appeared in partnership **Denovan & Fulton** [2/3] at new location.

Denovan & Fulton [Entry 2/3]
1870–1872
Glasgow

1870–72	47 Oswald Street

Lithographers and Engravers. Formerly **Denovan, James** [1/3]. 'Fulton' was almost certainly the engraver David Fulton, who returned to his trade when this short-lived partnership terminated in 1872. For several years there were no POD entries for James Denovan, but is probably the same as **Denovan, James** [3/3].

Denovan, James [Entry 3/3]
1879–20thC
Glasgow

1879–92	90 Mitchell Street.
1892–20thC	57 Mitchell Street

Believed to be a re-appearance, after 7 years, of **Denovan, James** [1/3]. Possibly worked for another lithographer in interim.

Devoto, John B. & Co.
1860–1867
Glasgow

1860–60	47 Stockwell Street
1860–62	24 Wilson Street
1862–67	36 Montrose Street

Slater 1860, 1867: Engraver and Lithographer.

Dick, Maxwell
*c.*1836–1870
Irvine

*c.*1836–70	High Street

Former bookbinder in Paisley. 1820: Established bookselling business and library in Irvine. Listed Pigot 1825. 1836: Acquired printing business on death of Edward Macquistan. No local directories have been traced for this period, but it is probable that Dick introduced lithography shortly afterwards. Maxwell Dick was a man of considerable mechanical ingenuity, responsible for several inventions including, in 1829, a suspension railway. Printed by Macquistan, with plans engraved by **Gellatly, John,** of Edinburgh, the invention was published in Irvine in 1830, under the title 'Description of the Suspension Railway invented by Maxwell Dick'. Dick was also credited, in part, with the invention of the screw propeller.

One of his apprentices was Daniel Macmillan, who, with his brother Alexander, was later to found the great international publishing group, Macmillan & Co. Ltd. When Dick died in 1870, his business was acquired by Charles Murchland. Listed Pigot 1837, Slater 1867.

Art-P Portrait of 'Robert Burns' (known but not traced).

Dilks, James & Co.
1859–1867
Glasgow
1859–60	40 Shamrock Street
1860–67	45 Gordon Street
Engraver, Lithographer and Letterpress Printer.

Donaldson, R.
1844–1846
Glasgow
1844–46	48 Howard Street
Started as Letterpress Printer only in 1842.

Dougall, Andrew
1857–1868
Glasgow
1857–68	4 St Enoch Wynd
Formerly a letter-engraver at **Joseph Swan**. Listed Slater 1860, 1867: Engraver and Lithographer.

Douglas, E.
1838–1839
Edinburgh
1838–39	33 West Register Street

Douglas, Kenneth
1853–c.1870
Inverness
1853–c.66	2 High Street
c.1866–c.70	2 Bridge Street
Previously a Bookseller in Tain 1820–25, Douglas moved to Inverness in 1826, where, having acquired the business of the late Robert Baillie Lusk, he became established as a Bookseller and Stationer, later adding engraving and lithographic printing.

Adv: Advertised in *Inverness Advertiser*, 9 August 1853 for an apprentice for his engraving & lithographic business.

Dow, John G. & Co. [Entry 1/3]
1841–1842
Glasgow
1841–42	45 Queen Street
Also Engraver. In 1842 joined in partnership **Dow & Arnot** [2/3].

Dow & Arnot [Entry 2/3]
1842–1843
Glasgow
1842–43	43 Argyle Street
Lithographers and Engravers. Formerly **Dow, John G. & Co.** [1/3]. When his brief partnership with Arnot terminated, **John Dow** [3/3] continued at same location.

Dow, John G. & Co. [Entry 3/3]
1843–1847
Glasgow
1843–45	43 Argyle Street
1845–47	56 Trongate and
	28 Nelson Street †
Former partner in **Dow & Arnot** [2/3].
† Now also listed as Letterpress Printers.

Dowie, Andrew L.
1864–1872
Glasgow
1864–65	62 Robertson Street
	Works: Robertson Lane
1865–66	45 Gordon Street
1866–68	62 Robertson Street
1868–69	70 Union Street
1869–72	45 Union Street
Lithographer, Engraver, Stationer, and Publisher. Listed Slater 1867.

Drennan, William
1867–1869
Glasgow
1867–69	175 Buchanan Street
Shared above address with **Gillies, John**.

Drummond, Andrew [Entry 1/3]
1851–1857
Kirkcaldy
1851–56	West Pier
1856–57	High Street, opposite
	Oswald's Wynd
Previously highly experienced as engraver and lithographer with several important firms. Moved to Stirling

in 1857, trading as **Drummond, Andrew** [2/3]. See A.J. Campbell, 'Fife Shopkeepers and Traders 1820–1870', 4 vols, 1989 (unpublished work, available in Kirkcaldy Central Library and National Library of Scotland).
Art-T-Adv 1857: View of 'Dunfermline Academy'.

Drummond, Andrew [Entry 2/3]
1857–1858
Stirling
 1857–58 Bow Street
Formerly **Drummond, A.** [1/3], Kirkcaldy.
Adv: Within 6 months of establishing his business in Stirling, Drummond advertised in the *Fifeshire Advertiser* that he had been 'induced' by his old customers to return to Kirkcaldy, where he again set up in business, **Drummond, Andrew** [3/3].

Drummond Andrew [Entry 3/3]
1858–1859
Kirkcaldy
 1858–59 Port-Brae, Kirkcaldy
Formerly **Drummond, Andrew**, Stirling. Now returned to re-establish earlier business in Kirkcaldy, but ceased trading and retired March 1859.
Adv: In *Fifeshire Advertiser*.

Duffus, John
1862–1876
Aberdeen
 1862–67 9 Union Buildings
 1867–70 Exchange Court, Union Street
 1870–75 36½ Union Street
 1875–76 Crown Court, 41½ Union Street
Listed Slater 1867 and PTD 1872. Lithographer, Manufacturing Stationer, and General Printer.

Dunbar, Thomas
1853–1855
Glasgow
 1853–55 41 North Albion Street
'Pattern Designer, Lithographer and Printcutter.'

Duncan & Co.
1843–1851
Edinburgh
 1843–51 1 Gabriel's Road
May be 'Duncan' of **Duncan & Hay**.

Duncan & Hay
1840–1841
Edinburgh
 1840–41 150 High Street
Also Engraver and Copperplate Printer. When partnership ended, **Hay, David** continued briefly at same address. May connect with **Duncan & Co.**, Edinburgh.

Duncan, W. & D. [Entry 1/2]
1840–1843
Glasgow
 1840–43 53 Arcade
Previously 'Engravers and Printers in General'. When the partnership ended, **Duncan, Daniel F.** continued the business.
Art-Mil-M 1840: 'Mr Phinn's Map of Glasgow'. 1839: 'Earl of Eglinton, Ayrshire Yeomanry'.

Duncan, Daniel Ferguson [Entry 2/2]
1843–1879
Glasgow
 1843–44 53 Arcade
 1844–45 3 Turners Court, 87 Argyle Street
 1845–79 62 Argyle Street, Sydney Court
Listed Slater 1860, 1867: Engraver and Lithographic Printer. Former partner in **Duncan W. & D.** Added Letterpress c.1865. The firm specialised in printing professional agreements and designed forms.
Adv: Advertised POD 1855.

Dunn & Wright
1864–1886
Glasgow
 1864–66 62 West Nile Street
 1866–67 62 West Nile Street & 100 Stirling Road
 1867–69 26 West Nile Street & 110 Stirling Road
 1869–74 26 West Nile Street & 102 Stirling Road
 1874–76 47 West Nile Street & 102 Stirling Road
 1876–78 47 West Nile Street and 100 & 108 Stirling Road
 1878–79 176 Buchanan St. & 102 Stirling Road
 1879–84 176 Buchanan Street and 102 & 106 Stirling Road
 1884–86 100 & 102 West George Street and 100 to 106 Stirling Road
Stationers, Engravers, Lithographic and Letterpress Printers, Stereotypers. Listed Slater 1867 and PTDs 1872–1885. Formerly the partnership of brothers Samuel

& Thomas Dunn, Letterpress Printers at 62 West Nile Street, and now joined by Letterpress Printer C.L. Wright. Following the deaths of the brothers, the partnership ended in 1886, but until 1888 the firm's name continued to be listed in PODs, with note '(now C.L. Wright)'. **Wright, C.L.** continued at same address. It is possible that **Dunn, James**, was a relation of the brothers.

Dunn, James

1889–20thC
Glasgow
 1889–20thC 11 Bothwell Street
Engraver and Lithographer. Possibly James Dunn was both a relation of the brothers Samuel and Thomas Dunn and an ex-employee of **Dunn & Wright**.

Dunnell & Palmer

1859–1860
Glasgow
 1859–60 6 South Hanover Street

Eadie, John & Co.

1871–1877
Glasgow
 1871–77 170 Buchanan Street
Lithographic and Letterpress Printer. Believed to be a son of **Eadie, William**.

Eadie, William (& Co.) [Entry 1/2]

1859–1872
Glasgow
 1859–62 8 Prince's Square
 1862–72 14 Prince's Square
Following more than ten years as a letterpress printer, Eadie introduced lithography in 1859. Also listed as Engraver in 1860, but not in 1865, nor subsequently. c.1862 he passed the letterpress business to **Eadie, W. Anderson** [2/2], presumed to be a son. When, c.1871, William Eadie retired or died, the letterpress side of the business was continued by W. A. Eadie, in the same premises. **Eadie, John**, probably William's second son, set up a separate lithographic and letterpress business.

Eadie, W. Anderson [Entry 2/2]

1880–20th C
Glasgow
 1880–84 31 St Vincent Place
 1884–91 106 West George Street

1891–20thC 21 Drury Street
Formerly a Letterpress Printer since c.1862, at which time he occupied the same premises as **Eadie, William** [1/2], who, in all probability, was his father.

Easton, James [Entry 1/2]

1857–1859
Glasgow
 1857–59 107 Buchanan Street
1859: Took son into partnership at new location trading as **Easton, James & Son** [2/2].

Easton, James & Son [Entry 2/2]

1859–1869
Glasgow
 1859–69 45 Union Street
Formerly **Easton, James** [1/2]. Listed Slater 1867 as Engraver and Lithographer.

Ebsworth, Joseph W.

1845–1848
Edinburgh
 1845–48 4 Montgomery Street †
According to his entry in the *Dictionary of National Biography*, Joseph Woodall Ebsworth was born in Lambeth on 2 September 1824. A few years later his father, Joseph Ebsworth *senior*, moved with his family to Edinburgh, being first listed in the POD of 1828 as a Printseller, Publisher and Bookseller. He was also a teacher of vocal music, and an actor and prompter at the Theatre Royal. He opened an English and Foreign Dramatic Repository and a Caricature Repository at 23 Elm Row, and in April 1841 became a Burgess and Guild Brother. The career of his son was barely less varied. Having studied at one of the Edinburgh Schools of Art, Joseph W. Ebsworth *junior* set up as a lithographic printer. He was also an engraver on metal and wood, and a watercolourist. No examples of his lithographic work have been traced, but an engraving, 'North View of Edinburgh, from the upper gallery of Scott Monument', dating to c.1846, and three watercolour views of 'The Scott Monument' dated 1847, are held in the Edinburgh Room of the Central Library. In 1848 J. W. Ebsworth left Edinburgh for Manchester, where having firstly joined the Lithographic and Letterpress Printing firm of George Falkner, he became Artistic Director of the Manchester Institute of Technology, and later a Professor at the Glasgow School of Art. In later years he changed direction in life, and, although continuing to publish, entered the

Church in 1864, becoming Vicar of Molash in Kent 1871–1894. He died in 1908.

† Entries in the 'General' and 'Street' sections of PODs confirm the address as 4 Montgomery Street. The trade-listed address of '4 Montague Street' is considered erroneous.

Edmonston, Francis & Son
1849–1876
Edinburgh
 1849–63 60 North Bridge
 1863–76 63 North Bridge
During his many years as an engraver, Francis Edmonston is known to have produced armorial work while at a pre-1838 address in George Street. In PODs the firm was listed only as 'Engravers and Printers' but it is likely that lithography was introduced when Edmonston took his son into partnership in 1849. Listed 'Engravers and Lithographers' in Slater 1860. May have abandoned lithography for a while and was not listed Slater 1867, nor in PTD 1872, but was re-listed in PODs 1872–76.

Erskine, William
Edinburgh
See **Macfarlane & Erskine** (1871–1980)

Ewing, Alexander R.
1853–1881
Glasgow
 1853–70 33 Buchanan Street
 1870–79 67 Buchanan Street
 1879–81 85 Buchanan Street
Slater 1860, 1867: Copperplate and Lithographic Printer and Engraver.

Fairbairn & Hogg [Entry 1/2]
1856–1858
Edinburgh
 1856–58 9 South St Andrew Street
Engravers and Lithographers. Succeeded to the premises of the artistic lithographer **Samuel Leith**. Shortly after termination of this brief partnership the firm was succeeded on the premises by **Smith, William & Co.** while **Fairbairn, James** [2/2] established his own business at a new location.

Fairbairn, James [Entry 2/2]
1860–63

Edinburgh
 1860–63 14 S. St Andrew Street
Former partner in **Fairbairn & Hogg** [1/2]. Listed as Engraver and Lithographer in Slater 1860. Prior to his brief partnership with Hogg, Fairbairn had traded for some years as an engraver at 41 George Street.

Farmer, John
1862–1863
Glasgow
 1862–63 95 Hutcheson Street
Also pattern book and card maker. Succeeded in premises by **Littlejohn & Steel**.

Fenton, James [Entry 1/2]
1829–1846
Dundee
 1829–37 24 High Street, South Side
 1837–46 4 Crichton Street
b. 1797, *d.* 1853. From 1825 an artistic steel-engraver and copperplate printer. Earliest known artistic prints were engravings issued in 1836, followed by lithograph in 1841. Listed Pigot 1837. 1846: Entered partnership **Fenton J. & C.** [2/2].

Art-T-Adv 1841: Lithograph 'East and Cross Churches, Dundee etc.'

Fenton, James & Charles [Entry 2/2]
1846–1868
Dundee
 1846–68 6 Crichton Street
Engravers, Printers, Lithographers, Stationers. Formerly **Fenton, James** [1/2]. First listed in *Dundee Directory* 1846, also in Slater 1860 and 1867. When James died in 1853, the business was continued by Charles without change of title.

Adv-ms *Dundee Directory* 1861. 'Fentons' Book of Accounts 1847–53', held in Dundee Central Library.

Ferguson, John
1866–1870
Glasgow
 1866–70 Carrubers Close †
Listed Slater 1867, but PODs list as Lithographer 'at Kronheim's'. **Kronheim, Joseph M.** was a renowned London firm with a branch office in Glasgow.

† No evidence traced that Ferguson had his own business, and this address was probably his residence.

Ferguson, William *junior*
1858–1862
Glasgow

1858–62	74 Buchanan Street

Fergusson, Alexander
1870–20thC
Ayr

1870–20thC	18 High Street

Originally served apprenticeship at *Ayr Advertiser*. 1864: Letterpress Printer and Stationer. In 1867 he moved to 18 High Street, introducing lithography and bookbinding in 1870. Following his death in 1904, his prosperous business was continued by two of his three sons, and their successors, until *c.*1960.

Adv: Advertised in *Ayr Directory* 1870.

Ferrier & Speirs
1865–20thC
Glasgow

1865–84	165 Ingram Street
1884–87	245 Ingram Street
1887–92	117 W. George Street
1892–20thC	94 W. Nile Street

Also Letterpress Printers. The last of these premises was earlier occupied by **Cameron & Ferguson** (1867–1890). Not listed in PTDs 1872–1900.

Finlayson, John
1847–1852
Glasgow

1847–49	68 Glassford Street
1849–52	40 John Street

'Pattern Designers, Lithographers, and Print Cutters.'

Fisher, Charles
1825–1829
Edinburgh

1825–26	'97 Foot of Leith Wynd, opp. Trinity Hospital'
1826–29	10 West Register Street

Previously foreman of the well-known artistic lithographers, Rowney & Forster of London. Shortly before this firm ceased trading, Fisher moved to Edinburgh and established his own lithographic printing and supplies business, offering for sale several presses of new design.

Art-O-M-Adv 'Ancient Scottish Highland Games as practised annually at St Fillans, Perthshire'. Inscribed: 'Wm. Turner de Lond fecit', and dedicated by him 'To the Chieftains and Members of St Fillan's Highland Society'–'from Stone by C. Fisher'. 1826: 'Plan of lands of Buddon, Angus' by Wm. Blackadder [RHP.4079]. *c.*1826: 'Plan of Estate or District of Strathconan' from 1824/5 survey by James Flint (RHP.2525). n.d: 'The Fight of the Lion and Mastiffs' by William Turner de Lond (in Edinburgh Central Library). Advertised in *The Scotsman*, 4 April 1825, offering lithographic equipment and supplies.

Fisher, John
1859–1871
Glasgow

1859–61	14 Holmhead Street
1861–71	95 George Street

Slater 1860: Engraver and Lithographer.

Forbes, Daniel
1862–1894
Glasgow

1862–66	95 Union Street
1866–71	45 Gordon Street
1871–75	170 Buchanan Street
1875–77	15–19 Douglas Street and 210/212 Holm Street (Works)
1877–78	17 Douglas Street and 210/212 Holm Street (Works)
1878–94	17 Douglas Street

Manufacturing Stationer, Engraver, Lithographic and Letterpress Printer. Listed Slater 1867 and PTDs 1872–1893.

Ford, Alexander
1866–1877
Edinburgh

1866–77	142 High Street

'Lithographer, Engraver, and Letterpress Printer.' Listed Slater 1867 and PTD 1876.

Adv: Advertised in PODs for 1867, 1868, and 1869.

Forrester & Pentland
1859–1860
Glasgow

1859–60	45 John Street

Partnership dissolved within one year, but business briefly continued as **Pentland & Son**.

Forrester & Morison [Entry 1/3]
1821–1825
Edinburgh
 1821–25 22 St James Square
Listed Pigot 1825. Partnership of Alexander Forrester and 'Morison' (Andrew?). 1823: Due to lack of experience, the partners encountered serious technical difficulties in printing a series of views by the artist *John S. Paterson,* Teacher of Art at Montrose Academy. Having printed ten of the thirty views, the work was transferred to other lithographers, principally Charles Hullmandel of London. It is possible that this led to the dissolution of the partnership in 1825, after which Alexander Forrester continued at same address trading as **Forrester & Co.** [2/3].

Art-T-M-Adv 1823: Advertised in *Caledonian Mercury* for commercial work. 1823: Lithographed ten of John S. Paterson's illustrations in *Views of Scenery in Angus & Mearns,* published in Montrose by John Smith (*b.* 1781, *d.* 1827.) 1822: Map of 'Lower division of the Firth or River Tay and part of the North Sea' by James Jardine [RHP.4293]. 1823: 'Farm Plan of Whitsome-Newton' from a survey by Nicholas Weatherly [RHP. 3666/1].

Forrester & Co. [Entry 2/3]
1825–1829
Edinburgh
 1825–29 22 St James Square
N. B. Advertiser circulation list of 1827 has Forrester's initial as 'A.'; known from an 1829 advertisement to be Alexander Forrester, former partner in Forrester & Morison [1/3]. It seems that the difficulties in producing Paterson's views, and the ending of his partnership with Morison, left Forrester with severe financial problems, for on 12 September 1825 he was admitted to Sanctuary for debt at Holyroodhouse. However, he continued in business, specializing in the production of maps and estate plans, many of which are held in the Scottish Record Office. 1829: Moved to new address trading as **Forrester, A.** [3/3].

Art-M 1826: 'Plan of the Town of Morpeth'. 1826: 'Plan of Mar Forest, Aberdeenshire with woods divided into lots' [RHP.811].

Forrester, Alexander [Entry 3/3]
1829–1833

Edinburgh
 1829–30 30 St Andrews Square
 1830–31 31 St Andrews Square
 1831–32 10 George Street †
 1832–33 16 Broughton Place
Prolific producer of estate plans and maps, mostly inscribed 'A. Forrester'. Originally partner in **Forrester & Morison** [1/3]. Known from an 1829 advertisement to have recently moved from 22 St James Square, where he traded as **Forrester & Co.** [2/3]. Alexander Forrester was still listed as a lithographic printer when he moved to Broughton Street, but appears to have retired by 1833.

† 1832: Succeeded at this address by **Forrester (Wm.) & Nichol.** The emergence of this partnership suggests that other members of the Forrester family may have worked with Alexander Forrester sometime within the period leading up to 1832.

Art-M-Adv 1826: 'Plan of Carolside & Clackmae. Property of James Hume' from a survey in 1826 by Wm. Crawford *junior* [RHP.1206]. Two plans, 'The Island of Benbecula' [RHP.1039] and 'The Island of South Uist' [RHP.1040] are both inscribed 'Property of R. G. McDonald', and were taken from surveys by Wm. Bald in 1805. The year of printing is not inscribed, but was probably *c.*1829. *c.*1829: 'Part of Commonty of Glenkally, Angus' from a survey in 1828 by James Rollo [RHP.3106]. 1831: 'Estate of Strichen' by J. Boulton.

Forrester & Nichol † [Entry 1/3]
1832–1839
Edinburgh
 1832–34 10 George Street
 1834–38 3 George Street
 1838–39 14 George Street
10 George Street was previously occupied by **Alexander Forrester** [3/3]. The Voters Roll of 1832 shows that Alexander was succeeded by William Forrester, who was both resident and joint-tenant, and William Nichol, who was listed as the other joint-tenant, but resided at 23 Dunbar Street. It is probable that William and Alexander Forrester were related, and may well have worked together prior to 1832. Listed Pigot 1837 as lithographers only. In 1839 the partnership was dissolved. Forrester entered new partnership as **Forrester & Ruthven** [2/3]. **William Nichol** started his own business.

† Inscriptions on prints show that the spelling 'Nicol' in pre-1841 PODs is incorrect.

Art-T-M-P-O-Adv-ms *c.*1835: Outline Views 43–48 in E.C.C. [i.e. Mrs Robert Campbell], *Scottish Scenery:*

Sketches from Nature, Part 8; for other Parts see **Bell & Co.**, **Nimmo, R. H.**, and **Smith, J. & W.** 'Plan of Forss Common' (Caithness) lithographed from 1831 sketch by James Flint [RHP.2951]. 1837: 'Plan of Lands of Dryden', (Midlothian) by David Wilson [RHP.3021]. 'General Maps & Charts of Pitullie Harbour' from a survey in 1837. 'Map of Dundee' in POD 1834. Several plates in the 1838 edition of Professor J. P. Nichol's *The Phenomena and order of the Solar System* (Edinburgh, 1838), including portrait of Danish astronomer 'Tycho Brahe', 'Map of the Moon', 'Magnitude of the Planets' etc. Manuscript of quotation issued by William Nichol on 24 July 1838 held in NLS. The firm advertised in Gray's *Edinburgh Directory* 1833.

Forrester & Ruthven [Entry 2/3]
1839–1842
Edinburgh
1839–40	14 George Street
1840–42	6 St Andrew Square

Lithographic and Letterpress Printers, and Engravers. Partnership of William Forrester, former partner in **Forrester & Nichol** [1/3], with James Ruthven, formerly a Letterpress Printer at 23 New Street from 1836 to 1839. The partnership was dissolved when **James Ruthven** (probably a relation of the press manufacturer John Ruthven) left to start his own business. **William Forrester** [3/3] continued the existing business.
Art-M 1840: 'Plan of Buckhaven Harbour'. 1840: 'Plan of Bredisholme' drawn by William Forrest.

Forrester, William [Entry 3/3]
1842–1861
Edinburgh
1842–48	6 St Andrew Square
1848–54	South East Thistle Lane
1854–59	56 Hanover Street
1859–61	7 George Street

Listed PODs and Slater 1860 as a Lithographic and Letterpress Printer, and Engraver. William Forrester, shown as 44 years of age in the Census of 1841, was former partner in **Forrester & Ruthven** [2/3]. Specialised in the making of maps and estate plans, of which several examples are held in National Library of Scotland Map Library and Scottish Record Office.
Art-M 1842: 'Plan of Estate of Pitskelly' by James Horne [RHP.1186/2]. 1843: 'General Maps of Scotland'. 1852: 'Plan of Ground taken for Scottish Central Railway' from a survey by Brown & Young [RHP.1876].

Forsyth, Ebenezer [Entry 1/2]
1856–1873
Inverness
1856–73	11 Bank Street

Acquired *Inverness Advertiser* in November 1855. Letterpress and Copperplate Printing. 1856: Added Lithography. When Ebenezer Forsyth died in 1873, the business continued as **Forsyth, W.B. & E.** [2/2].
Adv: 17 June 1856: Advertised *Inverness Advertiser*.

Forsyth, W. B. & E. [Entry 2/2]
1873–1885
Inverness
1873–85	11 Bank Street

Following the death in 1873 of **Forsyth, Ebenezer** [1/2], the *Inverness Advertiser* and the printing business were continued by his son, W. Banks Forsyth, until 1885, when the business was acquired by the *Inverness Courier*.

Franklin, William [Entry 1/2]
1854–1866
Glasgow
1854–63	7 Argyle Street
1863–66	62 Argyle Street

Slater 1860, 1867. Paper Ruler, Lithographer and Account Book Manufacturer. In 1866 Franklin entered partnership **Franklin & Jack** [2/2].

Franklin & Jack [Entry 2/2]
1866–1868
Glasgow
1866–68	62 Argyle Street

Formerly **Franklin, William** [1/2]. Listed Slater 1867 as Lithographic and Letterpress Printers and Engravers. When partnership ended in 1868, Jack entered new partnership as **Jack & Carrick**.

Fraser & Anderson [Entry 1/2]
*c.*1860–1878
Perth
*c.*1860–78	87 High Street

Listed Slater 1860, 1867, and PTD 1876. Engravers and Lithographers. 1878: Partnership ended, but **Fraser, D.** [2/2] continued the business.

Fraser, Donald [or David] [Entry 2/2]
1879–1883

Perth
1879–83 87 High Street
PODs list as Donald Fraser, but PTD 1880 as 'David'. Engraver and Lithographer. Formerly **Fraser & Anderson** [1/1] at same location.

Fraser & Ferguson
1866–1875
Glasgow
1866–75 116 St Vincent Street
Slater 1867 and PTD 1872. Also Letterpress Printer.

Freeman & Co.
1896–20thC
Glasgow
1896–20thC 145 West Nile Street
Formerly **Strathern & Freeman** at same address. Lithographic and Letterpress Printers. Both titles appear in POD 1896. Freeman & Co. listed in PTD for 1900, but not in POD 1900.

Fullarton, Archibald & Co.
1872–1879
Edinburgh, Leith
1872–75 168 Leith Walk (Stead's Place)
1875–79 104 High Street
Established in Edinburgh in 1819, originating from the publishing and bookselling business founded in Glasgow in 1809 by partnership of W. Sommerville, A. Fullarton, & J. Blackie; for earlier history see **Blackie, W. G.** [1/2]. Although maintaining his printing works in Glasgow, Fullarton established a letterpress printing department in Stead's Place, in 1844. Listed PODs from 1844 and Slater 1867. First listed as Lithographers in PTD for 1872, but not subsequently. Listed only as 'Printer' in PODs. Engraving facilities were located in Glasgow where a number of maps and atlases such as *Hand Atlas of the World* (1870–72) were engraved. After 1879 the business appears to have concentrated on publishing.

Fulton, Andrew
1841–1848
Glasgow
1841–48 27 Wilson Street
'Pattern Drawer, Print Cutter, and Lithographer to Engineers.'

Fyfe, J. & P.
1837–1841

Glasgow
1837–41 22 Argyle Street
'Lithographers, Engravers and Copperplate Printers.' The Glasgow POD for 1852 also lists a **Peter Fyfe**. May have been the second partner, or related.
Art-P Portrait of James Wylie (Bookplate).

Fyfe, Peter
1852–1855
Glasgow
1852–55 23 Hutcheson Street
Lithographer and Engraver. Possibly same as P. Fyfe of **J. & P. Fyfe.**

Galbraith & M'Culloch
1857–1858
Glasgow
1857–58 184 Buchanan Street
It is possible that Galbraith's partner was **McCulloch, George**.

Gardiner, W. & J.
1845–1853
Perth
1845–53 39 High Street
William and J. Gardiner. Sons of clockmaker Patrick Gardiner (*d.*1828). Originally clockmakers, and also known as engravers of armorial bearings. Added lithography in 1845. William Gardiner died in Perth on 30 January 1848, at the age of 47. Believed to have some family connection with **Gardiner, William** (1839–1840), of Cupar, who is said to have come from Perth.
Art-O Perth Museum & Art Gallery holds a small scrapbook of engravings and a lithograph.

Gardiner, William
1839–1840
Cupar
1839–40 St Catherine Street
Bookseller, previously in partnership with Robert Anderson, as publishers of the *Fifeshire Journal*. Believed related to **Gardiner, W. & J.**, of Perth. William Gardiner, who had been a bookseller in Cupar since *c.*1833, will be best remembered for the publication in 1840 of a fascinating monthly magazine entitled *Gardiner's Miscellany*. The objective of this journal was, in Gardiner's own words, 'to assist in the cultivation of a taste for Science and Literature, by giving articles on general

subjects, and other local legends, history, and antiquities'. Sadly, after completing only five of the twelve parts planned, the costs of publication led to Gardiner's bankruptcy in August of the same year. In 1841 production of *Gardiner's Miscellany* was continued by George Tullis of **Tullis Press**, who fulfilled the original publishing commitment by completing the remaining seven parts. See A.J. Campbell, *The Fifeshire Journal Press* (Fife Bibliography: The Presses of Fife, 3) (Buckhaven, 1992).

Art-T-O The five parts of *Gardiner's Miscellany* published in 1840 by William Gardiner each contained a lithographed illustration drawn by D. Ochterlonie and inscribed 'W. Gardiner Lithogr.'.

Gardner & Stevenson [Entry 1/3]
1854–1877
Glasgow
1854–55	20 Union Street
1855–62	45 Gordon Street
1862–75	2 W. Register Street
1875–77	52 N. Frederick Street

Listed Slater 1860, 1867, PTDs 1872 and 1876. 'Engineering Lithographers, Draughtsmen, Engravers.' PODs from 1860 list as Letterpress also. Partnership terminated in 1877, and Gardner entered new partnership of **Gardner & Mollison** [2/3].

Gardner & Mollison [Entry 2/3]
1877–1881
Glasgow
1877–81	52 N. Frederick Street

Lithographic and Letterpress Printers. Gardner was former partner in **Gardner & Stevenson** [1/3]. Listed PTD 1880. When partnership ended in 1881, business continued as **Gardner, Robert & Co.** [3/3].

Gardner, Robert & Co. [Entry 3/3]
1881–20thC
Glasgow
1881–89	52 North Frederick Street
1889–20thC	136/138 George Street

'Engineering Lithographers.' Also Letterpress Printers. Former partner in **Gardner & Stevenson** [2/2]. Listed PTDs 1885–1900.

Art-M 1884: 'Candleriggs in 1760', a reproduction based on an original plan of 1764 by John McArthur.

Gavin, Hector
1844–1845
Edinburgh
1844–45	16 S. St Andrews Street

Son of talented engraver Hector Gavin (1738–1814). Having seemingly given up lithography within the year, Gavin continued engraving until after 1850. He died in 1874, at the age of 90.

Gebbie, J. & Co.
1859–1865
Glasgow
1859–65	16 St Enoch's Square

Gellatly, John [Entry 1/2]
1838–1861
Edinburgh
1838–41	46 West Register Street
1841–43	44 West Register Street
1843–46	1 George Street
1846–61	26 George Street

When he introduced lithography in 1838, John Gellatly (*b.*1803) had already achieved considerable distinction since first starting business in 1827 as an Engraver and Copperplate Printer at 186 Rose Street. Within that period he had engraved several landscapes, maps and plans, including the plans of the invention by **Dick, Maxwell** of a suspension railway in 1830. Although John Gellatly died in 1859, the firm was listed in Slater 1860, and thereafter continued as **Gellatly & Whyte** [2/2].

Art-T-M Lithographed print (undated) 'Edinburgh from the Castle'. 'Plan of proposed Edinburgh and Perth Railway 1845'. 1848: Plan of 'New & Old Aberdeen corrected to 1848' etc. by A. Ogg (Land Surveyor), A. Gibb (Railways), and J. Abernethy (Harbour) [RHP. 804/2]. 1851: 'Plan showing disputed Roads in Inverkeithny' by Robert Milne [RHP.109]. 1852: 'Plan of the City of Glasgow'.

Gellatly & Whyte [Entry 2/2]
1861–1871
Edinburgh
1861–71	26 George Street

Following death of **Gellatly, John** [1/2] in 1859, firm was continued by Robert Whyte under title Gellatly & Whyte. Listed Slater 1867 as Engraver, Lithographer, and Publisher of copy-books.

Gemmel & Shields
1870–1871
Glasgow

1870–71	44 Queen Street

Gentles, William
1859–1863
Glasgow

1859–60	48 West Nile Street
1860–63	99 West Nile Street

Former agents in Glasgow for distinguished Edinburgh lithographers **Schenck & Macfarlane**. Agency was terminated when Gentles established his own lithographic department in 1859.

George, W.J. & Co.
1848–1859
Glasgow

1848–50	60 Maxwell Street
1850–54	46 Jamaica Street
1854–55	95 Argyle Street
1855–59	74 Argyle Street

Lithographic and Letterpress Printers.

Gibb & Hay [Entry 1/2]
1880–1887
Aberdeen

1880–83	3 Queen Street
1883–87	3 Queen Street and 40 Broad Street

Partnership of Andrew Johnston Gibb and J. Marley Hay. Engravers and Lithographers. Successors to artistic lithographers **Keith & Gibb**, at same location. In contrast to other accounts, which indicate that Gibb was born in 1821, the Aberdeen Census of 1881 records his age as 55, and, unusually, also shows that the firm employed '7 men, 5 boys and 1 girl'. When, later in 1881, Gibb died suddenly, the business was continued by his elder son, Andrew Johnston Gibb, and Marley Hay. In 1887 Hay retired and the business continued as **Gibb, Andrew & Co.** [2/2]. Listed PTD 1885. The plan of Aberdeen produced in 1885 shows the address as 'Royal Litho Works'.
Art-M 'Plan of Buckie Harbour' from survey of 1885 by John Willet [RHP.2987/3]. 'Plan of the City of Aberdeen revised to 1885.'

Gibb, Andrew & Co. [Entry 2/2]
1887–1898

Aberdeen

1887–98	3 Queen Street and 40 Broad Street

Andrew Johnston Gibb, Engraver and Lithographer. Formerly with the partnership **Gibb & Hay** [1/2]. It is probable that Andrew's younger brother, Linton M. Gibb, also served with the firm during this period, having completed his formal education in 1884 (see T. Watt, *Aberdeen Grammar School Roll of Pupils, 1785–1919* [Aberdeen, 1923]). In June 1893 Andrew Johnston Gibb died at the age of only 27. The business continued without change of title. Listed PTDs 1889, 1893. Although not recorded in PODs, Andrew Gibb & Co. is listed in the PTD 1900 at 10 Belmont Street. This was the address occupied by George & William Fraser, lithographic printers since the mid-1880s, later confirmed as the employers of Linton M. Gibb (see Watt, *op. cit.*). This suggests that the business of Andrew Gibb & Co. was actually acquired by G. & W. Fraser soon after 1898.
Art-O-M Armorial bookplate for Aberdeen Library. 1890: 'Plan of Lands of Blackhouse' by Duncan & Ironside [RHP.4113]. 1894: 'Feuing Plan of lands of Hilton' by Walker & Duncan [RHP.4117]. 1894: 'Plan of Tidal Waters, Connieston Harbour' [RHP.2972]. 1897: 'Plan of Tidal Waters, Buckie Harbour, Cluny', by John Barron, Eng. [RHP.2996/1].

Gibb, Thomas [Entry 1/2]
1870–1889
Paisley

1870–74	8 Forbes Place and Marshall's Lane
1874–83	Abbey Mill, Abbey Close
1883–89	7 Old Sneddon House

Former partner in **Clelland & Gibb**. Engraver and Lithographer. It is probable that Thomas Gibb died *c.*1889, as the business was then listed as Gibb, Thomas, Mrs, and later as **Gibb, Agnes, Mrs** [2/2].
Adv: Advertised in *Paisley Directories* 1872 and 1876.

Gibb, Agnes (Mrs Thomas Gibb) [Entry 2/2]
1889–1898
Paisley

1889–98	7 Old Sneddon House

Engraver and Lithographer. Continued business after death (presumed) of her husband, **Thomas Gibb** [1/2].

Gibson, Thomas S.
1847–1848
Glasgow

1847–48	56 Queen Street

Listed Stationer, Letterpress Printer and Bookbinder only in POD, but as Lithographic Printer in Slater 1847.

Gilbert & Co., Bernard

1842–1847

Dundee

1842–47	21 Meadowside

Originally an Engraver. Added lithography in 1842. 1847: Succeeded by 'A. & E. Gilbert, Engravers & Co.' who were not listed as lithographers.

Gilchrist, William

1845–1852

Glasgow

1845–52	145 Argyle Street

Originally apprenticed with *The Chronicle*, in Buchanan Street. Previously established as Engraver and Letterpress Printer since 1841, and highly regarded in the trade. From 1851/2 he was listed only as a letterpress printer, until he ceased trading *c.*1887.

Gillies, John

1867–1868

Glasgow

1867–68	175 Buchanan Street

Shared above address with **Drennan, William**.

Gilmour, J.B. [Entry 1/2]

1845–1846

Glasgow

1845–46	74 Argyle Street

Also Letterpress Printer and Engraver. Originally apprenticed to distinguished engraver and lithographer **Joseph Swan**. Founder of company of historic importance, **Gilmour & Dean** [2/2].

Gilmour & Dean [Entry 2/2]

1846–20thC

Glasgow

1846–53	86 Buchanan Street and 13 Exchange Place
1853–54	86 Buchanan Street and 13 & 15 Exchange Place
1854–57	15 Exchange Place
1857–74	3 Exchange Place
1874–20thC	50 N. Hanover Street

Lithographers, Engravers, and, from *c.*1865, Letterpress Printers. Business was originally founded by **Gilmour J.B.** [1/2] and continued into late 20th century, achieving distinction as bookprinters. Alexander Davison Dean, who died in 1910, was generally recognised in Glasgow as the finest engraver of the time. According to their advertisement in the POD for 1854, the firm undertook 'every kind of mercantile and artistic lithography', including 'maps, railway plans, mechanical drawings, and landscape and marine drawings in tinted litho'. Listed Slater 1860, 1867, and PTDs 1872–1900.

Art-P-M-O-Adv 1865: 'Facsimile on Stone' of 'Vase with Microscopic Fossil Shells from East Kilbride' – frontispiece in John Gray, *Biographical Notice of The Rev. David Ure* (Glasgow, 1865). 1900: Portrait: 'Col. James Neilson'. 1892: 'Plan of the Estate of Findrassie, Moray' by H.M.S. Mackie [RHP.3324]. The firm advertised in PTD 1872 and PODs 1854–1880.

Girdwood, George [and Girdwood, David †]

1853–20thC

Dundee

1853–58	10 Union Street
1858–76	17 Reform Street
1876–78	7 Meadowside
1878–80	7 Albert Square
1880–82	90 & 94 Commercial St.
1882–86	70 & 74 Commercial St. ‡
1886–20thC	53 Meadowside

Born *c.*1826, a native of Kirkcaldy, Girdwood moved to Dundee *c.*1850, where he founded a highly successful business as an Engraver, Lithographer and Stationer. Girdwood was best known for his artistic lithographic works, in both monochrome and colour, which were received 'in terms of high and deserved praise' by the local press. He died 'at the age of about 35' on 5 May 1861 (obituary in *Dundee Advertiser,* January 1861), but the business was continued by the family, with the assistance of a manager, without change of title. The firm appears to have added Letterpress Printing in 1864, and was listed in Slater 1867 and PTDs 1876–1900.

† Between 1864–67 and 1874–76 a David Girdwood worked with the firm, but was listed separately during the intermediate years as an Engraver and Stationer only. From 1876 onwards his listings ceased. In 1888 the manager, J. M. Nicholl, became a partner in the firm, although this was not reflected by a change in the firm's title which, apart from the addition of 'Co. Ltd.', remains the same today.

‡ The change appears to be due to renumbering.

Art-T-M-Adv-ms 1858: Engraved 16 local views in Charles Maxwell, *Historical and Descriptive Guide to Dundee* (Dundee, 1858). 1879: Lithographed 'Plan of Estate of Fearn, Angus' [RHP.1167]. Various letterheads etc. in 'Lamb Collection' at Dundee Central Library. Advertised in POD Dundee 1860, with 8 pages of advertisements for other firms, all with 'Girdwood' inscription.

Glassford, John H.
1850–1863
Glasgow

1850–52	64 Buchanan Street
1852–56	25 Royal Exchange Square
1856–57	no directory entry
1857–59	25 Exchange Square
1859–63	110 Buchanan Street

Lithographer, Engraver, Draughtsman. Slater 1860.

Goldie, John
1870–1873 and 1877–1888
Glasgow

1870–72	73 Castle Street
1872–73	71 Castle Street
1873–77	no directory entry
1878–86	159 Stirling Road
1886–88	121 N. Montrose Street

PTD 1872. Lithographic and Letterpress Printer.

Gordon, George G.
1857–1860
Glasgow

1857–60	109 West George Street

Listed Slater 1860.

Gorman, William & Co.
1844–20thC
Glasgow

1844–49	99 Trongate
1849–53	5 Hutcheson Street
1853–56	43 Argyle Street
1856–71	29 Jamaica Street
1871–76	13 Renfrew Street
1876–20thC	153 West Nile Street

Engravers, Lithographers. Added Letterpress *c.*1856. Slater 1860, 1867. PTDs 1872, 1876, 1885–1900. **Adv:** POD 1885, 1890.

Gow, Archibald C.
1862–1869
Glasgow

1862–69	10 Jamaica Street

Listed under 'Lithographers' in PODs as 'Gow, Writer'. Listed as 'Lithographer only' in Slater 1867.

Graham, Thomas [Entry 1/2]
1853–1861
Paisley

1853–57	101 High Street
1857–61	10 High Street †

Succeeded his former partner **Neilson, John** when Neilson transferred to Glasgow. Paisley Local Studies Library holds a record that the firm was actually founded in 1851, and printed spool tickets for Coats Mill. *Paisley Directory* 1853: 'Engraver, Printer, Lithographer & Account-Book Manufacturer'. 1857: Appears to have ceased engraving. 1861: Joined partnership **Graham, Thomas and Robert** [2/2].
† Address shared with **Hay, Robert and Son**.

Graham, Thomas & Robert [Entry 2/2]
1861–20thC
Paisley

1861–66	10 High Street †
1866–67	10 High Street and
	4 Bridge Street
1867–20thC	4 Bridge Street

Previously **Graham, Thomas** [1/2] at same location. 1865: 'Lithographers and Printers by steam power, and account-book manufacturers'. Also Engravers. Listed Slater 1867.
† Address shared with **Hay, Robert & Son**.

Grant, George & William
1866–1879
Glasgow

1866–75	43 Union Street
1875–79	27 Union Street

Listed POD 1866 and Slater 1867. Stationers and Lithographers. Also as Engravers in POD 1870. No confirmed trace after 1879, but possibly the same as George Grant, Lithographer, listed in POD 1890 at Sydney Court, 62 Argyle Street.

Gray & M'Farlane
1864–1865

Glasgow

 1864–65 95 Hutcheson Street

Shared the premises with **Steel, A. & Co**.

Gray & Son

1841–1856

Glasgow

1841–44	67 Trongate, 'Tron Steeple' †
1844–45	67 Trongate and 77 Buchanan Street
1845–52	67 Trongate and 107 Buchanan Street
1852–56	67 Trongate

Engravers, Lithographers. Added Letterpress *c*.1850. Believed to be John Gray & Son.

† PODs of 1828 and 1835 separately list John and Robert Gray as engravers at this address. POD 1840 separately lists Robert Gray and Gray & Son.

Art-T-Adv

Gray, James & Son (& Co. †)

1836–1838

Edinburgh

1836–37	59 South Bridge
1837–38	219 High Street

'Printer and Publisher'. Believed to be son of James Gray, Watchmaker to Her Majesty. He also resided at above addresses. Listed *Gray's Directory* 1836 and Pigot 1837, but not trade-listed in PODs.

† Listed as '& Co.' in 1836 only.

Green, Alexander

1855–1858

Glasgow

 1855–58 74 Eglinton Street

Engraver and Lithographer.

Grocott, Thomas

1847–1849

Glasgow

 1847–49 11/13 Wellington Arcade

Engraver and Letterpress Printer from *c*.1840, now introduced lithography.

Guthrie, John

1868–1880

Kilmarnock

 1868–80 18 King Street

Also Bookseller and Stationer.

Listed PTDs 1872, 1876, and 1880.

Hall, Joseph

1833–1846

Edinburgh

 1833–46 'Diorama', Lothian Road

Listed Pigot 1837. Although working in a modest lean-to building adjoining the 'Diorama' and 'Cosmorama' entertainment centre, Hall successfully printed and published a remarkable collection of facsimiles after etchings and drawings by Old Masters. He appears to have retired in 1845/6, the POD of 1846/7 listing him as 'Late Lithographer' at 3 Howe Street. **Highet, John**, of Troon, was originally apprenticed to Joseph Hall.

Art-T-O-M-Adv 1834: Lithographed view of the 'Diorama' and 'Cosmorama' Entertainment Centres in Lothian Road, with Hall's Lithographic Establishment adjoining. Also used as an advertisement in Edinburgh POD 1834/5. 1836: 'Estate Plan of Greenside ... Property of James Ker' [RHP.4455]. 1840: Johnson's 'Map of Lanark'. *c*.1840: *Facsimiles of Select Etchings and Drawings of The Old Masters*, a rare volume (held in a private collection) containing 50 plates representing the original works of 17 artists of world renown – inscribed 'Lithographed and Published by J. Hall, Lothian Road, Edinburgh'. Two of the images in this work have been taken from prints after original drawings held in the National Gallery of Scotland.

Hamilton, Archibald

1871–1877

Glasgow

 1871–77 229 Argyle Street

Believed former partner in **Young & Hamilton**. Also involved in brass engraving for shipbuilding industry.

Hamilton, James

1864–20th C

Glasgow

1864–74	21 Argyle Street
1874–20thC	39 Stockwell Street

Succeeded to the business of **Miller, Robert**, which was originally established by **Cleland, John** in 1822. Listed as Lithographer and Engraver in Slater 1867, and added Letterpress *c*.1874. Also listed PTDs 1872, 1876 and 1885–1900.

Hanton, Seabourne H.

1867–1869

Glasgow

| 1867–69 | 23 St Enoch Square |

Listed under Lithographers, but described in PODs as 'artist at W. Macrones' (**Macrone, William**).

Harris, John & Co.
1865–1866

Glasgow

| 1865–66 | 132 Paisley Road |

Also Letterpress Printer.

Harrower & Brown
1848–1850

Glasgow

| 1848–50 | 11 St Andrew's Square |

Previously 'General Printers and Engravers' only.

Harvey, Joseph & Co.
1884–1892

Edinburgh

| 1884–88 | 15 Clyde Street |
| 1888–92 | 15 Queen Street |

Also Letterpress. Former partner in **Murray, Harvey & Co.** at first of above addresses. Not listed in PTDs.

Hay, Alexander
1853–1896

Edinburgh

| 1853–54 | 1 Gabriel's Road |
| 1854–96 | 4 North Bridge |

Previously Engraver since c.1843. Added Letterpress c.1880. Listed PODs and Slater 1860, 1867 and PTDs 1872–1893.

Art–P Better known as fine engraver of mezzotints.

Hay, David
1841–1842

Edinburgh

| 1841–42 | 150 High Street |

Former partner in **Duncan & Hay**.

Hay, Robert *senior* [Entry 1/4]
1836–1841

Paisley

| 1836–41 | 15 St Mirren Street |

Originally Journalist. 1830–44: Editor *Paisley Advertiser* (at St Mirren's Court). 1830–36: In printing and en-graving partnership, **Neilson & Hay**, Paisley. 1836: Established own lithographic business, but continued to share premises with John Neilson. 1841: Took elder son, Robert, into partnership as **Hay, Robert & Son** [2/4].

Hay, Robert & Son [Entry 2/4]
1841–20thC

Paisley

| 1841–45 | 15 St Mirrens Street |
| 1845–20thC | 10 High Street |

Listed *Paisley Directory* 1841: 'Engravers, Copperplate Printers and Lithographers'. Previously **Hay, Robert**. 1841: With elder son, also Robert, now in partnership, the firm acquired an engraving and copperplate business on death of the owner, Andrew Blaikie. Following the death of his father in 1847, Robert Hay *junior* took over management of the firm. In 1853 he became joint pro-prietor and Editor of the *Paisley Journal*. 1856: Branch of **Hay, Robert** [3/4*] established in Glasgow. When Robert Hay *junior* died in 1881, he was succeeded by his younger brother **James Hay** [4/4*] who had also estab-lished a lithographic business in Glasgow in the 1860s. Listed Slater 1860, 1867. PTDs 1872–1900.

Art-M-Adv 'Plan of Paisley – 1490 till about 1545. Reduced from Plan based on the Abbot's Chartulary.' There are two known printings by Hay of this plan, one, dated 1878, appears in William Hector, *Selections from the Judicial Records of Renfrewshire*, second series (Paisley, 1878), the other in Robert Brown, *History of Paisley* (Paisley, 1886). A similar reproduction of the original plan titled 'Paisley 1490 to about 1545 from the Abbot's Chartulary' [RHP. 543] was lithographed by **Ballantine, W.**, of Edinburgh, in 1828. The firm adver-tised in Paisley POD 1872.

Hay, Robert [Entry 3/4*]
1856–1864

Glasgow

1856–57	42 St Andrew's Square
1857–58	136 Buchanan Street and 183 George Street
1858–63	183 George Street
1863–64	20 Stirling's Road and 10 High Street, Paisley

Listed Slater 1860 as 'Lithographer and Engraver'. Branch Office of **Robert Hay & Son** [2/4], of Paisley. One of two off-shoots of the firm established in Glasgow; the other operated under the title **Hay, James F.** [4/4].

Hay, James F. [Entry 4/4*]

1860–1862

Glasgow

1860–61	62 Argyle Street
1861–62	2 West Regent Street

Listed Slater 1860 as 'Lithographer and Engraver'. Younger son of **Hay, Robert** *senior* [1/4] of Paisley. In 1881 James assumed management of **Robert Hay & Son** [2/4]**,** of Paisley, following the death of his brother Robert Hay *junior*.

Heatherill, James (& Co. †)

1867–1899

Glasgow

1867–68	71 George Square and 273 George Street
1868–73	33 W Nile Street
1873–75	no directory entries
1876–77	1 St Vincent Street
1877–94	24 George Square
1894–95	24 George Square and 12 St Vincent Lane East
1895–99	178 West George Street

Also Stationer.

† Status changed to '& Co.' from 1872.

Heggie, Robert

1867–1894

Cupar

1867–69	40 Crossgate
1869–94	South Bridge

b. Cupar 1827, *d.* Cupar 1904. Lithographic, Letterpress and Copperplate Printing, Die-Stamping and Ruling. Listed PODs, Slater 1867, PTDs 1876, 1880.

Adv: *Fife Herald*, 6 June 1867.

Heggins & Thom

Edinburgh

Incorrect entry in POD: see **Higgin & Thom**.

Hellrigel, Frederick †

1844–1848

Glasgow

1844–46	132 Sauchiehall Street
1846–47	15 Renfrew Street
1847–48	15 Bains Place

Engraver and Lithographer.

† Also listed as 'Hellridge' under 'Engravers' in POD 1846.

Henderson, Andrew

1853–1871

Edinburgh

1853-59	2 Coalhill, Leith
1859-66	71 Shore, Leith
1866-68	42 Quality Street
1868-71	9 Springfield, Leith Walk

Also Engraver, Letterpress Printer, and Publisher.

Henderson, John [Entry 1/2 *]

1835–1839

Banff

1835–39	Low Street

It seems most likely that Henderson worked with **Samuel Leith**, and then succeeded to his business following Leith's move to Edinburgh in 1835. 1839: Having achieved some local success in Banff, **John Henderson** [2/2*] also felt the need to move to an area with greater potential demand, and established a new lithographic printing business in the City of Aberdeen.

Henderson, John [Entry 2/2*]

1839–1849

Aberdeen

1839–41	44 Queen Street
1841–42	47 Queen Street
1842–49	15 Union Buildings

Previously established as **John Henderson** [1/2*] in Banff. Prolific and highly successful artistic lithographer. Lithographer and Printseller to Queen Victoria. Listed Pigot 1837. Died 1848/9, following accidental fall. The business continued temporarily under the management of his foreman **Alexander Dakers**, until taken over by **Keith & Gibb**. See Iain Beavan, '19th Century Book Trade in Aberdeen' (Aberdeen University Ph.D. thesis, 1992). See also *Brown's Bookstall No. 72* (December 1908).

Art-T-M-Adv 1840: Six tinted lithographs in 'Views of Aberdeen', drawn by various artists and published by John Hay, under the title *Hay's Views of Aberdeen* (Abbey, *Scenery*, 496). *c.*1844: 'The Denburn Valley from Union Bridge' after a painting by Giles. 1844: 'The River Don, Aberdeenshire. General Maps.' 1844: 'Lands of Pitullie and Pittendrum' as surveyed by George Whyte [RHP.1730]. 1848: 'Plan of Roads in Stonehaven' by

J.F. Beattie [RHP.2532]. Illustrated advertisements in *Bon-Accord Directories* 1841, offering services for 'Portraits, Landscapes, Plans of Estates, Maps'.

Henry, Hugh & Sons [Entry 1/3*]
1866–1869
Glasgow

1866–69	88 Glassford Street

It appears certain that in 1869 Hugh Henry moved to Ayr and entered the partnership **Henry & Grant** [2/3].

Henry & Grant [Entry 2/3]
1869–1873
Ayr

1869–73	35 & 37 Newmarket Street

It seems likely that Hugh Henry was former partner in **Henry, Hugh & Sons** [1/2], of Glasgow. Having moved to Ayr, he joined in partnership with former printer and bookbinder Alexander Grant. In the same year they added lithography, engraving and stationery. In 1873 the partnership ended, but business was successfully continued into 20thC by **Henry, Hugh** [3/3].
Adv: In POD for Ayr 1870.

Henry, Hugh [Entry 3/3]
1873–20thC
Ayr

1873–20thC	35 & 37 Newmarket Street

Formerly in partnership **Henry & Grant** [2/3].

Hepburn, Robert & Co.
1869–1870
Paisley

1869–70	Abbey Mill

Engravers and Lithographers.

Higgin & Thom
1854–1890
Edinburgh

1854–57	1 Gabriel's Road
1857–62	21 S. St David Street
1862–78	8 North Bank Street
1878–90	9a North Bank Street

Lithographic, Letterpress and Copperplate Printers and Engravers. Directories 1855–57 showed spelling as 'Heggins', 1858–69 as 'Higgins', and from 1869 on as 'Higgin'. Listed Slater 1860, 1867, and PTDs 1872, 1876, 1880, and 1885.

Highet, John
c.1849–1886
Troon

c.1849–86	Ayr Street

Bookseller, Librarian and Lithographer. Gained medals for penmanship at Ayr Academy. Originally apprenticed to Edinburgh lithographer **Joseph Hall**. Obituary: *Ayr Advertiser*, 9 Dec. 1886. Died aged 76.

Hislop, Francis
1871–c.1882
Kirkcaldy

1871–c.82	294 High Street

The address of the *Fifeshire Advertiser*. He succeeded, with his cousin **William Lindsay Whyte**, to the proprietorship of the *Fifeshire Advertiser* on the death of John Jeffers Wilson in 1866. Having introduced a lithographic department in 1867, they disposed of it to their manager, **Archibald Beveridge**, in 1869. When Whyte died in 1871, Hislop became sole proprietor of the *Advertiser* and was listed as a lithographer in PTDs 1872 and 1876. In 1877 he sold the business to **John Bryson**. However, Bryson already had his own lithographic business, and Hislop's further listing in the PTD for 1880 suggests that the lithographic establishment was not included in the sale.

Hoffman, Peter [Entry 1/2]
1862–1863
Glasgow

1862–63	31 Miller Street

In 1863 joined in partnership **Leggat & Hoffman** and, in 1871, **Hoffman & Campbell** [2/2].

Hoffman & Campbell [Entry 2/2]
1871–1875
Glasgow

1871–75	63 St Vincent Street

Lithographers and Engravers. **Peter Hoffman** [1/2] former partner in **Leggat & Hoffman** (1863–1871).

Holmes (or Holms), N. J. & Co.
1852–1859
Glasgow

1852–54	28 Cochran Street
1854–56	no directory entries
1856–57	30 Cochran Street

1857–58	29 Buchanan Street and 22 Mitchell Street
1858–59	64 Howard Street

Nathaniel J. Holmes; also listed as 'Holms' from 1855/6. Letterpress and Lithographic Printer.

Home, Robert [Entry 1/4]
1843–1859
Edinburgh

1843–51	9 Terrace
1851–59	63 North Bridge

Previously Engraver and Copperplate Printer, listed firstly in James Court in 1830, and then in Lawnmarket. From 1835 the firm successfully specialised in engraving and printing music. Following Robert Home's death in 1853, the business was continued as **Home, Robert & Co.** [2/2] either by a son of the same name, or by his representatives.

Home, Robert & Co. [Entry 2/4]
1859–1872
Edinburgh

1859–60	63 North Bridge Street
1860–66	13 George Street
1866–68	27 Elder Street
1868–72	11 Lower Greenside Lane

Believed son of **Robert Home** [1/4]. Listed 'Lithographer & Engraver of Music' in Slater 1860. 1872: Became partner in **Home & M'Donald** [3/4].

Home & M'Donald [Entry 3/4]
1872–1884
Edinburgh

1872–84	11 Greenside Lane

Previously, **Robert Home & Co.** [2/4]. Engravers, Lithographic and Letterpress Printers. Listed PTDs 1872, 1876, 1880. Partnership ended in 1884, but firm continued as **Home, Robert & Son** [4/4].

Home, Robert & Son [Entry 4/4]
1884–1892
Edinburgh

1884–92	11 Greenside Lane

Engravers, Lithographic, Letterpress and Copperplate Printers. Listed in PODs, but not PDTs. Former partner in **Home & McDonald** [3/4]. The firm achieved an excellent reputation for the fine quality of its music engraving, much of its production being taken up by the Ger-

man publishers Litolff. Listed in J. & R. Parlane, *Musical Scotland Past and Present* (Paisley, 1894).

Hope, James R.
1859–1866
Edinburgh

1859–61	8 North Bridge
1861–66	27 South Bridge

Also Engraver, Letterpress Printer and Stationer.
Adv: Advertised in PODs 1863–1865.

Houston, Charles
1860–1865
Glasgow

1860–61	61 Centre Street Trades
1861–64	239 Argyle Street
1864–65	51 Adelphi Street

Listed Slater 1860 as 'Lithographer and Engraver'.

Howitt 'Mr.' (possibly *William*)
1856
Dumfries

1856	High Street

Known from an amusing review of a lithograph by 'Mr Howitt' in *Dumfries & Galloway Standard*, 19 November 1856. No POD listings traced, but appears to have been an artist and amateur lithographer. Dumfries Archives list a 'William Howatt' living in the High Street.
Art-T 'View of The High Street, Dumfries.'

Hughes, Robert [Entry 1/2]
1849–1868
Aberdeen

1849–*c*.53	76 Broad Street
c.1853–65	15 Netherkirkgate
1865–68	30 Broad Street

Engraver, Copperplate and Lithographic Printer. Hughes was listed in Slater 1867, but appears to have died at that time, being succeeded in the following year by his wife, **Hughes, Robert Mrs** [2/2].

Hughes, Mrs Robert [Entry 2/2]
1868–1881
Aberdeen

1868–74	30 Broad Street
1874–81	60 Broad Street

Widow of **Robert Hughes** [1/2]. Although consistently describing herself as an engraver in Aberdeen directories,

Mrs Hughes was also listed as a lithographer in PDTs 1872, 1876, and 1880.

Hume, Robert W.
1837–1849
Edinburgh [Leith]

1837–40	57 Shore, Leith
1840–43	52 & 57 Shore, Leith
1843–46	52 Shore, Leith
1846–49	7 Commercial Place, Leith

First listed in Pigots 1837. Then in POD 1838 as 'Bookseller, Stationer and Lithographer'.

Art-M-Mus 1837: 'Plan of Town & Harbour of Burghead'. Probably the first in Scotland to lithograph music: 1841: *The Sacred Lyre*. 1842: A Song Sheet with music, published daily under the title *The Halfpenny Lyre* or sometimes *The Lyre*. The words for *Deacon Draff's Song,* Number 106 in the series, were written by the Orcadian poet and author, David Vedder, whose version of *The Story of Reynard the Fox* (David Bogue 1852) was lithographed by Schenck & Macfarlane of Edinburgh.

Hunter, John S.
1862–1865
Glasgow

1862–65	75 East Howard Street

Hutchison, John
1865–1867
Glasgow

1865–67	190 Trongate

Lithographer and Engraver. Possibly John Hutchison, Copperplate Printer, who became Burgess and Guild Brother by purchase on 26 February 1840.

Hutchison, William M.
1865–71
Edinburgh

1865–69	4 Merchant Street
1869–71	64 Bristo Street

Listed Slater 1867 as Lithographer and Engraver.

Hutton, R. & G.
1863–1867
Edinburgh

1863–64	56 Nicolson Street
1864–66	23 South Bridge
1866–67	41 Cockburn Street

Also Engravers. PODs 1863–67 show Letterpress Printers Hutton, R. & J. at same addresses. Possibly a typographical error, but repetition suggests Robert Hutton was senior partner in both businesses, and probably father of both G. and J. Hutton.

Imlay, Hugh
1867–1875
Aberdeen

1867–74	8 St Nicholas Street
1874–75	Nelson Street

Also Engraver and Envelope Manufacturer. PTD 1872.

Inglis, George & Co.
1843–1845
Edinburgh

1843–44	11 Mound
1844–45	5 Hanover Street

Lithographic Printer only.

Inglis, Robert
1861–1862
Glasgow

1861–62	44 Hutcheson Street

Believed previously letterpress printer, publisher and stationer at 203 Gallowgate (*c.*1856).

Innes, John
1841–1842
Glasgow

1841–42	63 Candlerigg Street

Pattern Drawer, Print Cutter working for muslin trade, and Lithographic Printer.

Innes, John [Entry 1/2]
1879–1892
Cupar

1879–92	6–8 Bonnygate and Burnside Printing Works

Basically a continuation of the old **Tullis Press** business of *c.*1840–49. Following bankruptcy of **Orr, J.C.**, the business was transferred to John Innes by Robert Tullis. 1892: Firm re-titled **Innes J. & G.** [2/2]. Not listed PTDs. See A.J. Campbell, *The Press of J. & G. Innes, Cupar* (Fife Bibliography: The Presses of Fife, 5) (Buckhaven, 1992).

Innes, J. & G. [Entry 2/2]
1892–20thC
Cupar
 1892–20thC 6–8 Bonnygate and
 Burnside Printing Works
Formerly **Innes, John** [1/2]. George Innes joined his brother John as partner in 1892. Having become the largest printing and publishing business in east Fife, the firm finally ceased trading a few years after its 150th Anniversary in the late 20thC. Not listed in PTDs. See A.J. Campbell, *The Press of J. & G. Innes, Cupar* (Fife Bibliography: The Presses of Fife, 5) (Buckhaven, 1992).

'Inverness Advertiser'
1856-1885
Inverness
This newspaper was first printed and published on 19 June 1849 by Gavin Tait on behalf of the proprietor, James M'Cosh. Following various structural changes, the business was acquired in 1855 by **Forsyth, Ebenezer**, who introduced the lithographic process in 1856.
Adv: 17 June 1856: 'Inverness Advertiser' 'Printing in all its different branches by Letterpress, Copperplate and Lithography.' The business was acquired by the *Inverness Courier* in 1885.

Jack & Carrick
1868–20thC
Glasgow
 1868–20thC 62 Argyle Street
Formerly **Franklin & Jack** at same address. Lithographic and Letterpress Printers.

Jack, David
1855–1856
Glasgow
 1855–56 61 Jamaica Street
Stationer, Lithographer, Engraver and envelope manufacturer. PODs 1860 and 1865 list Jack, David & Son under Letterpress Printers only.

Jack, James T.
1852–1853
Glasgow
 1852–53 43 Argyle Street

Jamieson, Robert [Entry 1/3]
1855–1858
Glasgow
 1855–57 3 West Nile Street
 1857–58 38 Queen Street
Lithographer and Engraver. 1858: Entered partnership **Jamieson & Mills** [2/3], remaining at last of above addresses.

Jamieson & Mills [Entry 2/3]
1858–1870
Glasgow
 1858–59 38 Queen Street
 1859–61 7 Queen Street
 1861–67 64 Buchanan Street †
 1867–68 no directory entry
 1868–70 59 Maxwell Street
Formerly **Jamieson, Robert** [1/3]. Listed Slater 1860 as 'Lithographer only' but also as Engravers and Letterpress Printers in POD 1860 and Slater 1867. When the partnership ended in 1870, **Jamieson, Robert** [3/3] continued business at new address.
† Although remaining in the partnership until 1870, **William Mills** was listed separately at this address from 1867.

Jamieson, Robert [Entry 3/3]
1870–1878
Glasgow
 1870–78 84 Oswald Street
Engraver, Lithographic and Letterpress Printer. Listed PTD 1872 and 1876. Following the end of **Jamieson & Mills** [2/3] partnership, Jamieson continued trading at above location.

Johnston, James [Entry 1/3]
1864–1865
Edinburgh
 1864–65 105 High Street
'Engraver, Lithographic and Letterpress Printer, and Stationer'. 1865: Entered brief partnership **Johnston & Auld** [2/3].

Johnston & Auld [Entry 2/3]
1865–1867
Edinburgh
 1865–67 8 North Bridge

Formerly **Johnston, James**. Engravers, Lithographic and Letterpress Printers. Due to ending of partnership and change in title to **Johnston & Co.** [3/3], entries in Slater 1867 appear misleading.

Johnston & Co. [Entry 3/3]
1867–1877
Edinburgh

1867–68	8 North Bridge
1868–74	20 South Bridge
1874–77	44 South Bridge

Also Letterpress Printers and Engravers. Formerly **Johnston & Auld** [2/3]. Listed PDTs 1872, 1876.

Johnston & Campbell
1843–1844
Glasgow

1843–44	16 Queen Street

Also Engravers. Following end of partnership, business was continued by **Walter Campbell**.

Johnston, James
1852–1853
Glasgow

1852–53	42 Argyle Street

POD 1852: Trade-listed 'Lithographer'.

Johnston, John
Greenock
1834–1861

1834–61	46 Hamilton Street

'Typographic Printers'. Listed in Pigot 1837 as Lithographic Printer sharing the above address with William Johnston & Son. It seems likely that John was the 'Son' of William Johnston & Son, a letterpress printing firm which started at 14 Hamilton Street in 1815 and traded until 1848.

Johnston, W. & A.K.
1851–20thC
Edinburgh

1851–79	4 St Andrew Square
1879–81	16 S. St Andrew Street
1881–95	16 S. St Andrew Street and Edina Works, Easter Street
1895–99	7 South Hanover Street and Edina Works, Easter Street
1899–20thC	20 S. St Andrew Street † and Edina Works, Easter Street

Originally established as a steel and copper-plate engraving business, on Christmas Day 1825, by William Johnston (later Sir), a former apprentice with James Kirkwood & Son. Listed as Lithographers from 1851 and Letterpress Printers from 1868. Listed PTDs 1872–1900. From 1869 the firm also operated from offices in London. William Johnston's junior partner was his brother, the distinguished engraver Alexander Keith Johnston. In 1859 the firm acquired the equally renowned artistic and banknote engraving business (but not the premises) of **William Home Lizars**, following his death in March of that year. W. & A.K. Johnston achieved high acclaim for the outstanding quality of their steel-engravings of maps and banknotes, numerous examples of the latter being quoted in W.T. Johnston, *Dictionary of Scottish Artists* (Livingston, 1993–), *Part 5: Engravers*. By 1865 the firm had adopted lithography as the means of colouring maps. Slater 1860 lists as Lithographers, and 'Geographers, Printers and Publishers to the Queen', and similarly in 1867 with the addition of 'Engravers'. Many lithographed plans produced by the firm are held by The Scottish Record Office. Their Edina Printing Works had a floor space of 50,000 square feet and extended over two acres of ground. It was a model of its kind, and by the late 1890s housed 300 employees. See obituary of Alexander K. Johnston in *The Lithographer*, 7 August 1871.

† Address at 20 South St Andrew Street listed in PTD 1900, but not in POD.

Art-T-P-M-O-Mil-Adv-Archival Undated portrait 'John Leyden' after Capt. George Elliot. 1852: Print: 'The Heart of Midlothian'. 1853: Frontispiece in J.M. Mitchell's 'The Herring'. *c.*1855: 'Melbourne Place and Victoria Terrace'. *c.*1855: Print: 'National Gallery and galleries of Royal Scottish Academy' by W.H. Playfair, Architect. 1865: 'Facsimile of a map of Edinburgh drawn *c.*1647 by James Gordon'. 1867: 'Plan of Estuary of River Eden showing mussel scalps' by Wylie & Peddie [RHP.1278]. 'Plan of Isles of Colonsay and Oronsay' taken from an 1804 survey by D. Wilson [RHP.2992]. 1880: Chromolithograph: 'Entrance to St Giles Cathedral Church etc.' by W. Hay, Architect. 1881: 'Review of the Volunteers in the Queen's Park 25-8-81'. The firm advertised regularly in PODs and PDTs. The National Library of Scotland holds some of the firm's archival material, which also includes that of W. H. Lizars.

Johnston, W. & Co.
1858–1861
Edinburgh
 1858–61 1 Hill Square
Also Letterpress Printers and Engravers. Possibly connected in some way with their contemporaries **Johnston, W. & A.K.** Listed Slater 1860.

Jonas, Alfred Charles
1879–1880
Kilmarnock
 1879–80 32 Duke Street
Letterpress Printer, Lithographer, Embosser, and Address Label Manufacturer. Listed *Kilmarnock Directory* 1879 and PDT 1880.

Keith & Gibb
1848–1880
Aberdeen
 1848–71 15 Union Buildings †
 1871–80 3 Queen Street
Following the untimely death of the artistic lithographer **John Henderson**, his business was acquired by the highly successful and profitable partnership of Alexander Keith (1810–1901), son of a house and ship painter, and Andrew G. Gibb (1821–1881). Originally apprenticed to an engraver in Aberdeen, followed by two years' practical experience in Glasgow, Gibb was also a talented draughtsman, whose most memorable artistic work may be seen on most of the 130 or so tinted plates in Vol. 2 of *The Sculptured Stones of Scotland* (see below). Alexander's brother, John, was also an employee for a while. Several of the firm's trainees achieved distinction in later life, including Sir George Reid, President of the Royal Scottish Academy 1891–1902. Listed PTDs 1872, 1876, 1880. When Keith left the business in 1880, the title of the firm changed to **Gibb & Hay**, and in 1887 to **Gibb, Andrew & Co.**
† Slater 1867 lists as Lithographers and Engravers at this address.
Art-T-O-M Artistic work included: 1849: 'Fete at Keith Hall'; 1850: Tinted lithos in P. Samuel, *The Wesleyan Methodist Missions in Jamaica & Honduras* (Abbey, *Travel*, 681); Undated: 'Interior of the Town Hall, Inverury'. 1857: 'High Street Inverury', marking the visit of Queen Victoria. 1861: 'Shetland Islands. Route Maps'. 1862: 'Map of Aberdeen'. Tinted lithos in *The Sculptured Stones of Scotland*, 2 vols, The Spalding Club (1856–1867). 1849: 'Feuing plan of part of the

lands of Rubislaw' [RHP.1763]. 1867: Plan of 'Commonty or scattald of Brough, etc., Shetland' [RHP.3952]. 1871: Map of 'City of Aberdeen corrected up to 1871' [RHP.4143].

Keith, Charles
*c.*1865–*c.*1882
Inverness
 *c.*1865–76 20 & 21 Church Street
 1876–*c.*82 39 & 41 Church Street
Listed Slater 1867 and PTDs 1872, 1876, and 1880.

Kennedy, A. & W.
1856–20thc
Glasgow
 1856–61 27 Glassford Street
 1861–72 13 Glassford Street.
 1872–74 not trade-listed in PODs
 1874–82 13 Glassford Street
 1882–20thC 29 Glassford Street
Engraver, Lithographer, and Letterpress Printer. Listed Slater 1860, 1867, but in PTD 1872 only.
Adv: Advertised in PODs 1862–1865.

Kennedy, Gilbert [Entry 1/3]
1867–1890
Glasgow
 1867–88 89 Argyle Street and 11 Turner's Court †
 1888–90 38 Queen Street
Also Stationer and Account Book manufacturer. *c.*1880: Added Letterpress Printing. Not listed in PTDs. In 1890 Kennedy entered partnership of **Kennedy & Hunter** [2/3].
† The address at Turner's Court was omitted for several intermediate years, due to space limitations in the directories.

Kennedy, G. & Hunter [Entry 2/3]
1890–1894
Glasgow
 1890–94 52 W. Nile Street
Formerly **Kennedy, Gilbert** [1/3]. Lithographic and Letterpress Printers. 1894: Partnership was dissolved but the business was continued by **Kennedy, Gilbert** [3/3].

Kennedy, Gilbert [Entry 3/3]
1894–1895

Glasgow

1894–95 52 W. Nile Street

Formerly **Kennedy, G. & Hunter** [2/3]. After partnership ended, Kennedy's attempt to continue the business proved short-lived. Not listed in PTDs.

Kerr, James

1837–1854

Glasgow

1837–45 59 Trongate †

1845–54 145 Argyle Street

Long established as Engraver. Introduced lithography and Copperplate Printing in 1837. 1854: Succeeded at last address by **Scott, John**.

† Pigot 1837 lists an address at 4 Laigh Kirk Close. Between 1841 and 1845 Kerr shared this address with **George Munro**.

Art-P No lithographic examples traced, but in 1800 Kerr engraved a portrait of 'The Rev. Robert Clarke'.

Khull, Edward

c.1829–1849

Glasgow

c.1829–35 65 Virginia Street

1835–47 Dunlop Street

1847–49 16 Canterbury Place

Originally established in 1810 as a Letterpress Printer at 43 Trongate, Khull moved to Saltmarket in 1812, and to East Clyde Street in 1816. Previously a sub-contractor to publishers **Blackie, W.G.**, he entered partnership as Khull, Blackie in 1819. When the partnership ended in 1826, he again set up his own business, but was soon succeeded by his son, Edward *junior*. It seems that the cheerful and genial disposition for which his father was noted was not inherited by the son. In his *Reminiscences of Editors, Reporters, and Printers, during the last Sixty Years* (privately printed, Glasgow, 1890), the Glasgow printer Andrew Aird commented 'Khull [i.e. Khull *junior*] had a very sharp temper, and his tongue seemed to be in complete harmony with it'. Although trade-listed only as a Letterpress Printer and Stereotyper in PODs and Pigot 1837, Edward *junior* appears to have added lithography around 1829, his name being inscribed on a recently auctioned lithograph dated 1833. Following the move to Dunlop Street the business rapidly declined, and Edward Khull *junior* finally ceased trading and emigrated to Australia.

Art-O 1833: 'An Account of the Grand Masonic Procession, at laying the foundation Stone of the Broomielaw Bridge'.

Kinfauns Press

c.1827–c.1833

Perth

c.1827–c.33 Kinfauns Castle

Title of imprint which appears on a number of letterpress works and, more importantly, on two catalogues in which lithographed embellishments were drawn on stone by the gifted **David Morison *junior***, of Perth. Morison was commisioned by Lord Gray of Kinfauns with the task of compiling and producing two catalogues, firstly of the works in his library, and, later, of his collection of pictures. A copy of the former, lithographed by Morison's assistant **Peter Cochrane**, was presented by Lord Gray to Sir Walter Scott. The location of this private press has long been the subject of considerable controversy, with claims that specific investigations have produced no evidence of a press having been established within the Castle. The concept that David Morison's catalogues may been drawn and printed within the Castle seems to have had a strong romantic appeal, to the extent that even those who doubted seemed to reflect a general wish for it to be true. Now the enigma has been finally resolved. Firstly, the existence of a letterpress printing unit within the Castle was verified by the discovery of two small examples of letterpress work bearing the unequivocal imprints 'Printed at Kinfauns Castle 1818', and 'Printed at Kinfauns Castle 1819'. These are contained in an album entitled 'A Collection of Newspaper and other Fragments of printing pasted into a Scrapbook' (National Library of Scotland, ABS.10.88.2, acquired in 1988). With the location of the letterpress unit firmly established, the co-operation of skills necessary to achieve the artistic blending and close juxtaposition of letterpress text and lithographed embellishments in the *Catalogue of Gray's Library* lent credence to the possibility that the lithographic press was also sited within the Castle. Then in May 1998, Robin Roger, Principal Officer Fine & Applied Art, Perth Museum & Art Gallery, reported that the following record referring to the *Catalogue of the Gray's Library* had been found in the 1828 *Report of the Council of Management of the Literary and Antiquarian Society of Perth*, of which David Morison was Secretary: 'This unique work was printed from a small press at Kinfauns Castle, and the Illustrations and Illuminations, which are

lithographed, were done by Mr Morison with *one pen*. Only 12 copies were printed. It is accompanied by a prefatory Poem, and various literary and bibliographical notes.' Interestingly, Kinfauns Castle was also equipped with a laboratory, which may well have been involved in the preparation of materials for the lithographic department.

Art-O The imprint of Kinfauns Press appears on the following important works: 1828: *Catalogue of the Gray Library, Kinfauns Castle*. Embellishments drawn by David Morison and lithographed by Peter Cochrane (National Library of Scotland, H.11.a.21). 1833: *Catalogue of Pictures, Ancient and Modern, in Kinfauns Castle, chiefly collected by Francis, Earl Gray*. Embellished by David Morison, who may also have been the lithographic printer, as Cochrane's name does not appear on this catalogue, which Morison dedicated to Lord Gray on the title page.

King, Thomas & Co. [Entry 1/2]
1860–1862
Glasgow
 1860–61 49 Oxford Street
 1861–62 97 Maxwell Street
Also Letterpress Printer. Thomas King ceased trading in 1862, but his son, Thomas King *junior* [2/2], continued business at first of above addresses.

King, Thomas *junior* [Entry 2/2]
1862–1863
Glasgow
 1862–63 49 Oxford Street
Son of **King, Thomas** [1/2]. Appears to have continued business in the original premises, but, unlike his father, was not trade-listed as a Letterpress Printer.

Kirkcaldy Printing Works
1869–1891
Kirkcaldy
An alternative 'Works' title used by **Beveridge, Archibald**.

Kirkcaldy Steam Printing & Lithographic Works
1857–1881
Kirkcaldy
An alternative 'Works' title used by the successive business structures of **Crawford, John** [1/4 to 4/4] of Kirkcaldy.

Kirkwood, James & Son
1831–1850
Edinburgh
 1831–50 11 South St Andrew Street
Previously an engraver in Perth, James Kirkwood relocated to Edinburgh in 1786. Burgess and Guild Brother 2 November 1786. Highly distinguished family firm of Engravers and Copperplate Printers noted for their fine artistic works and the engraving of banknotes on copper plates. The firm was also renowned as manufacturers of globes. On the night of 15 November 1824 their six-storey tenement building in Old Assembly Close was totally destroyed by a fire, later attributed to the burning of a pot of linseed oil used in the preparation of copper plates. The fire spread rapidly through the city, resulting in several deaths and more than 300 families being rendered homeless. In spite of the loss of many valuable plates, the business was soon re-established under the direction of Robert Kirkwood *junior*, being listed in 1825 at 11 South St Andrew Street. The lithographic process, introduced in 1831, was mostly used for transfer work, to protect valuable copper plates, and routine jobbing work. One of few known examples of lithographic work is listed below. The passing of the Kirkwood business was noted in the firm's final entry in the POD of 1850, when the business was acquired by engraver and copperplate printer **Alexander Scott**.

Art-M-Adv 1836: 'Chart of the East Coast of the Firth of Forth'. Advertisement confirming introduction of lithography in *Edinburgh, Leith, Glasgow and North British Literary Gazette*, 21 July 1832, with further advertisements on 9 November 1833 and 12 July 1834.

Kronheim, Joseph M. & Co.
1861–1870
Glasgow
 1861–62 17 Royal Exchange Square
 1862–70 25 South Frederick Street
'Lithographers, Ornamental Printers, Embossers etc.' Listed Slater 1867. Arriving in Britain in the late 1830s, Joseph M. Kronheim commenced working in 1839 with the Edinburgh typefounders Miller & Richard, before establishing his own engraving business there in 1842. However, in 1845/6 he moved to London, where his lithographic and engraving business in Shoe Lane achieved considerable distinction for quality and artistry. He was a licensee of the Baxter colour printing process from 1850. This branch office in Glasgow was managed by T.A. Broadbent, and from 1866 to 1870, they employed **John**

Ferguson as lithographer. Although numerous examples are to be found of Kronheim's work, those traced to date were all produced in London.

Langlands, George

c.1874–1884
Dumbarton
c.1874–77	11 High Street
1877–84	57 High Street

b.1839, d.1884. Post Master, Bookseller, Stationer & Lithographer. Had strong working relationship with **Bennett Brothers** and **Bennett & Thompson**, and was married to Hannah, the daughter of Samuel Bennett.
Adv: 3-page advert. in *Dumbarton Directory* of 1877.

Lauder, John

1844–1863
Glasgow
1844–47	95 Candlerigg Street
1848–49	33 N. Frederick Street
1849–50	38 Queen Street
1850–52	no directory entry
1852–63	38 Queen Street

Also Pattern Designer for muslin trade.

Lawson, Alexander [Entry 1/4]

1858–1860
Glasgow
1858–60	17 Virginia Street

Also Engraver. 1860: Entered the partnership of **Lawson, R. & A.** [2/4].

Lawson, Robert & Alexander [Entry 2/4]

1860–1861
Glasgow
1860–61	22 Argyle Street

Formerly **Lawson, Alexander** [1/4]. When this partnership ended within the year, **Lawson, Alexander** [3/4] and **Lawson Robert** [4/4] continued at the same address, but operated independently.

Lawson, Alexander [Entry 3/4]

1861–1880
Glasgow
1861–67	22 Argyle Street
1867–68	33 Virginia Street, Crown Court
1868–71	22 Argyle Street
1871–80	29 Hutcheson Street

Listed Lithographer and Engraver in PODs, also in PTDs 1872–1880. Former partner in **Lawson R. & A.** [2/4]. Added Letterpress c.1871. Also note reference under **Lawson, John**.

Lawson, Robert (& Co. †) [Entry 4/4 *]

1861–20thC
Glasgow
1861–65	22 Argyle Street
1865–80	14 Queen Street
1880–93	24 Queen Street
1893–20thC	194a St Vincent Street

Formerly in partnership **Lawson, R. & A.** [2/4] at 22 Argyle Street. Listed Engraver and Lithographer, Slater 1867, and PDTs 1872–1900 inclusive. Added Letterpress following move in 1865. Shared premises with **Lawson, John** from 1878 to 1886, although they were separately listed.
† '& Co.' dropped from 1874.

Lawson, Charles S. [Entry 1/3]

1864–69
Dundee
1864–69	132 Murraygate

1864: 'Lithographer and Printer', also an artist. 1867: Engraver and Lithographer. 1869: Entered partnership with brother James, as **Lawson Brothers** [2/3].

Lawson Brothers [Entry 2/3]

1869–80
Dundee
1869–76	15 Murraygate
1876–78	10 Lindsay Street
1878–80	Hazel Court, 31 Nethergate

Charles S. and James Lawson. Engravers, Lithographic and Letterpress Printers. Formerly **Lawson, Charles S.** [1/3]. Listed PTD 1876. 1880: When partnership ended, **Lawson, Charles** [3/3] continued the business.
Art-T 'St Andrew's Church, Dundee' and 'Tower of St Mary'; artist for both prints was Charles S. Lawson. 'New Wesleyan Methodist Chapel, Dundee'; although not indicated, this also appears to be the work of Charles Lawson.

Lawson, Charles S. [Entry 3/3]

1880–85
Dundee
1880–82	31 Nethergate

1882–84 2 Peter Street
1884–85 7 Cowgate
Formerly **Lawson Brothers** [2/3]. 'General Printer, Lithographic Printer, and Artist'.

Lawson, John

1878–20thC
Glasgow

1878–86 '(at R. Lawson's)' †
1886–88 no directory entries
1888–20thC 22 Argyle Street

Also Letterpress from *c*.1890. John Lawson first operated from the Queen Street address of **Robert Lawson.** In 1888 he moved to premises earlier occupied by **Robert & Alexander Lawson.** Listed PDTs 1889, 1893, 1900.
† POD listing.

Leggat & Hoffman [Entry 1/2]

1863–1871
Glasgow

1863–71 110 Buchanan Street

Engravers and Lithographers. 1871: When partnership ended, Leggat started new business as **Leggat Brothers** [2/2], and Peter Hoffman became partner in **Hoffman & Campbell.**

Leggat Brothers [Entry 2/2]

1871–20thC
Glasgow

1871–72 44 West George Street
1872–74 29 Maxwell Street
1874–75 4 Sauchiehall Street
1875–90 38 Sauchiehall St. and 5 Renfrew Lane
1890–1900 38 Sauchiehall Street
1900–20thC 107 Bishop St. Port-Dundas

Engravers and Lithographers. Formerly **Leggat & Hoffman** [1/2]. Added Letterpress *c*.1880. Listed PTDs 1872–1893.

Leith, Samuel [Entry 1/3*]

1830–1835
Banff

1830–35 Believed to be in Low Street

Having returned to Scotland after working as supervisor of a sugar plantation in Jamaica, Samuel Leith set up a lithographic printing business in his small native town of Banff. His natural ability coupled with his enthusiasm for artistic lithography were such that within the first five

years of trading he received an award from the Highland Society of London for the quality of his lithographic work. In 1835 he moved to Edinburgh, where he joined in partnership with John Smith, trading as **Leith & Smith** [2/3/].

Art-T-M 1831: 'Map of Port-Ellen Harbour'. 1834: View of 'Wallace Nook' after James Skene. 1834: Lithographed fifteen of the views in *Sketches of Scenes in Scotland*, from sketches by Lieut-Colonel Murray of Ochtertyre, published by **David Morison** of Perth (see PLATE 3 opposite). 1835: 'Plan of Proposed new harbour at the town of Nairn' by Joseph Mitchell [RHP. 4273].

Leith & Smith [Entry 2/3]

1835–1840
Edinburgh

1835–40 30 Hanover Street

Listed Pigot 1837. **Leith, Samuel** [1/3] formerly successful as artistic lithographer in Banff, now resident in Edinburgh, in partnership with John Smith, former partner in **Smith, J. & W.** PODs also list **William Smith**, 'Writing-Master', at the same address, and it is virtually certain that he was also involved in the business. The partnership ended in 1840, when **Smith, John** succeeded to the business, and **Leith, Samuel** [3/3] started a new business.

Art-M 1836: 'General Maps & Charts of Inverary Harbour'.

Leith, Samuel [Entry 3/3]

1840–1856
Edinburgh

1840–56 9 S. St Andrew Street

Originally successful as an artistic lithographer in Banff, and, until 1840, in partnership **Leith & Smith** [2/3], Edinburgh. Samuel Leith, who was also a serious collector of fine oil paintings and prints, did much to encourage the development of artistic lithography in Scotland. In 1840 he brought from Germany artist, lithographer and engraver **Friedrich Schenck** and lithographic printer W. Wahler (who later appeared in the partnership **M'Dowall, Grieg & Wahler**), and set up his new business in South St Andrew Street. One of their earliest works together was the fine panoramic view of Edinburgh described below. A year before his death in 1857, he retired as a lithographic printer, and established a print-selling business in Princes Street.

PLATE 3. 'View from the Hill of Kinnoull, Eastward', drawn by Lieut-Col. Murray of Ochtertyre and lithographed by Samuel Leith of Banff for *Sketches of Scenery in Scotland* (David Morison Junr & Co., Perth, 1834). Reduced from 253 x 177 mm. (National Library of Scotland, R.289.c. Reproduced by permission of the Trustees of the Library.)

Art-T-O-M In 1841 the firm produced a remarkable panoramic view entitled 'Edinburgh and the surrounding Country as seen from Calton Hill'. Published by W. MacGill, Edinburgh, and measuring an extraordinary 89.7 x 8.9 inches, the print was composed of six sections, closely spaced to provide one complete panoramic scene. This highly acclaimed work was drawn on stone by W.H. Townsend. Unfortunately, in the catalogue of the Edinburgh Central Library, Edinburgh Room (where a coloured and framed version may be seen) this is incorrectly attributed to one 'J.W. Townsend'. 1840: Plan of 'Reay Commonty or alledged [sic] Commonty' by Thomas Cameron [RHP.2728]. 1840: 'Part of Inverness-shire showing Glengarry Estate, Inverlochy Castle and part of Lochaber' by G. Campbell-Smith [RHP.3261/1]. 1842: David Vedder, *Poems, Legendary, Lyrical and Descriptive* (Edinburgh, 1842) in which the illustrations were engraved on stone by Friedrich Schenck after original etchings by Walter Geikie. 1845: Facsimile 'Mapp of ye Orkney Islands and Harbours'. *c.*1850: 'View of Kirkwall', inscribed 'Drawn on Stone by John Irvine'. Drawn 1817 (printing date unknown; see introduction above, p.15): 'Back of the Old Jail Edinburgh', this being one of a number of Edinburgh scenes lithographed by Leith after drawings by Daniel Somerville.

Liddell, Peter [Entry 1/3]
1845–1846
Edinburgh
1845–46 1 W. Nicholson Street
Engraver and Lithographer. 1846: Believed to have entered partnership **Liddell Brothers** [2/3].

Liddell Brothers [Entry 2/3]
1846–1867
Edinburgh
1846–47	13 North Bridge
1847–50	18 North Bridge and 62 Charlotte Street, Leith
1850–60	62 Charlotte Street, Leith
1860–62	69 Shore, Leith and 46 Nicholson Street
1862–65	no directory entries
1865–67	'Foot of Drummond Street'

Believed to be Peter and Robert Liddell. 'Engravers, Lithographers, Printers and Opticians'. Slater 1860 lists as P. & R. Liddell under 'Lithographers' and Liddell Brothers under 'Engravers'. It may be that other members of the Liddell family were also involved in the businesses. It is also uncertain whether the second partner in Liddell Brothers was the same as **Robert Liddel** [3/3*].

Liddell, Robert [Entry 3/3*]
1850–1859
Edinburgh
1850–59 46 Nicholson Street
Engraver and Lithographer, but from 1859 Robert Liddell was listed as an optician and manufacturer of spirit levels. Possibly same as R. Liddell of **Liddell Brothers** [2/3].

Lind & Spence
1860
Edinburgh
1860 54a North Hanover Street
Listed in Slater 1860, also as Engravers at 73 North Hanover Street. No listings of Lind or Spence, either individually or as partners, traced in any section of PODs. Probably an abandoned or short-lived project.

Lindsay, John
1860
Edinburgh
1860 39 South Bridge Street
In business from 1856 into the 20thC as a Letterpress Printer. No evidence has been found to support listing as Lithographer in Slater 1860. Not listed as such in Slater 1867, PTDs 1872–1900, or PODs. This suggests the plan to introduce lithography was abandoned, or the 1860 entry in Slater was erroneous.

Lithographic Printing Office
1829–1837
Aberdeen
1829–35	10 Queen Street
1835–37	44 Upperkirkgate

Watson, James, of Aberdeen, was certainly connected with this firm in 1835, and may well have been the proprietor from 1829. If so, then this was the lithographic business in which **Colin Ross Milne** served his brief apprenticeship with Watson. See Iain Beavan, '19th Century Book Trade in Aberdeen' (Aberdeen University Ph.D. thesis, 1992).

Littlejohn & Steel
1863–1864

Glasgow

1863–64 95 Hutcheson Street

In 1864 the firm continued as **Steel, A. & Co.**, and was briefly joined in the premises by **Gray & M'Farlane**.

Lizars, William Home

c.1824 † or *c*.1839–1860

Edinburgh

c.1824–60 3 St James Square

This highly distinguished firm of engravers was originally founded by Daniel Lizars *senior* around 1775. Previously, Lizars had served a nine-year apprenticeship with the well-known engraver Andrew Bell. On 12 January 1782 Daniel *senior* was made 'Burgess by right of his Master'. When he died in 1812, the family business continued trading at their existing Parliamentary Stairs address under the partnership of his sons, William Home and Daniel Lizars, being listed in the POD 1813/14 as W. & D. Lizars, Engravers and Copperplate Printers. Resulting from expansion of the business, the firm moved in 1817 to 3 St James Square. Daniel *junior,* perhaps less stable than his brother, left the business in 1819, and in 1823 opened a bookselling and stationery shop at 61 Princes Street, but following bankruptcy, emigrated to Canada in 1833. When the partnership was dissolved, the business was continued by William Home Lizars, who had earlier served an engraving apprenticeship with his father and studied art with the Academy of the Board of Manufactures. In addition to Letterpress Printing, the firm was first listed as Lithographic Printers in the unclassified section of the Edinburgh POD for 1847. However, the existence of earlier works indicates that the firm introduced lithography well before this date. Published in 1824 for the benefit of the sufferers, and sold by Constable & Co., Edinburgh for seven shillings and sixpence, *Eight engravings of the ruins occasioned by the Great Fire of Edinburgh on the 15th, 16th & 17th November 1824* contained six illustrations signed 'Etched by W.H. Lizars'. In all probability the remaining two views entitled 'In the Old Assembly Close' and 'Cons Close. 17th November 1824. Spot where three men were crushed to death' were 'drawn on the spot' and printed by transfer lithography. Unfortunately, they are unsigned, and while Lizars may well have been the artist, it is not completely certain that the lithographic printing was his own work. The earliest known confirmation of Lizars involvement in lithography dates to a work in 1839 (see

below). Although renowned for the excellence of their engraving, comparatively few examples of the firm's lithographic work have been traced, and the process was used primarily for preserving expensive engraved plates by transferring the images to stone. The concentrated use of the process on this 'in-plant' work may well explain their late entry as lithographic printers in Post Office directories. Among several of the firm's employees who later achieved distinction in their own engraving and printing businesses, was their engraving manager, **William Banks**. Following the death of W.H. Lizars in 1859, the business was acquired by **W. & A.K. Johnston**. However, Lizars's premises were taken over by **Mould & Tod**.

† Positive evidence of Lizar's involvement in lithography well before their POD 1847 listing as users of the process, was kindly provided by Elizabeth A. Strong, McNaughtan's Bookshop, Edinburgh.

Art-T-P-M-O 1824: Two views of the Great Fire of Edinburgh produced by transfer lithography, but origin uncertain, see notes above. 1839: Twelve hand-coloured illustrations signed 'Lizars Lithog. Edinr.', in Catherine Sinclair, *Holiday House: A Series of Tales. Dedicated to Lady Diana Boyle.* (Edinburgh: William Whyte, 1839). 1845: Chromolithographed label pasted to top board in *Fletcher's Guide to St. Andrews* (St Andrews: Melville Fletcher; Edinburgh: W.H. Lizars, 1845). c.1847: Portrait of 'Swedish Nightingale, Jenny Lind'. 1849: *Specimens of Engraving, Lithography and Typography* (Edinburgh, 1851). 1851: W. W. Fyfe, *Summer Life on Land & Water at South Queensferry.* (Edinburgh: Oliver & Boyd; London: Ackermann & Co., 1851). In addition to an engraved frontispiece, title page and four plates, this work contains six lithographed plates. The preface confirms the entire production to be the work of W.H. Lizars. 1852: 'Plan of a Mine containing the Mineral Springs of Airthrey'. Survey by James Bryson. Two-colour chromolithographs in *The Proceedings of The Royal Physical Society of Edinburgh*, Part 1, 1854–1856. Chromolithograph: Facsimile of the 'Indenture between the Earl of Eglinton and the Viscount Montgomerie, 1630', in Sir William Fraser, *Memorials of the Montgomeries, Earls of Eglinton* (Edinburgh, 1859). Undated: 'Tower of Saint Regulus and Cathedral' after Robert Herdman. c.1847: 'Plan of The March between Teuchar and Auchry' by William Brooke [RHP.800]. 'Plan of Edinburgh, Leith & Newhaven Railway,' copied from a survey in 1840 [RHP.782]. 1847: 'Plan of Leith Harbour and Docks' [RHP.2709].

Locket, J. & J.
1854–1856
Glasgow
 1854–56 98 West Nile Street
Joseph and John Locket. Also engravers to calico printers. Branch Office only; main business was located in Manchester.
Adv: In POD 1854.

Logan, William
1855–1873
Glasgow
 1855–73 74 Argyle Street
Listed Slater 1860: Lithographic printer and Engraver. Believed to be former partner in **Robin & Logan**.

Lorimer, Robert
1870–1871
Glasgow
 1870–71 406 Argyle Street
Lithographic and Letterpress Printer.

Love, Robert
1860–1867
Glasgow
 1860–67 40 Kent Street

Luke, Andrew
1861–1869
Glasgow
 1861–69 35 Turners Court, Argyle Street
Listed 'Lithographer only' in Slater 1867, but also listed as Letterpress in PODs.

Lumsden, James
1821–1822
Glasgow
 1821–22 60 and 61 Queen Street †
Engravers, Copperplate Printers, Stationers, Publishers. Originally founded by James Lumsden *senior* (1752–1821) in latter part of 18th century. When he retired in 1810, he passed over the business to his son, James Lumsden *junior* (1778–1856) for the sum of £500. Around 1814 Lumsden *junior* engaged the services of Hugh Wilson (*b.*1797 in Paisley), who from 1810 had served an apprenticeship in engraving with Andrew Blaikie at The Cross, Paisley. Wilson performed well, and following his appointment as manager of the engraving department, was encouraged by Lumsden to ex-

periment with various printing processes. In June 1820 Wilson exhibited a self-inking stereotype printing press to the Philosophical Society of Glasgow; and the firm also experimented with lithography, exhibiting examples at the Society's meetings in March, May and August 1821 (see entries in Glasgow Philosophical Society Minute Book held in Glasgow University Library, Special Collections). However, Lumsdens do not appear to have been listed as lithographic printers in any directories of the period, nor to have offered a service in the process, being listed in Pigot 1821 as Engravers and Copperplate Printers at 60 Queen Street. At the end of 1821 James Lumsden decided to concentrate on the growing stationery market. Wilson acquired his engraving and copperplate printing business, being first listed in the POD 1822, as **Wilson, Hugh**, Engraver. Thereafter Lumsden published and/or sold many of Wilson's subsequent works. In 1838 James Lumsden *junior* became Founder and Chairman of the Clydesdale Bank, and it is probable that he exercised some influence on Wilson's later involvement in security printing. A statue of James Lumsden stands outside the Royal Infirary, Glasgow.
Art-T-C 1821: 'A landscape' and 'two lithographed *Glasgow* circulars' known, but not traced.

Lyon Brothers [Entry 1/2]
1869–1879
Edinburgh
 1869–79 21 Nicolson Street
Originally Booksellers and Stationers only. Now 'Stationers, Lithographers, Engravers'. When the brothers ended their partnership, **Lyon, George** [2/2] continued the business. Listed PDTs 1872, 1876, 1880.

Lyon, George [Entry 2/2]
1879–20thC
Edinburgh
 1879–20thC 21 Nicolson Street
Also Letterpress. Former partner in **Lyon Brothers** [1/2]. Listed in all PODs, and PDT 1885.

M'Allister, Alexander
1860–1861
Glasgow
 1860–61 22 Miller Street
Listed as Lithographer in Slater 1860. Appears short-lived venture, as neither the name nor the street number was traced in PODs between 1856 and 1862. However,

in POD 1875 an Alexander M'Allister was briefly listed as a Letterpress Printer at 11 Miller Street.

M'Aulay & M'Cartney
1848–1852
Glasgow
1848–49	273 George Street
1849–52	75 Argyle Street
Also Engravers, Pattern Card and Bookmakers.

Macaulay†, Richard
1850–1858
Glasgow
1850–52	32 Cleland Street
1852–58	35 Glassford Street
'Stationer, Lithographer, Engraver and Pattern Card Maker.'
† Spelled Macauley in PODs 1850 and 1851.

MacBride, Anthony C.
1862–1863
Glasgow
1862–63	140 Renfield Street
Also Lithographic Draughtsman.

M'Callum, James
1865–1870
Glasgow
1865–70	32 Dunlop Street
First listed in 1853 as Letterpress Printer at 182 Trongate and one of the earliest users of Steam Power.

M'Clement (or M'Clemont †), Samuel
1852–1864
Glasgow
1852–53	131 Argyle Street
1853–63	31 Argyle Street
1863–64	225 Crown Street
Previously engraver only at 7 Argyle Street.
† From 1861 spelling in PODs was 'M'Clemont'.

McClure
Glasgow
See **Maclure**

M'Coll & Auld
1846–1847

Glasgow
1846–47	13 Argyle Street

M'Cormick, Peter
1869–1871
Glasgow
1869–71	229 Argyle Street

McCulloch, George
1854–1858
Glasgow
1854–58	22 Prince George Place
It is possible that George McCulloch became a partner in **Galbraith & M'Culloch**.

MacDonald, A.G.
1835–1836
Glasgow
1835–36	190 Trongate
Engraver and Lithographic Printer. Former apprentice of **James Miller**. In 1836 MacDonald joined with another ex-Miller apprentice, Andrew Maclure, in the distinguished partnership **MacLure & MacDonald**.

M'Donald & Pritty
1842–1844
Glasgow
1842–44	36 Argyle Arcade
'Engravers, Lithographers and Copperplate Printers.' When the partnership ended in 1844, the business was continued by **Pritty, Francis** at the same address.

M'Donald, Daniel [Entry 1/3]
1830–1849
Glasgow
1830–38	18 Hutcheson Street
1838–48	31 Argyle Street, Moodies Court
1848–49	108 Duke Street
Lithographic, Copperplate, and Letterpress Printer, and Engraver. Listed Pigot 1837. 1849: Entered partnership with son David as **M'Donald, D. & Son** [2/3]. Until 1839 the firm employed lithographer **M'Tear, Andrew**.
Art-M-Adv Advertised move to 'more commodious premises in Moodies Court' in POD 1839, also the opening of a branch office at 28½ Buchanan Street in frontispiece of POD 1841. 1846: Plan of new road Ayr to Maybole [RHP.2551].

M'Donald, Daniel & Son [Entry 2/3]
1849–1852
Glasgow
 1849–52 31 Argyle Street
Lithographic and Letterpress Printing and Copperplate Engraving. Previously **M'Donald, Daniel** [1/3]. It appears that Daniel M'Donald retired or died, for in 1852 he was succeeded by his son and partner, **M'Donald, David** [3/3].

M'Donald, David [Entry 3/3]
1852–1858
Glasgow
 1852–56 3 Antigua Place, Nelson Street
 1856–58 81 Trongate
Lithographic Printer. Formerly in partnership **M'Donald, Daniel & Son** [2/3]. With the departure of Daniel, copperplate engraving and letterpress printing appear to have been abandoned.

M'Donald, H. & J.
1854–1855
Glasgow
 1854–55 Moodie's Court and Argyle Street
M'Donald, H. was probably **M'Donald, Henry**.

M'Donald, Hector
1867–1891
Glasgow
 1867–72 5 Hutcheson Street †
 1872–73 no directory entry
 1873–76 6 Oswald Street
 1876–77 8 Oswald Street (PTD entry only)
 1877–84 26 Glassford Street
 1884–86 no directory entries
 1886–91 133 Dumbarton Road
Also Engraver. Listed PODs. Listed PTD 1876 only.
† Address shared with **John M'Gavigan.**

M'Donald, Henry
1849–1852
Glasgow
 1849–52 4 Dunlop Street
Lithographer and Engraver. Probably the H. M'Donald of **M'Donald, H. & J.**

M'Donald, John & Co.
1852–1856
Glasgow
 1852–55 107 Buchanan Street
 1855–56 24 Howard Street
Engraver, Lithographic and Letterpress Printer.

MacDonald, William & Sons
1878–20thC
Galston
 1878–20thC Bridge Street
Listed as M' or Mc or Mac. Listed PDTs 1880–1900.

M'Dowall, David
1849–1850
Glasgow
 1849–50 15 Nicholas Street
Engraver and Lithographer.

M'Dowall, Grieg & Wahler
1846–1848
Edinburgh
 1846–48 59 South Bridge
Lithographic and Letterpress Printers. POD 1846 wrongly lists as '& Walker', but POD 1847 correctly as '& Wahler'. This is almost certainly the Wahler brought over from Germany, in 1840, by **Samuel Leith** [3/3]. Also note Wahler's connection with **Sutcliffe, John.**

Macfarlane, Alexander
1867–1868
Glasgow
 1867–68 190 Trongate
Slater 1867: 'Lithographer only'.

Macfarlane, Daniel & Co.
1869–20thC
Edinburgh
 1869–75 5 India Buildings
 1875–87 3 India Buildings
 1887–88 3 India Buildings and
 8 Chamber Street
 1888–20thC 8 Chamber Street and Guthrie Street
Also Letterpress and, from *c*.1875, Engraving. Listed in PTDs 1872, 1876, 1880, 1885 and 1900.

Macfarlane, David (& Co. †)
1835–1847

Glasgow

1835–36	20 Candleriggs
1836–37	16 Queen Street
1837–38	124 Trongate
1838–41	18 Hutcheson Street
1841–44	169 Trongate
1844–45	148 Trongate
1845–46	17 Renfield Street
1846–47	20 Candleriggs

Listed Pigot 1837. Following numerous changes of location, it appears that the firm started and ended at the same address.
† '& Co.' from 1846.

Macfarlane & Erskine
1871–20thC
Edinburgh

1871–20thC 14 & 19 St James Square

Lithographic and Letterpress Printers and Engravers. Formerly **Schenck & Macfarlane** (1850–1871). In 1871 Maurice Ogle, of Glasgow, published the 'Autobiographical Reminiscences' of John Paterson, writer of the text for *Kay's Portraits*. In this work the frontispiece portrait is inscribed 'Schenck and Macfarlane', but printing of the text is credited to Macfarlane and Erskine, suggesting that the change in title actually occurred during the printing of this work. First listed in POD and PTD of 1872. The new partnership comprised the now seriously ill William Husband Macfarlane and William Erskine, a director of the publishers **William Collins**. *c.*1873 Macfarlane left to convalesce in Italy, but died there in 1875. Although becoming more commercially orientated, the firm continued to produce some fine artistic work. The business was managed by the Erskine family over several generations, and continued trading until 1969, when it moved to Dalkeith, and became part of the Charles Letts' group, into which it was totally absorbed in 1980.

Art-T-M-O 1874: Chromolithographed illustrations in Thomas Milner, *Gallery of Geography* (Glasgow: McPhun, 1874). 1881: Print of 'Royal Review of the Scottish Volunteers at Queen's Park Edinburgh, on 25th August 1881'. 1865: 'Plan of Strathnashealag Estate' [RHP.3350]. 1877: 'Plan of Grounds of John Hope, Heriot Hospital and Leith Walk' [RHP.2969/1]. 1899: Illustrations in William 'Crimea' Simpson, *Glasgow in the Forties* (Glasgow: Morrison, 1899).

M'Farlane, William & Robert [Entry 1/3]
1853–1859
Glasgow

1853–55	333 Sauchiehall Street
1855–56	333 Sauchiehall Street,
	240 George Street and 1 Queen Arcade
1856–59	333 Sauchiehall Street and
	240 George Street

Booksellers, Stationers, Engravers, Lithographic and Letterpress Printers. The first signs of an impending split became apparent in 1857 and 1858 when the partnership was listed only in the unclassified section of the PODs, with **M'Farlane, R.** [3/3] being listed separately at the last of the above addresses. Then in 1859 the business re-appeared in the trade-listings as **M'Farlane, W. & A.** [2/3].

M'Farlane, William & Archibald [Entry 2/3]
1859–1863
Glasgow

| 1859–63 | 333 Sauchiehall Street |

Engravers, Lithographic and Letterpress Printers. Listed Slater 1860. William M'Farlane former partner in **M'Farlane, W. & R.** [1/3]. Now in partnership with Archibald M'Farlane at the original address.

M'Farlane, Robert [Entry 3/3*]
1857–1866
Glasgow

1857–58	240 George Street
1858–62	no directory entries
1862–65	171 W. Graham Street
1865–66	171 W. Graham Street and
	63 George's Road

Former partner in **M'Farlane W. & R.** [1/3]. Not trade-listed until 1862, and then only as a Lithographic Printer.

Macfarlane, William Husband
Edinburgh
1859–1871

Born in Dunfermline 28 July 1805, second son of The Rev. James Macfarlane. William's brother, John Macfarlane LL.D., was the prolific writer of religious works. Following some years as a Tea, Provisions and Spirit Merchant, William became junior partner in **Schenck & Macfarlane** in 1850, and succeeded to ownership when the partnership was dissolved in 1859. However, by agreement, the title of business continued as Schenck & Macfarlane. Due to restrictions in the dissolution agreement with Friedrich Schenck, the firm produced a number

of topographical views, portraits and plans within the period 1860 to 1871, in which the firm's title was abbreviated in the inscriptions to 'W. H. Macfarlane'. In 1871, faced with serious illness, Macfarlane entered the new partnership of **Macfarlane & Erskine**. Shortly afterwards William Macfarlane went abroad to recuperate, but died in Italy in May 1875. The 'W.H. Macfarlane' inscription appears on the following examples:

Art-T-P-M-Mil-O 1860: 'Royal Volunteer Review as seen from St Anthony's Chapel, Holyrood Park, 7th August 1860'. *c.*1860: 'Grange House, Edinburgh', drawn by C. Schacher. Undated: Portrait 'Sir William Wallace' (artist unknown). Embellished title page in the illustrated family Bible published by William Collins Sons & Co. in 1866. Music cover: 'Up Men of Strathern' or 'The March of the Crieff Rifles'. 1870: 'Feuing Plan of Livilands Park, St. Ninians' by David Rhind [RHP.882/2]. 1870: 'Plan of Dunoon for defender *in causa* 'Mackintosh v. Moir' by G.C. Bruce, C.E.' [RHP. 3110/1-2].

M'Gavigan, John
1867–20thC
Glasgow

1867–75	5 Hutcheson Street †
1875–93	190 Trongate
1893–20thC	62 Argyle Street

Formerly ticket writer. Listed Lithographer Slater 1867 and PTDs 1872–1900.
† Shared this address for a time with **MacDonald, Hector**.

M'Glashan, Alexander [Entry 1/5]
1843–1851
Edinburgh

1843–51	26 Clyde Street

Formerly an engraver of steel and copper plates at 23 Clyde Street. Having moved to above address, introduced lithography in 1843. 1851: entered partnership **M'Glashan & Wilding** [2/5].

M'Glashan & Wilding [Entry 2/5]
1851–1858
Edinburgh

1851–58	26 Clyde Street

Formerly **M'Glashan, Alexander** [1/5]. In the PODs 1851–56, the classified listings for 'Engravers' show M'Glashan in partnership with W. Wilding, but only

'M'Glashan, Alex.' is listed under the heading 'Printers Lithographic'. However, the partnership was correctly listed as Engravers and Lithographers in the general section of POD for 1851. Following the ending of the partnership in 1858, **Alexander M'Glashan** [3/5] continued at same address.

M'Glashan, Alexander [Entry 3/5]
1858–1875
Edinburgh

1858–71	26 Clyde Street
1871–75	27 St James Square

Listed Slater 1860, 1867 as Engraver and Lithographer. Formerly in partnership **M'Glashan & Wilding** [2/5]. In 1875 he entered partnership **M'Glashan & Smith** [5/5].
Art-Mil 1863: see **M'Glashan & Walker** [4/5].

M'Glashan & Walker [Entry 4/5]
1863
Edinburgh

1863	130 Princes Street

This is same M'Glashan as **McGlashan, Alexander** [3/5]. No such lithographic partnership is listed in PODs, and the title is known only from inscriptions which appear on the examples below. However, M'Glashan was also a partner in M'Glashan & Walker, trade-listed in the POD of 1863 as 'Photographers'. This suggests that the lithographed examples were based on actual photographs taken by M'Glashan & Walker, but in all probability lithographed by Alexander M'Glashan at 26 Clyde Street.
Art-Mil In R. Jameson, *Historic Record of Cameron Highlanders* (Edinburgh: Blackwood, 1863): two chromo-lithographed illustrations, '79th Regiment of Foot'. In one of these the regiment is showing the colours.

M'Glashan & Smith [Entry 5/5]
1875–1892
Edinburgh

1875–92	27 St James Square

Formerly **M'Glashan, Alexander** [3/5]. Engravers, Lithographic and Letterpress Printers. Having been involved in a succession of businesses, Alexander M'Glashan finally ceased trading in 1892. Surprisingly, none of the M'Glashan businesses were listed under 'Lithographers' in PTDs 1872–1900.

M'Gowan (or M'Gown), John
1870–1899
Glasgow

1870–72	45 Union Street
1872–77	97 Union Street
1877–78	no directory entry
1878–79	104 W. George Street
1879–81	5 Mitchell Street and 47 Renfield Street
1881–95	47/49 Renfield Street
1895–96	49 Renfield Street
1896–99	3 Bothwell Street

Engraver and Lithographer. Added Letterpress after move in 1872. Listed as 'M'Gowan' in PODs, but as 'M'Gown' in PTDs for 1872, 1876, 1880, 1885, and 1889. 1900: Entered partnership M'Gown, J. & E. at 3 Bothwell Street (not listed here).

M'Intyre, Alexander
1844–1848
Glasgow

1844–45	21 King Street †
1845–46	15 Hutcheson Street
1846–47	no directory entry
1847–48	15 Hutcheson Street

† Trade-listed in POD, but may be residential address.

Mack, Robert [Entry 1/4]
1839–1840
Glasgow

1839–40	13 Argyle Street

1840: Entered partnership **Mack & Smith** [2/4].

Mack & Smith [Entry 2/4]
1840–1853
Glasgow

1840–45	13 Argyle Street
1845–53	110 Buchanan Street

Lithographers, Engravers, pattern book and card manufacturers. Formerly **Mack, Robert** [1/4]. Now in partnership with William Adamson Smith. 1853: Partnership ended when **Smith, W.A.** left to start his own business. Mack entered new partnership as **Mack & Crawford** [3/4].
Art-M c.1845: 'Plan of Glasgow Harbour General Terminus & other Railways' [RHP.4164].

Mack & Crawford [Entry 3/4]
1853–1856

Glasgow

1853–56	128 Ingram Street

Lithographers and Engravers. Formerly **Mack & Smith** [2/4]. 1856: When partnership with Crawford ended, business continued as **Mack, Robert** [4/4].

Mack, Robert [Entry 4/4]
1856–1862
Glasgow

1856–58	128 Ingram Street
1858–62	3 West Nile Street

Following termination of partnership **Mack & Crawford** [3/4], Robert Mack continued the business.

M'Kay & Kirkwood
1852–1888
Glasgow

1852–57	135/137 Ingram Street
1857–73	135/137 Ingram Street & 98 Miller Street
1873–76	135 Ingram Street
1876–81	45 Cranston Street †
1881–85	217 Ingram St. & 102/104 Miller Street
1885–88	239 Ingram Street

Partnership of Lauchlan M'Kay and Charles Kirkwood. Previously **Currie, Mackay & Kirkwood**. Prior to 1852, when they introduced engraving and lithography, M'Kay and Kirkwood were partners in a separate stationery business at 135 Ingram Street. Now established as 'Booksellers, Stationers, Engravers, Lithographers, Bookbinders'. Added Letterpress c.1860. Printing Works located at 100 Stirling Road. Listed Slater 1860, 1867, and PTDs 1872, 1876, 1880, and 1885.
† PDT 1880 still lists firm at 135 Ingram Street.
Adv: Advertised in Slater 1860.

M'Keand, Charles
1860–1862
Glasgow

1860–62	31 Miller Street

Listed Slater 1860: Engraver and Lithographer. May be the same as **M'Keand, Charles** (1870–1871).

M'Keand, Charles
1870–1871
Glasgow

1870–71	40 Union Street

See note **M'Keand, Charles** (1860–1862).

M'Kellar, Donald & Co.
1856–1858
Glasgow

1856–58	100 Brunswick Street

Engraver and Lithographic Printer.

Mackellar, G. D.
1865–1875
Glasgow

1865–69	18 Renfield Street
1869–72	9 Mitchell Street
1872–75	90 Mitchell Street

Also Engraver and Publisher. Listed Slater 1867.

M'Kenna, John
1860–20thC
Glasgow

1860–62	21 Argyle Street
1862–66	74 Argyle Street
1866–67	258 George Street
1867–79	255 George Street
1879–80	no directory entry – moving
1880–20th	81 High John Street

Although consistently listed under POD classification for 'Lithographic Printers', was mostly shown as Writer, Draughtsman or Artist. However, this distinction is not apparent between 1877 and 1883. Not listed as lithographer in PTDs.

Mackenzie, James
1863–1875
Edinburgh

1863–75	129 High Street

Also Letterpress Printer, Stationer, Bookbinder. Listed POD 1868, Slater 1867 and PTD 1872.

Mackenzie, William
1852–20thC
Glasgow

1852–54	48 London Street
1854–71	45/47 Howard Street
1871–72	47 Howard Street
1872–20thC	43 Howard Street

Highly respected Lithographic and Letterpress Printer (Steam Power), Wood-Engraver, Stereotyper, Publisher and Bookseller. Originally established in 1806 by Duncan McKenzie, Letterpress Printer at 154 Trongate.

Trade-listed in POD 1835 at 48 Nelson Street. From 1841 the firm operated at 6 Maxwell Street under the title Mackenzie, White & Co., 'Printers and Publishers', but when the partnership ended in 1847, the business was continued by Duncan Mackenzie. In 1849, he was succeeded by William Mackenzie who, having added lithography in 1852, developed a successful business selling a wide variety of profusely illustrated books. Although some illustrations were produced by the lithographic process, the majority were from wood engravings by known artists. The books were offered in part form, and, in rural areas, hawked by travelling salesmen. One of their sample books may be seen in the National Library of Scotland. Listed Slater 1860, PTDs 1872, 1876 and 1880, but not thereafter.

Art-O Numerous chromolithographed illustrations in *The Library Shakespeare*, artists: G. Cruikshank, R. Dudley, Sir John Gilbert. Printed in Glasgow, and published in London in 1873 by W. Mackenzie.

M'Kerracher, William & Co.
1842–1843
Glasgow

1842–43	16 St Enoch Square

'Engravers, Lithographers and General Printers.'

Maclardy & Co.
1853–1854
Glasgow

1853–54	Morisons Court, 108 Argyle Street

'Lithographer, Engraver and Printer.'

M'Laren, Alexander
1844–1849
Glasgow

1844–45	10 Hutcheson Street
1845–47	109 Argyle Street
1847–48	9 Maxwell Street
1848–49	20 Royal Exchange

Lithographic and Copperplate Printer, Engraver and Stationer. May connect with **McLaren, Alex.**, of Paisley.

McLaren, Alexander
1846–1847
Paisley

1846–47	25 High Street

Possibly a branch of **McLaren, Alex.**, of Glasgow.

McLaren & Erskine
1865–77
Glasgow
 1865–77 5 Madeira Court, 257 Argyle Street
W. G. McLaren, Letterpress Printer since *c*.1855, now in partnership. Listed as 'Lithographers' in Slater 1867, but not in PODs or PTDs. POD 1867 lists as 'Letterpress and Steam Power and Music Printer'. Also Stereotypers.
Adv: POD 1865.

M'Laughlan, John
1861
Glasgow
POD 1861: Incorrect spelling; see **M'Loughlin, John**.

M'Leod, James
1861–1876
Edinburgh
 1861–63 30 St James Square
 1863–76 90 South Bridge
Engraver, and Lithographic Printer. Listed Slater 1867, and PTDs 1872, 1876.

M'Loughlin, John
1861–1866
Glasgow
 1861–62 56 Trongate
 1862–63 no directory entry
 1863–65 28/30 Nelson Street, City
 1865–66 28 Nelson Street
Incorrectly spelled M'Laughlin in POD 1861/2. Also Letterpress Printer and Stationer.

MacLure & MacDonald † ‡ (Entry 1/2)
1836–20thC
Glasgow
 1836–39 190 Trongate
 1839–53 57 Buchanan Street
 1853–85 20 Vincent Street
 1885–20thC 2 Bothwell Circus
Engravers, Lithographers. Added Letterpress *c*.1855.
A former apprentice of **James Miller**, Andrew Maclure (1812–1885), a talented artist, joined **A.G. MacDonald** as a partner in a firm which was to become one of the finest and most progressive printing businesses in Scotland. In 1851 they installed a press driven by steam, and almost certainly the first in Britain. The firm's success and reputation for excellence led to its appointment, listed in Pigot 1837, as 'Lithographers, Draughtsmen and Printers to the King', and in later directories as 'Lithographers to Queen Victoria'. Listed Slater 1860, 1867 and PTDs 1872–1900. The firm initiated important improvements in the quality of transfer paper and was a prolific producer of fine art works. In 1864 Andrew MacLure read a paper before the Royal Scottish Society of Arts concerning a system of reproducing an oil painting by lithography. This involved the taking of 25 impressions and embossing to simulate the texture of an oil painting on canvas. The paper was published in the Society's *Transactions* 6 (1864).

† In 1840 MacLure & MacDonald were joined in partnership by A. McGregor, who managed branches of the firm established in Manchester and Liverpool. Unusually, McGregor's name was only listed in the firm's title in connection with the branches in London, Liverpool and Manchester. It was listed separately in the PTD for 1872, but thereafter was omitted from the firm's title in 19th century editions of the PODs for Glasgow, in Slater 1860, 1867, and PTDs 1876–1900.

‡ '& Co.' from 1887.

Art-T-P-O-M-Mil-Inv-ms-Adv *c*.1840: Bookplate for 'James Stewart'. 1841: 'Map of City of Glasgow (Police Districts and Wards.)'. 1842: Printed illustrated ticket for private opening, on 18 February, of Edinburgh and Glasgow Railway (illustrated in PLATE 1). Date unknown: 'Glasgow Bridge, from the Harbour'. 1849: Set of five prints commemorating the Royal visit, 'Queen Victoria at Glasgow' (Abbey, *Scenery*, 503). 1849: 21 tinted plates in John Dunlop's 'Mooltan'. 1860: Print: 'The First Shot at Wimbledon'. 1877: Portrait of 'Elizabeth Georgiana, Duchess of Argyle', by Andrew MacLure. Colour advertisement bearing portrait of Queen Victoria inscribed 'Lithographers to the Queen' as frontispiece to Glasgow POD 1865. 1839: 'Plan of River Clyde from Glasgow Bridge to Port Glasgow' by Thomas Kyle [RHP.2861]. 1852: 'Water Supply Map for Rutherglen Waterworks'. 1863: 'Plan of new works at Ardrossan Harbour' [RHP.2053]. 1867: 'Plan of Estate of Kelvinside' [RHP.351]. 1874: 'The Trongate in 1774' after an original etching by James Brown; apparently reproduced to show the scene as it was a century before.

MacLure, MacDonald, McGregor *[Entry 2/2*]*
1840–20thC
Glasgow (Manchester, Liverpool, London)
See notes to **MacLure & MacDonald 1/2**.

Maclure †, John [Entry 1/3]
1830–1836
Glasgow
 1830–36 99 Trongate
Formerly listed as an 'engraver and rolling press' at 49 Trongate 1820–25, and known to have produced an engraving of 'John Davidson' for a bookplate. No examples of his lithographic work have been traced. Succeeded by his son **Maclure, David** [2/3] in 1836.
† Early directories spell as 'M'Clure', and variously listed as McClure, McLure, and Maclure.

Maclure, David [Entry 2/3]
1836–1853
Glasgow
 1836–49 99 Trongate
 1849–53 62 Argyle Street
Previously Printer at 43 Argyle Street (1828) and 28 Nelson Street (1835). 1836: Succeeded to business of his father **Maclure, John** [1/3]. Listed Pigot 1837 as Engraver, Lithographer and Letterpress Printer. 1853: Joined in partnership with son, also David, trading as **Maclure, David & Son** [3/3].
Art-M 'Sketch Plan of the City of Glasgow … divided into 17 Districts', dated 30 June 1842 (Glasgow University Library Mu22 - a.14).

Maclure, David & Son [Entry 3/3]
1853–1897
Glasgow
 1853–97 62 Argyle Street
Lithographic and Letterpress Printers. Formerly **Maclure, David** [2/3]. It appears certain that at some stage the son succeeded the father without further change to the firm's title. Listed PTDs 1872–1893. For a major part of their existence the Maclures shared the above address with **Daniel F. Duncan** and **Jack & Carrick**.

McNab & Co., Alexander
1844–1845
Aberdeen
 1844–45 9 & 10 South Gallery, New Market
See Iain Beavan, '19th Century Book Trade in Aberdeen' (Aberdeen University Ph.D. thesis 1992).

McNab & M'Kechnie [Entry 1/2]
1854–1855

Glasgow
 1854–55 42 St Andrew Square
Engravers, Lithographic and Letterpress Printers. 1855: Firm continued as **M'Nab & Co.** [2/2].

McNab & Co. [Entry 2/2]
1855–1857
Glasgow
 1855–57 42 St Andrew Square
Formerly **McNab & M'Kechnie** [1/2]. Engraver, Lithographic and Letterpress Printer.

M'Nair, James
1852–1869
Glasgow
 1852–68 15 Hutcheson Street
 1868–69 52 W. Howard Street
Slater 1860, 1867: 'Engraver and Lithographer'.

M'Naughton & Co. [Entry 1/2]
1870–1872
Glasgow
 1870–72 63 Buchanan Street
1872: In partnership **M'Naughton & Sinclair** [2/2].

M'Naughton & Sinclair [Entry 2/2]
1872–20thC
Glasgow
 1872–76 69 Buchanan Street
 1876–78 95 St Vincent Street
 1878–86 93 St Vincent Street
 1886–89 24 West Nile St. and 55 St Vincent St.
 1889–92 24 West Nile St. and 46 Mitchell St.
 1892–98 24 West Nile St. and 97 Campbell St.
 1898–20thC 24 West Nile Street
Lithographic and Letterpress Printer. Formerly **M'Naughton & Co.** [1/2]. Listed PDTs 1872, 1876, 1880, 1885, but not in subsequent PTDs.

MacPherson, Alexander
1847–1850
Glasgow
 1847–50 19 Balmanno Street
May connect with **MacPherson A. & J.**, Edinburgh.

MacPherson, A. & J.
1855–1859

Edinburgh
1855–59 12 Royal Exchange

Short-lived but important firm of artistic Lithographic Printers and Wood Engravers. Possible A. MacPherson connects with **M'Pherson, Alexander**, of Glasgow. MacPherson, J. was not listed in 1857. In 1862 the firm was succeeded in the premises by another artistic lithographer, **Friedrich Schenck**.

Art-T A. & J. MacPherson undertook the challenging task of producing 60 tinted lithos in The Reverend Robert Fraser, *The Kirk and the Manse* (Edinburgh: A. Fullarton, 1857) (Abbey, *Scenery*, 495). The views were drawn on stone by several artists including: James Gordon *junior*, F.H. Weisse, J.C. Brown, and J. MacPherson. An undated lithograph, 'Brechin Church', in Brechin Museum probably originates from this work. The inscription 'J. MacPherson' also appears on a print, dated 1848, of 'Trinity College Church', Edinburgh.

McQueen & Russell [Entry 1/2]
c.1874–*c*.1878
Galashiels
 c.1874–*c*.78 High Street

Listed in PTD for 1876 only. When *c*.1878 the partnership ended, **McQueen, John** [2/2] continued the business at a new address.

McQueen, John [Entry 2/2]
c.1878–20th C
Galashiels
 c.1878–20thC 25 & 27 Channel Street

Former partner in **McQueen & Russell** [1/2]. Listed in PTDs 1880, 1885, 1889, 1900.

Macrone, William (& Co. †)
1863–1886
Glasgow
 1863–70 23 St Enoch Square
 1870–79 12 Dixon Street
 1879–80 no directory entry
 1880–82 12 Dixon Street
 1882–85 28 St Enoch Square
 1885–86 1 Jamaica Street

Engravers, Lithographic and Letterpress Printers. Listed in Slater 1867, and PTDs 1872–1885.
† '& Co.' from 1880.
Art-?-Adv Advertised PTDs 1876 and 1880. PODs of 1867/8 & 1868/9 contain entries listing '**Hanton S. H.**,

Artist at Macrone's' suggesting the firm's involvement in some form of artistic work.

M'Tear, Andrew [Entry 1/2]
1840–1849
Glasgow
 1840–48 95 Argyle Street
 1848–49 2 St Enoch Square

Engraver, Lithographer. Probably as an introduction to starting his own business, M'Tear was first listed in POD 1839 as 'Lithographer at **D. M'Donalds**'. In 1849 he took W. M'Tear as partner, the firm trading thereafter as **A. & W. M'Tear** [2/2].

M'Tear, Andrew & William [Entry 2/2]
1849–1896
Glasgow
 1849–63 2 St Enoch Square
 1863–79 67 Buchanan Street
 1879–94 9 Gordon Street
 1894–96 4 North Exchange Court

Engravers, Lithographic and, from *c*.1880, Letterpress Printers. Formerly **M'Tear, Andrew** [1/2]. Listed in Slater 1860, 1867, and all PTDs 1872–1900. Reference in PTD 1880 to 'Alexander' M'Tear appears to be a typographical error.

Malcolm, John
1863–1866
Glasgow
 1863–66 10 Rosenhall Street

Listed under 'Lithographic Printers' in PODs, but also noted as ' Draughtsman'.

Marlow, James & Co.
1841–1848
Glasgow
 1841–42 113 King Street †
 1842–44 36 Bridgegate
 1844–48 78 Stockwell Street

Also 'Engraver and Printer'.
† Previously trade-listed at this address in POD 1840 as Marlow, J. & J. Engraver & Copperplate Printer.

Marr, James
1866–1887
Glasgow
 1866–68 320 Argyle Street

1868–69	330 Argyle Street
1869–80	230 Argyle Street
1880–87	396 Parliamentary Road

Engravers and Lithographers. Added Letterpress *c*.1875. Listed Slater 1867, PDTs 1872, 1876, 1880. PDT 1885 lists Marr, Thomas at last address, but this believed an error, as POD for 1885 still lists Marr, James at this location. Note **Marr, John S. & Sons**, presumed relatives.

Marr, John S. & Sons

1886–1887

Glasgow

1886–87	51 Dundas Street

Previously Letterpress Printers from *c*.1875. Probably related to **Marr, James**.

Marshall, Robert

1847–1877

Glasgow

1847–48	10 Hutcheson Street
1848–49	no directory entry
1849–51	31 Argyle Street
1851–53	no directory entry
1853–54	18 Hutcheson Street
1854–63	31 Argyle Street
1863–74	6 Cloy Place, off Maxwell Street
1874–76	57 Oswald Road
1876–77	171 W. Nile Street

Previously listed 'Lithographic Writer'. 1847: Trade-listed 'Lithographic Printer'. Slater 1867, PTD 1872.

Marshall, Thomas B.

1831–1836

Glasgow

1831–36	164 Trongate

Land Surveyor and Lithographer. May connect with Thomas Marshall who engraved maps for Pinkerton *c*.1804. No examples of lithographic work have been traced. See R.V. Tooley, *Dictionary of Mapmakers* (London, Map Collector, 1979).

Martin, James (& Co. †)

1855–1861

Edinburgh

1855–57	21 Greenside Street
1857–61	54 Hanover Street

Former Stationer. Now introduced Lithographic Printing and Engraving.

† Listed '& Co.' in Slater 1860.

Martin, William M. (& Co. †)

1857–1875

Glasgow

1857–75	42 Argyle Street

Engraver, Lithographic and Letterpress Printer. Listed Slater 1860, 1867.

† Listed '& Co.' in PTD 1872.

Mathie, James

1836–1856

Kilmarnock

1836–51	1 King Street
1851–55	1 King Street and Portland Terrace
1855–56	1 King Street and 2 Cheapside House, Portland Terrace

A bookseller from 1833, Mathie added lithographic printing in 1836. Following acquisition of additional premises in 1855, he was also listed in the local directory as a bookseller, bookbinder, printer and stationer. Listed Pigot 1837.

Maxwell, J. & Son

c.1888–20thC

Dumfries

c.1888–93	112 High Street
1893–20thC	97 & 99 High Street

Originally established 1852. Listed only as Bookseller etc. in POD 1882, suggesting that lithography was a recent introduction when the firm advertised its use of the process in 1888.

Adv: Advertised in *Dumfries & Galloway Standard and Advertiser*, 4 January 1888, as 'Booksellers, Newsagents, and Printers–Lithographic & Letterpress'. Lithographed advert. in P.O. Directory 1893. Listed in PTD 1893.

Mein, John Z.

1853–1874

Edinburgh

1853–54	63 North Bridge
1854–58	35 Leith Street
1858–67	9 Leith Street Terrace
1867–74	4 St James Square

Also Engraver. Listed Slater 1860, 1867, PTD 1872. The firm's listing as Letterpress Printers in PODs 1867 and 1868 may be an error as it was not repeated subsequently in PODs or Slater.

Melville, James [Entry 1/3]
1857–1860
Edinburgh

 1857–60 9 Rose Street

Listed under 'Lithographic Printers' in PODs, but as Lithographic 'Writer' in Slater 1860, in which year he entered partnership **Melville & Adamson** [2/3].

Melville & Adamson [Entry 2/3]
1860–1874 †
Edinburgh

1860–65	21 St James Square
1865–67	4 George Street
1867–68	10 N. St David Street
1868–69	17 George Street
1869–72	no directory entries
1872–74	6a Rose Street

Also Draughtsmen, Engravers, Lithographic Writers. Listed Slater 1867 and PTD 1872. In 1874 the partnership was dissolved, when William Adamson left the business and entered the new partnership of **Adamson & M'Queen**.

† James Melville continued the business, but operated as an engraver only at 9 Rose Street until 1881, when he took his son into partnership trading as **Melville, James & Sons** [3/3].

Melville, James & Son (s †) [Entry 3/3]
1881–20thC
Edinburgh

 1881–20thC 7 & 7a Clyde Street

Following termination of the partnership **Melville and Adamson** [2/3], James Melville spent six years as an engraver only. Then in 1881 he took his son into partnership as 'Engravers, Lithographers, Draughtsmen'.

† 1885: '& Sons'. Listed all PTDs 1885–1900.

Art-M 1887: Plan - 'Edinburgh Northern Tramways' prepared by Geo. Beattie & Sons [RHP.305]. The Scottish Record Office also holds a number of plans lithographed by the firm *c.*1920.

Melvin, Thomas & Co.
1866–1882

Greenock

1866–71	29 Cathcart Street
1871–81	4 Mansion House Lane
1881–82	25 Hamilton Street

Stationer & Lithographer. Formerly in short-lived partnership of **Murdoch & Melvin.** Melvin then continued the business. Listed Slater 1867 and PTDs 1872, 1876, 1880.

Mennons, John (& Co. †)
1831–1843
Greenock

1831–36	8 William Street
1836–43	3 William Street

Believed to be the son of John Mennons *senior*, founder of the *Glasgow Advertiser* in 1783. In *c.*1815 John Mennons & Son had printed and published local papers in Irvine. Following the death of his father in 1818, John Mennons *junior* became printer of the *Greenock Advertiser* from 1820, and proprietor by 1834. Listed as 'Type and Lithographic Printing Office' in *Fowler's Directory* of 1831. Listed Pigot 1837. See obituary of John Mennons *junior* in *Greenock Advertiser*, 11 August 1843.

† Listed as 'John Mennons & Co. Newspaper and General Printing Office' in *Greenock Directory* 1836-37.

Menzies & Hutchison [Entry 1/2]
1851–1853
Edinburgh

 1851–53 27 Hanover Street

Engravers, Printers and Lithographers. **Menzies, J. M.** [2/2] continued business when partnership ended.

Menzies, James Mowat [Entry 2/2]
1853–1882
Edinburgh

1853–60	27 Hanover Street
1860–82	30 Hanover Street †

Former partner in **Menzies & Hutchison** [1/2]; possibly related to John Menzies & Son, trade-listed in POD 1840 as Engravers and Printers. Listed as Engravers, Printers and Lithographers in POD 1853, but not included in Trade Section until 1868. Slater 1860 and 1867 also list premises at 25 Hanover Street.

† 30 Hanover Street was the firm's principal location and was also an address successively occupied by several distinguished lithographic printers.

Merry, Thomas Bicket [Entry 1/2]
1851–1852
Kilmarnock

1851–52	King Street

Presumed to be related by marriage to **John Bicket** and **Thomas Bicket**, lithographers in King Street (c.1846–51), Merry appears to have succeeded to their business at same location, but was listed in the 1851 Kilmarnock Directory only. In 1852 **Merry, Thomas Bicket** [2/2] moved his business to Glasgow.

Merry, Thomas Bicket [Entry 2/2]
1852–1868
Glasgow

1852–55	24 St Enoch Square
1855–57	107 Buchanan Street
1857–66	67 Great Clyde Street
1866–68	31 Buchanan Street

Previously in Kilmarnock, **Merry, Thomas Bicket** [1/2] re-located to Glasgow, where he set up as an Engraver, Lithographic and Letterpress Printer. Listed Slater 1860, 1867. In some PODs initials were reversed to B. T.
Adv: POD 1860.

Middleton, James
1844–1849
Glasgow

1844–46	167 High Street
1846–49	74 Argyle Street

Listed Pigot 1837 as Engraver and Copperplate Printer at 14 Stirling Street. Added Lithography 1844.

Millar, George (also listed as **Miller** †)
1846–1851
Edinburgh

1846–48	71 Princes Street
1848–51	68 Princes Street

Engraver, Copperplate and Lithographic Printer.
† POD listed as Miller under 'Lithographers', but Millar under 'Engravers'; the latter is correct.
Art-M 1848: 'Part of Estate of Kerse' (showing railway) after 1847 survey by T. Carfrae [RHP.1888].

Miller & Buchanan [Entry 1/2]
1846–1852
Glasgow

1846–52	21 Argyle Street

Lithographers and Engravers. Partnership of Robert Miller and David S. Buchanan. This business was originally founded by **Cleland, John** (1822–1825), and successively acquired by **Miller, James** (1825–1840), and **Campbell, Archibald** (1840–1846). 1852: Following dissolution, **Miller, Robert** [2/2] continued at existing site, and **Buchanan, David S.** started new business.
Art-T In 1849 the firm lithographed twenty highly attractive colour illustrations, drawn from watercolours by the artist Thomas Fairbairn, which they published under the title *Relics of Ancient Architecture and other Picturesque Scenes in Glasgow* (Abbey, *Scenery*, 502).

Miller, Robert [Entry 2/2]
1852–1864
Glasgow

1852–64	21 Argyle Street

Previously partner in Miller & Buchanan [1/2]. Following dissolution, continued business at same address as lithographic printer only. In 1864 he was succeeded by **Hamilton, James**.

Miller, James
1825–1840
Glasgow

1825	Moved from 30 Virginia Street
1825–31	85 Trongate
1831–32	85 Trongate and 22 Argyle Street
1832–34	21 Argyle Street
1834–35	21 Argyle Street and 256 Buchanan St.
1835–40	21 Argyle Street

Miller succeeded to the business of **Cleland, John** in 1825, and immediately moved to new premises. In 1837 he added engraving. Listed Pigot 1837. Miller exercised consummate skill in selecting and training staff, and several of the finest lithographers in Scotland first learned their art in his establishment, including **David Allan**, **Andrew Maclure**, and **Archibald Macdonald**. In 1840 James Miller was succeeded by **Archibald Campbell**. Campbell was said by **Thomas Murdoch** to have been in partnership as Campbell & Rae, but this title does not appear under trade-listings in PODs.
Art-T-M 1833: Two illustrations in 'The Opening of the Glasgow and Garnkirk Railway' (Alexander Hill). 1829: Plan (untitled) of proposed railway line and tunnel between Saint Rollox and The Broomielaw.

Miller, John (or Millar †)
1858–1868
Edinburgh

1858–61	142 High Street
1861–62	49 George IV Bridge
1862–63	8 Merchant Street
1863–67	27 Cockburn Street
1867–68	2 Drummond Street

Also listed as Letterpress Printer and Publisher from 1863. Slater 1860, 1867.
† Sometimes listed 'Millar'.

Miller, John [Entry 1/2]
1828–1835
Dunfermline

1828–35	Bridge Street

b.Dunbar 1780, d.1852. Popular and well respected Letterpress Printer and Bookseller located at Abbey Park Place, Dunfermline, since 1804. He moved to Bridge Street in 1807, where his introduction of lithography in 1828 was warmly received by the local Press. Between 1826 and 1833 he published a number of chapbooks.
1835: Took son into partnership as **Miller, J. & Son [2/2]**.

Miller, John & Son [Entry 2/2]
1835–1866
Dunfermline

1835–38	7 Bridge Street
1838–60	Bridge Street
1860–66	9 Bridge Street

Letterpress and Lithographic Printer. Formerly **Miller, John** [1/2]. Following John Miller's death in 1852, the business was continued by his son, until bankruptcy ensued in 1866. He is said to have been succeeded by an employee, John Stewart.

Miller, John (& Co. †)
1857–20thC
Glasgow

1857–59	1/3 S. Hanover Street
1859–60	122 Ingram Street
1860–63	3 Hanover Street and 122 Ingram Street
1863–72	1 Hanover Street and 122 Ingram Street
1872–78	122 Ingram Street
1878–79	15 Renfield Street
1879–83	15 Renfield Street and Carronvale Works, Denny

1883–20thC	116 Renfield Street

Lithographic and, from c.1863, Letterpress Printer and Engraver. Listed Slater 1860, 1867, and all PTDs 1872–1900, but without reference to Carronvale Works.
† '& Co.' from 1866 to 1879.
Adv: Advertised in Slater 1867.

Miller, J. Davis
1862–1882
Glasgow

1862–65	3 Buchanan Street
1865–69	104½ Argyle Street †
1869–75	104a Argyle Street †
1875–80	23 Gordon Street
1880–82	90 Mitchell Street

Engraver and Lithographer. Shortly after succeeding **Robin & Lindsay** at 3 Buchanan Street, Miller engraved a 'New Pictorial Map of Glasgow' which he published in *Miller's New and Complete Guide through Glasgow*. No examples of his lithographic work have been traced.
1875: Added Letterpress. Listed Slater 1867, PTD 1872.
† Same site.

Miller & M'Ilvride
1859–1860
Glasgow

1858–59	6 South Hanover Street

Mills, William
1867–1875
Glasgow

1867–70	64 Buchanan Street
1870–71	55 Glassford Street
1871–74	37 Glassford Street †
1874–75	43 Pitt Street

Between 1858 and 1870 Mills was also a partner in Jamieson & Mills, and they shared 64 Buchanan Street between 1861 and 1867. Not listed in PTDs.
† In 1871 the premises were also occupied by **W. & J. Murdoch**. From 1873 Mills appears to have worked with them, as PODs for 1873 & 1874 list as 'at W. & J. Murdoch's'.

Milne, Colin Ross
1832–1833
Forres

1832–33	Milne's Wynd

Not listed in any Directories. Following a brief lithographic apprenticeship with **James Watson** in Aberdeen, Milne's career as a lithographer in Forres ended almost immediately, when he failed in his first attempt to print music. Milne had purchased his press from James Watson, with the understanding that it had been constructed and used by the inventor of the lithographic process, Aloys Senefelder. Evidently discouraged by his failure, Milne then spent a short period as journeyman with **James Ballantyne & Co.**, Edinburgh, before emigrating in 1833 to the U.S.A. On arrival he worked firstly with a firm in New York, and then in 1834 set up business in Baltimore in partnership with Scottish artist Thomas Campbell (who had emigrated from Campbelltown), achieving considerable distinction as an artistic lithographic printer. See 'When Lithography was in its very Infancy: The Personal Narrative of Colin Ross Milne who came to Louisville in 1836', dictated in 1897 and published in *The Louisville Courier-Journal* (Kentucky, U.S.A.) on 27 February 1898, a few months after his death at the age of 84.

Art-T-P-O-ms (all examples produced in U.S.A.) *c.*1835: Reproductions from Hogarth's 'Industry and Idleness'. *c.*1835: Portraits of 'Charles Wesley' and 'Lord Byron'. *c.*1835: Map: 'The Colony of Liberia'. Milne's Certificate of Apprenticeship located in private collection in U.S.A.

Milne, Sim & Co.
1877–*c.*1879
Inverness
 1877–*c.*79 4 Bridge Street
Acquired the business of **Sim, Alexander & Son** at the same location, but the business was short-lived thereafter. Not listed in PTDs.
Adv: *Inverness Advertiser*, 30 March 1877.

Mitchell & Archibald [Entry 1/4]
1839–1841
Glasgow
 1839–41 15 Hutcheson Street
Engraver, Copperplate and Lithographic Printers. 1841: Partnership dissolved. The business continued as **Mitchell, James & Co.** [2/4].

Mitchell, James & Co. [Entry 2/4]
1841–1853

Glasgow
1841–42	15 Hutcheson Street
1842–44	15 Hutcheson St. and 43 Argyle Arcade
1844–46	43 Argyle Arcade
1846–52	45 Argyle Arcade
1852–53	15 Buchanan Street

Engraver and Lithographer, known to have engraved map of 'Glasgow' in 1842. Added Letterpress by 1846. 1853: Entered partnership **Mitchell & Logan** [3/4].
Art-T Print (undated): 'Dumbarton Castle'.

Mitchell & Logan [Entry 3/4]
1853–1854
Glasgow
 1853–54 15 Buchanan Street
Engravers and Lithographers. **Mitchell, James** [2/4] now in brief partnership with William Logan, having apparently now abandoned letterpress printing. 1854: Partnership ended when **Logan, William** left to start his own business. **Mitchell, James** [4/4] re-established business at new location.

Mitchell, James & Co. [Entry 4/4]
1855–1872
Glasgow
1855–57	132 Buchanan Street
1857–58	136 Buchanan Street
1858–64	108 Argyle Street
1864–70	9 Gordon Street
1870–72	19 Gordon Street

Formerly in partnership **Mitchell and Logan** [3/4]. Engraver and Lithographic Printer. Listed Slater 1867. Further listing as Letterpress Printer in POD 1860 is not confirmed, and may be erroneous.
Art-M *c.*1860: *Miniature Atlas* (Glasgow, *c.*1860; copy in National Library of Scotland, Map Library, Map.s.119.14).

Moir, Robert
1869–1882
Edinburgh
1869–70	31 Blair Street
1870–71	no directory entry
1871–72	7 Hunter Square
1872–82	5 Leith St. Terrace

Previously Engraver only from 1860. From 1882 Robert Moir appears to have given up lithographic printing, but continued as an Engraver into the 20thC.

Moncrieff, T. R.

c.1875–c.1883

Arbroath

 c.1875–c.83 84 High Street

Thomas Reid Moncrieff. Listed PTD 1876 and 1880.

Money, James, Craig & Co. [Entry 1/3]

1856–1858

Glasgow

 1856–57 31 Nelson Street

 1857–58 3 Albion Street

Lithographers, Account Book Manufacturers, and Stationers. In the POD for 1856 this entry is listed as 'Money, Jas. C. & Co.' This is felt to be an error, for the entry in the POD of 1857 lists the partnership of Money, J., Craig & Co. Partnership was dissolved in 1858, when Money entered the new partnership of **Money & Barron** [2/3].

Money & Barron [Entry 2/3]

1858–1859

Glasgow

 1858–59 11 Miller Street

Former partner in **Money, James; Craig & Co.** [1/3]. 1859: James Money dissolved partnership with Barron, and then traded as **Money & Co.** [3/3].

Money, James & Co. [Entry 3/3]

1859–1860

Glasgow

 1859–60 41 West Regent Street

Slater 1860. Former partner in **Money & Barron** [2/3].

Morgan, Francis & Co.

1858–1859

Glasgow

 1858–59 7 Argyle Street

Morison, David Junr., & Co.

c.1825–1837 †

Perth

 c.1825–37 2 Watergate

Part of a distinguished letterpress printing and publishing business, originally established in 1772 by Robert Morison *senior* (1722–1791). In the early 1780s Morison was joined in the business by his sons James (1762–1809), Publisher and Bookseller, and Robert *junior* (1764–1853). From c.1784 Robert Morison traded as a Letterpress Printer at 14 High Street (Pigot 1825). The Morisons operated to meticulous standards, and in 1794 were appointed 'Printers to the University of St. Andrews', achieving considerable acclaim for the quality of their classical works. When James died in 1791, his son, David, an outstanding scholar, gave up his legal studies and joined the family business, learning the art of printing from his uncle, Robert. David Morison (1792–1855) proved to be a brilliant man of exceptional talent and versatility, becoming Publisher, Librarian, Author, Printer, Artist and Architect, being also involved in the lithography of several very fine artistic works. It is virtually certain that among the most important of these were two catalogues commissioned by Lord Gray of Kinfauns and produced by David Morison at a private press operating in Kinfaun's Castle and published under the imprint *Kinfauns Press*. In addition to his other achievements, David Morison established The Perth Ink Manufactory, with branches in London and Liverpool. He also became involved in the colour printing of wallpaper, an idea which he may have gained from **James Ballantyne** of Edinburgh, who first used lithography for this purpose in 1832. From the time David Morison retired from the family business in 1837, it appears to have declined in terms of artistic productions. The printing business of his uncle, Robert Morison, continued until 1853, when he died in his eighty-ninth year. An unresolved enigma is the inclusion of 'Junr.' following David Morison's name. This appears to have been adopted in 1815, at which time David Morison would have been 23. Yet *Morison's Perth and Perthshire Register for 1813* is shown as 'Printed by R. Morison for David Morison, Bookseller', without reference to 'Junr.', suggesting the possibility that there may also have been a David Morison *senior* in the family business.

† As the earliest traced directory for Perth dates to 1837, it has not been possible to establish reliably the date at which David Morison introduced lithography into the family business, but as he appeared already familiar with the process when he and **Peter Cochrane** produced the first of the works under the *Kinfauns Press* imprint in 1828, it is possible that introduction of lithography into his own press dated to around 1825.

Art-T *Sketches of Scenes in Scotland*, drawn on stone from outline sketches by Lieut-Colonel Murray of Ochtertyre, with descriptive text by David Morison. Although initiated in 1831, the work, seriously delayed by technical difficulties related to the scale of the original

drawings, was finally published in October 1834, being 'Honoured with the express approbation and patronage of His Most Gracious Majesty'. It comprised some 55 views, of which 6 only bore the inscription 'Morison, Lithog.', 15 were inscribed 'S. Leith' (**Leith, Samuel, Banff**). On the remaining 34 views the lithographer's name was not inscribed. The title-page imprint is 'Printed by R. Morison for David Morison, Junr. & Co.'.

Morrison, Archibald
1846–1876
Glasgow
1846–55	18 Hutcheson Street †
1855–76	15 Hutcheson Street

† In 1853–54 these premises were also occupied by **Marshall, Robert**.

Morrison, James
1849–1857
Glasgow
1849–51	124 Trongate
1851–57	24 Stockwell Street

Engraver and Lithographer.

Morrison, John & Sons
1859-20thC
Greenock
1859–72	21 Hamilton St. and 67 Rue End Street †
1872–74	37 W. Blackhall St. and 67 Rue End St.
1874–20thC	67 Rue End Street

1841: Originally established as Bookbinder and Paper-ruler at 15 William Street. Listed in *Aberdeen Directory* 1859 as 'Booksellers, Stationers, Bookbinders, Lithographers, Paper-rulers, Librarians'. Listed Slater 1867 and PTDs 1872–1900. The firm's label appears in several bound volumes of *The Engineer* published *c*.1864.

† In 1859 the firm also occupied premises at Harvie Lane Hall.

Morton, James
1860–1862
Edinburgh
1860–61	44 South Bridge †
1861–62	9a Drummond Street

† Listed in POD, but Slater 1860 shows as Lithographer and Engraver at 54 South Bridge. The firm is also listed as Lithographers at 34 North Bridge in Slater 1867.

Possibly a plan which did not materialise, as no reference was traced of this firm in any section of POD after 1862.

Motherwell, James & William [Entry 1/2]
1862–1864
Glasgow
1862–64	17 Gordon Street

Partnership incorrectly listed as J. & M. Motherwell in the POD for 1862. 1864: The partnership was dissolved, but the business was continued by **Motherwell, W.** [2/2] at a new address. The PTD for 1893 lists two lithographers in Paisley as Motherwell, James and Motherwell, William & Co. Only the latter appeared in the PDT for 1900. May also connect with **James Motherwell** of Greenock.

Motherwell, William [Entry 2/2]
1864–1866
Glasgow
1864–66	54 Dunchattan Street

Former partner in **Motherwell J. & W.** [1/2].

Motherwell, James
1867–*c*.1878
Greenock
1867–72	10 William Street
1872–76	27 Sugarhouse Lane
1876–*c*.78	37 Hamilton Street

May connect with **Motherwell, J. & W. Glasgow**. Listed Slater 1867 and PTD 1876.

Art-P Lithographed portrait of engineer 'James Watt' (undated), by unknown artist.

Motson, John C.
1885–*c*.1891
Kilmarnock
1885–*c*.91	32 Duke Street

Listed in PDTs 1885, and 1889, but not listed 1893. 'Lithographer, Printer, and Stationer'. The above address previously occupied by **Jonas, A.C.**, 1879–80.

Mould, J.B. [Entry 1/2]
1839–1842
Edinburgh
1839–42	29 North Bridge

Engraver and Copperplate Printer since 1825, lastly at 31 North Bridge. Added Lithographic printing 1839. 1842: Entered partnership **Mould & Tod** [2/2].

Mould & Tod [Entry 2/2]
1842–20thC
Edinburgh

1842–50	29 North Bridge
1850–60	3 Waterloo Place
1860–20thC	3 & 4 St James Square †

J. B. Mould [1/2], now joined in partnership with James Tod. Listed Slater 1860, 1867 as Engravers, Lithographic and Letterpress Printers. James Tod appears to have been regarded with some esteem in the city, his appointments including the post of Chairman of the Chamber of Commerce (1891).
† In 1860 the firm took over the premises (but not the business) of the renowned engravers and lithographers **Lizars, W. H.**
Art-M *c.*1850: 'Plan of Estate of Strathnashealag' [RHP.978]. 1864: 'Plan of Estates of Firth and Old Woodhouselee, Lasswade' by A. Sutter [RHP.3056]. 1867: Plan of 'Lands and barony of Findon as subdivided in 1784' (from Ordnance Survey) [RHP.4313].

Muir, Gowans & Co. [Entry 1/2]
1847–1848
Glasgow

1847–48	4 Dunlop Street

Already established as letterpress printers for more than ten years. When partnership ended, Robert Muir continued as a Letterpress Printer only at same address, until 1862/3, when, trading as Muir, Robert & Co. [2/2], he again appeared as a lithographer.

Muir, Robert & Co. [Entry 2/2]
1863–1866
Glasgow

1863–64	106 St Vincent Street
1865–66	116 St Vincent Street

Following the 1848 ending of the partnership **Muir, Gowans & Co.** [1/2], Muir continued for some years as a Letterpress Printer only, then moved to St. Vincent Street where he re-introduced lithography.

Muirhead, Robert
1862–20thC
Glasgow

1862–67	21 Argyle Street
1867–70	52 Argyle Street
1870–76	9 Gordon Street
1876–20thC	21 Drury Street

Regularly listed in PODs under 'Printers – Lithographic' but mostly shown as 'Writer' or 'Draughtsman'. Listed Slater 1867, but not in PTDs.

Munro, George
1835–1852
Glasgow

1835–38	17 Nelson Street
1838–40	79 Trongate
1840–52	59 Trongate †

Previously Engraver and Lapidary. Listed Pigot 1837 as Engraver, Copperplate Printer and Lithographer.
† Between 1841 and 1846 Munro shared this address with **Kerr, James**.

Murdoch & Melvin
1864–1866
Greenock

1864–66	14 Cathcart Street

When this short-lived partnership ended, **Melvin, Thomas** continued the business.

Murdoch & Porter [Entry 1/4]
1858–1863
Glasgow

1858–63	35 Glassford Street

Listed Slater 1860 as 'Lithographer and Engraver'. When partnership ended in 1863, William Murdoch entered new partnership of Murdoch & Telfer [2/4]. Alexander Porter became a Doctor.

Murdoch & Telfer [Entry 2/4]
1863–1865
Glasgow

1863–64	35 Glassford Street
1864–65	55 Glassford Street

Also Engravers. William Murdoch former partner in **Murdoch & Porter** [1/4]. 1865: Partnership with Telfer dissolved. Murdoch then entered new partnership of Murdoch, William & James [3/4].

Murdoch, William & James [Entry 3/4]
1865–1890
Glasgow

1865–72	55 Glassford Street and 81 Wilson Street
1872–90	37 Glassford Street

Formerly **Murdoch & Telfer** [2/4]. Lithographers and Engravers. *c.*1872: Added Letterpress Printing. Listed

Slater 1867, PTDs 1872 to 1889. *c.*1873: Co-operated with **Mills, William**. When the partnership ended in 1890, it seems likely that James Murdoch then became one of the partners in **Murdoch J. & J.** [4/4].

Murdoch, J. & J. [Entry 4/4*]
1890–20thC
Glasgow

1890–1900	253 Argyle Street
1900–20thC	87/89 M'Alpine Street

Also Letterpress. Believed one of the above was James, former partner in **Murdoch, W. & J.** [3/4].

Murdoch, Thomas & Co.
1858–20thC
Glasgow

1858–61	62 Argyle Street
1861–66	24 Hutcheson Street
1866–81	34 Hutcheson Street
1881–92	57 Buchanan Street
1892–20thC	54 Union Street

Slater 1860, 1867: Lithographic and Letterpress Printers and Engravers. Originally apprenticed to **Joseph Swan**, and then with **William A. Smith**, before starting his own business. Thomas Murdoch was author of fascinating booklet, *The Early History of Lithography in Glasgow*, which he published from 54 Union Street in 1902. Possibly related to other lithographic printers in Glasgow named 'Murdoch', but no connections traced.

Murphy A.W.
1850–1852
Glasgow

1850–52	62 N. Frederick Street

Murray, Alexander H.
1854–1865
Glasgow

1854–60	1 South Frederick Street
1860–65	31 Argyle Street

Listed Slater 1860 as 'Lithographer and Engraver', but POD 1860 also trade-lists as Letterpress Printer.

Murray, Angus
1854–1886
Glasgow

1854–56	1 South St Frederick Street

1856–63	3 North Albion Street
1863–67	23 North Albion Street
1867–70	11 Turners Court, 87 Argyle Street
1870–76	40 N. Frederick Street
1876–79	3 James Morrison Street
1879–86	47 Kelvinhaugh Street

Listed PTD 1872 and Slater 1860, 1867 as 'Lithographer and Engraver', but also intermittently listed in Trade Section of PODs as Letterpress Printer.

Murray, Archibald K. & Co.
1869–1879
Glasgow

1869–79	243 Parliamentary Road

Lithographic and Letterpress Printers. Toy Book and colour printers. Listed PTD 1872, 1876. Former partner in **Neilson & Murray**, Paisley. Premises formerly occupied by **Murray, Thomas & Son** (1857–1869 and 1876). It seems likely that A.K. Murray was the son of Thomas Murray.

Art-Mil-Adv: 20 plates in Major A.K. Murray's *History of the Scottish Regiments* (Thomas Murray & Son. 1862). Advertised PTD 1872, 1876.

Murray, George [Entry 1/2]
1869–1871
Edinburgh

1869–71	42 Hanover Street

Also 'Stationer, Engraver and Printer'. In 1871 entered partnership as **Murray, Harvey & Co.** [2/2] at same address.

Murray, Harvey & Co. [Entry 2/2]
1871–1884
Edinburgh

1871–74	42 Hanover Street
1874–78	40 & 42 Hanover Street
1878–84	15 Clyde Street

Also Engravers. Formerly **Murray, George** [1/2]. His partner was **Joseph Harvey**, who succeeded to the business when the partnership ended in 1884.

Murray, J. B.
1854–1856
Glasgow

1854–56	71 Virginia Street

Also Engraver.

Murray, Thomas & Son
1857–1869 and 1876–1896
Glasgow

1857–59	239/241 Parliamentary Road & 293 Parliamentary Road
1859–65	239/243 Parliamentary Road
1865–67	243 Parliamentary Road and 49 Buchanan Road
1867–69	243 Parliamentary Road
1869–76	not trade-listed
1876–96	31 Buchanan Street

Engravers, Lithographic and Letterpress Printers, and Publishers. Listed Slater 1860. In 1869 Thomas Murray & Son appear to have ceased trading, being succeeded at 243 Parliamentary Road premises by **Murray, A.K. & Co.** However, the firm re-appeared in the PTD for 1876, which also showed an additional address at 52 St Enoch Square. Trade-listings in PODs resumed in 1879, coinciding with the closure of Murray, A.K. & Co.

Murray, William
1861–1865
Glasgow

1861–62	3 North Albion Street
1862–65	25 North Albion Street

Lithographer and Artist.

Naismith, John Wilson
1858–1865
Edinburgh

1858–64	1 St James Square
1864–65	13 St James Square

Listed Slater 1860 as Lithographer and Engraver, but shown as an Engraver only in trade-index of PODs.

Neill & Pollock
1855–1856
Glasgow

1855–56	Antigua Place, Nelson Street

'Printers and Lithographers.'

Neilson, John [Entry 1/6]
1821–1830
Paisley

1821–30	15 St Mirren's Court

Paisley POD 1820/1 'Printer'. Originally apprenticed as compositor to his father, John Neilson *senior*, from 1798,

and continued the business following his death in 1819. By 1820 the business had been re-located from Causeyside to St Mirren's Court, and it was here that the highly enterprising John Neilson introduced lithography in 1821. It seems probable that he was largely self-taught, and it is uncertain whether he immediately offered a lithographic printing service to his customers. He was also the first in Paisley to introduce stereotyping. From its first publication in 1824, Neilson became printer of the *Paisley Advertiser*. 1830: Entered partnership as **Neilson & Hay** [2/6].

Art-T-P-O The Paisley Museum holds thirty lithographs inscribed 'Neilson's Lithog.' only one of which is dated. They cover a variety of subjects, with artistry ranging from simple amateur sketches to works approaching professional standard. Some appear to date from his introduction of lithography. They include: 'Portrait of James Abernethy aged 103' and a sketched, full-length portrait of 'Paisley Celebrity Daft Dandy'.

Neilson & Hay [Entry 2/6]
1830–1836
Paisley

1830–36	15 St Mirren's Court †

Letterpress Printers and Lithographers. Formerly **Neilson, John** [1/6]. Partnership of John Neilson and Robert Hay, former engraver, journalist and now editor of *Paisley Advertiser*. The partnership ended in 1836. Although separately listed, they both remained in the same premises, with **Robert Hay** being listed as a 'Lithographer', and **John Neilson** [3/6] continuing his listing as 'Printer'.

† 1834– St Mirren's Street.

Adv: Front page of *Paisley Advertiser*, 11 December 1830, announcing 'that they have of late considerably improved their Lithographic Establishment'.

Neilson, John [Entry 3/6]
1836–1844
Paisley

1836–44	15 St Mirren's Street

Printer, Stereotype Founder, Bookbinder, Paper Ruler. Formerly **Neilson & Hay**. 1844: Entered partnership **Neilson & Murray** [4/6].

Art-T-P-O During this period Neilson produced prints as in [Entry 1/6]. 1840: 'Paisley Comic Race Meeting' by Dick Zuis. 'Portrait of Woman's Head'.

Neilson & Murray [Entry 4/6]
Paisley
1844–1846

 1844–46 15 St Mirren's Street

'Printers, Stationers etc.' Originators of *Murray's Time-tables*. Formerly **Neilson, John** [3/6]. Partnership of John Neilson and A.K. Murray, later **Murray, Archibald K.**, Glasgow (1859–1869). When the partnership ended, **Neilson, John** [5/6] continued the business.

Neilson, John [Entry 5/6]
1846–52
Paisley

 1846–52 101 High Street

Letterpress and Lithographic Printer, and Paper-Ruler. Formerly **Neilson & Murray** [4/6]. In December 1846 seventeen of the firm's apprentices held the first annual meeting of their 'Printers' Commemorative Society', formed in 1845 with the objective of maintaining social contact in later years. One of these apprentices was James Cook, later to become printer and publisher of the *Paisley Gazette* (see obituary of former apprentice James Cook in *Paisley & Renfrew Gazette*, 6 August 1892). In 1852 Neilson relinquished his Paisley business in favour of his undisclosed partner, **Thomas Graham**, and moved to Glasgow to concentrate on the business which he had already established there as **Neilson, John**, of Glasgow [6/6].

Neilson, John (& Co. †) [Entry 6/6]
1850–1857
Glasgow

 1850–53 161 Trongate
 1853–54 32 Dunlop Street
 1854–56 20 Howard Street
 1856–57 12 & 20 Howard Street

Engraver, Lithographic and Letterpress Printer. Formerly trading as a printer in Paisley as **Neilson, John** [5/6]. In Glasgow he was assisted by his able overseer, John M'Culloch. The firm made good progress initially, but in the face of severe difficulties collapsed in 1857, when Neilson retired. Thereafter the business formed the nucleus of McCorquodale & Co., well-known as printers of railway timetables. Resulting from an accident with a horse-drawn vehicle, John Neilson died in 1870. See obituary in *Paisley & Renfrewshire Gazette*, 26 June 1870.

† '& Co.' in 1856.

Nelson, Thomas & Sons
Edinburgh
1853–20thc

 1853–78 Hope Park
 1878–80 Operated in temporary accommodation †
 1880–20thC Parkside Works

This great printing and publishing firm was originally established near Bowhead and Castle Hill by Thomas Nelson (1780–1861) in 1798. Although Nelson took his sons, William and Thomas, into partnership in 1835 and 1840 respectively, the firm's title remained unchanged at that time. Their father being an invalid, Thomas *junior* managed the productive side of the organisation, while William operated successfully in the field. In 1843 the firm moved to Hope Park, where production was consolidated in one building, housing more than 500 employees. A web-fed rotary stereo-plate printing machine invented by Thomas Nelson *junior* was exhibited at the Great Exhibition of 1851. From 1845 until the early 1850s, the firm's lithographic work was provided by two Edinburgh lithographers, **Friedrich Schenck**, whose last known example for Nelson was the chromo-lithographed title page in J. Aikman's *Natural History of Birds, Beasts and Fishes*; and **James Ramage** whose name appears on illustrations in *Tales for all Seasons* by Fanny Forester, and *The Cousins*, all of which were published in 1850. In 1853 the title of the business changed to Thomas Nelson & Sons, and in the same year the firm established its own Lithographic Department. Initially, use of the process appears to have been largely confined to transfers from steel engravings, with occasional examples of chromo-lithography and double-tinted work appearing from around 1857. However, following the death o.˙ Thomas Nelson *senior* in 1861, their former sub-contractor, artist and lithographic printer James Ramage, was appointed manager of illustrative work. There followed a range of illustrated guides and books for children, for which the firm became renowned. Trade-listed as lithographic printers in Slater 1860, but not in PODs. See *The Story of a Famous Firm of Printer-Publishers*, Supplement to *The British & Colonial Printer*, 8 June 1951.

† On 10th April 1878, the Hope Park book producing establishment, said to be the largest in Britain at that time, was completely destroyed by a disastrous fire. Having maintained production for two years in temporary accommodation, the firm moved to their new Parkside Works in 1880.

Art-T-M-O-Inv 1853: 'The Souvenir'. 1857: John H. Balfour, *The Plants of the Bible* (London, 1857). 1859:

Windsor and Eton (Guide). A prolonged series published during the 1860s: 'Nelson's Oil Colour Picture Books for the Nursery'. 1867: Nelson patented invention (No. 2844) relating to special transfer paper, designed to produce a stippled effect. 1869: *London – The West End* (Guide). 1870: *Scarborough* (Guide). 1896: *Souvenir of Scotland: its cities, lakes and mountains* (120 Views).

Ness Brothers & Co.
1869–1870
Glasgow

 1869–70 16 St Enoch Square

Also Letterpress Printers. Formerly in partnership **Reid & Ness** at same premises.

Newmarch, Strafford & Co.
1856–1865
Glasgow

 1856–57 62 Maxwell Street
 1857–58 221/2 Maxwell Street
 1858–65 46 Maxwell Street

Also Ticket Writer. Erroneously listed as 'Mewmarch' in PODs of 1859, 1860. Listed Slater 1860. When they ceased trading in 1865, they were succeeded by one of their employees, **Frederick Callow**.

Nichol (Nicol †), William [Entry 1/3]
1839–1842
Edinburgh

 1839–42 27 Hanover Street

Former partner in **Forrester & Nic(h)ol**. Christened on 30 September 1811, at Huntly Hill, Brechin, William Nichol was one of Scotland's most prolific artistic lithographic printers. He also had a keen interest in engineering. He was the younger brother of James Pringle Nichol, distinguished Professor of Astronomy at Glasgow University, and later printed some of the illustrations for his brother's astronomical studies. Between the early 1830s and 1848 William was also Secretary of The Edinburgh Philosophical Society. From *c.*1840 onwards he produced many topographical views, working with several artists, but principally with James Gordon *junior*. The majority of his works were published *c.*1840 by J. & D. Nichol of Montrose, who were most probably related to William. In 1841 Nichol wrote the seven-page entry for 'Lithography' in *Encyclopaedia Britannica*, 7th Edition. In 1842 he entered the partnership of **Nichol & Taylor** [2/3].

† Inscriptions on his early works confirm that the spelling 'Nicol' in pre-1841 PODs is incorrect.

Art-T-O-M-Tre
1839: Cartoon (Print): 'The Reel of Bogie'. 1840: *Montrose, Illustrated in Five Views with a Plan of the Town*. This appears to have been a pilot folio for an important series of views drawn by the artist James Gordon *jun.*, and published by J. & D. Nichol of Montrose under the general title *City & Towns of Scotland Illustrated*. The series comprises Part I – *Aberdeen Illustrated in Nine Views* (1840); Part II – *Perth Illustrated in Eight Views* (1841); Part III – *Glasgow Illustrated in Twenty-one Views* (1841) (Abbey, Scenery, 508); Part IV – *Dumfries Illustrated in Eight Views* (1841). Each of these folios contains a plan of the relevant city/town and several vignettes. The British Library Map Library holds Parts I–IV, the most comprehensive collection traced. *c.*1841: The existence of three lithographed views originating from the same sources, and titled 'Edinburgh from the North'; 'Edinburgh, looking West: with the proposed Scott Monument'; and 'Head of West Bow, High Street, Edinburgh' suggests that an additional series, *Edinburgh Illustrated*, was started but abandoned. At an auction held at Bonhams of Knightsbridge, 1 December 1998, copies of *Aberdeen Illustrated* and *Montrose Illustrated* fetched £1,400 each.

Nichol & Taylor [Entry 2/3]
1842–1843
Edinburgh

 1842–43 11 Hanover Street

Previously **Nichol, William** [1/3]. In spite of Nichol's importance as an artistic lithographer, no examples of his work with Taylor have yet been traced. When the partnership ended in 1843, **Nichol, William** [3/3] continued business at same location.

Nichol, William (& Co. †) [Entry 3/3]
1843–1849
Edinburgh

 1843–44 11 Hanover Street
 1844–45 46 George Street
 1845–46 23 New Street
 1846–47 13 North Bridge
 1847–48 10 N. St Andrews Street
 1848–49 30 Hanover Street ‡

Formerly in partnership **Nichol & Taylor** [2/3]. 1849: Having resigned his position as Secretary of the Edinburgh Philosophical Society, William Nichol abandoned lithographic printing, and moved to Liverpool to take up an appointment as Secretary of the Mechanics' Institution.

† 1843 and 1847: Shown as '& Co.' in PODs and on some prints.

‡ 1848: Succeeded **Smith, John** at this address.

Art-T-P-M-Inv-ms 1843: 'Calton Hill, Edinburgh – Drawn from the summit of Salisbury Crags', artist: George Meikle Kemp. 1843: MS. of quotation for map of Moon in NLS. 1843: Portrait of Danish astronomer 'Tycho Brahe' (frontispiece) and several astronomical plates in Professor J. P. Nichol's *Architecture of the Heavens*. 1844: 'Plan of Glasgow' published in sheet form by Francis Orr & Sons, Glasgow. 1844: Submitted patent specification for improvement in lithographic presses. 1847: 'Map of Nova Scotia'.

Nimmo, David [Entry 1/2]
1851–1871
Edinburgh

1851–71	3 East Register Street

Listed 'Engraver' at 16 Calton Hill in 1843, 35 Leith Street in 1845, and 'Engraver and Printer' in 1848. First listed 'Engraver and Lithographer' in POD 1851, but not included in trade listings until 1869. Also listed Slater 1860. 1871: Entered partnership **D. & D. Nimmo** [2/2].

Art-T-M 1854: 'Plan of River Sitrig from Mr Elliot's cauld to junction with the Teviot', based on survey by John Melrose [RHP1480/4-5]. 1855: 'Plan of Dundee Harbour' from survey by Charles Ower [RHP.2846]. 1863: 'Plan of Stirling Water Works'. *c.*1870: 'View of 'Kirkwall', also inscribed as drawn by David Nimmo.

Nimmo, D. & D. [Entry 2/2]
1871–1886
Edinburgh

1871–75	3 East Register Street
1875–86	1 Swinton Row

Also Engravers. Formerly **Nimmo, David** [1/2]. Listed PTDs 1872–1885.

Art-M 'Plan of the Crown lands in parish of Walls, Orkney'. 'Plan No. 1 Fea and Wards' from 1870 survey by J. D. Miller [RHP.1740]. 1879: 'Lochore Estate, Ballingry' from a plan by J. R. Williamson [RHP.3343].

Nimmo, James [Entry 1/3]
1841–1857
Edinburgh

1841–45	7 Carruber's Close
1846–47	not trade-listed in POD
1847–57	7 Carruber's Close

James Nimmo, Engraver, Lithographic and Copperplate Printer, and Stationer. Probably son of **Nimmo, R.H.** 1857: Entered partnership (possibly with his son) as **Nimmo, J. & J.** [2/3].

Nimmo, J. & J. [Entry 2/3]
1857–1870
Edinburgh

1857–68	7 Carruber's Close
1868–70	15 Carruber's Close

Engraver and Lithographic Printers. Formerly **Nimmo, James** [1/3]. Slater 1860 and 1867 wrongly list as Nimmo, James. Possibly a father and son partnership, and the **Nimmo, James** [3/3] who continued the business was the son.

Nimmo, James [Entry 3/3]
1870–1884
Edinburgh

1870–76	15 Carrubber's Close
1876–84	377 High Street

Engraver and Lithographer. James Nimmo former partner in **Nimmo J. & J.** [2/3], but it is uncertain whether this was the original **Nimmo, James** [1/3] or perhaps his son.

Nimmo, Robert Alexander
1825–1826
Edinburgh

1825–26	1 South St David Street

Listed Pigot 1825. Engraver & Lithographer. Probably related to **Nimmo, R.H.**, with whom he shared the address.

Nimmo, Robert Hamilton
1824–1834
Edinburgh

1824–24	4 Writer's Court
1824–27	1 South St David Street
1827–34	30 Hanover Street

One of the earliest lithographic businesses to be established in Edinburgh. Listed 'Printer' in Voters List of 1832. Produced a number of extremely interesting artistic works. These included some prints relating to the notorious Burke and Hare murders. Being unusually macabre in content, they were highly controversial. Probably related to **Robert Alexander Nimmo**.

Art-O-M-Adv 16 February 1824: Initial advertisement in *Caledonian Mercury* seeking commercial work. 1826:

Ten lithographic coloured flowers with botanical descriptions. Drawn and coloured by a Lady, published in four parts, each containing ten illustrations, by David Brown. This work was advertised in the *Edinburgh Evening Courant*, 6 February 1826. 1829: 'Wretches Illustrations of Shakespeare'. 1830: 'Sketch of a Proposed Railway Line between the Cities of Edinburgh and Glasgow'. *c.*1833: Views 1–12 in E.C.C. [i.e. Mrs Robert Campbell], *Scottish Scenery: Sketches from Nature*, Parts 1 and 2; for other parts see **Bell & Co.**, **Forrester & Nichol**, and **Smith, J. & W.**

Noble, Donald
1859–1869
Glasgow
1859–69	17 Hospital Street

Oatts, John [Entry 1/3]
1853–1875
Glasgow
1853–58	34 Cochran Street
1858–59	17 Cochran Street
1859–65	19 Cochran Street
1865–71	61 N. Hanover Street
1871–73	280 George Street †
1873–74	no directory entry
1874–75	93 Virginia Street

'Stationer and Lithographer.' Previously Stationer at 102 Queen Street from 1835. Burgess and Guild Brother by purchase 10 March 1840. Also listed Engraver in Slater 1867. Listed PTD 1872.
† POD for 1871/2 also shows **Oatts, Charles**, Lithographer, at same address. Charles then became partner in **Oatts & Runciman** [2/3].

Oatts & Runciman [Entry 2/3]
1872–1892
Glasgow
1872–75	63 Mitchell Street
1875–82	66 Mitchell Street
1882–85	81 Buchanan Street
1885–89	81 Buchanan Street and 7 Mitchell Lane
1889–92	102 W. Nile Street

Partnership of Charles Oatts and Charles Runciman. Listed PTDs 1872, 1876, 1880, 1885, 1889. Added Letterpress *c.*1878. When partnership ended in 1892, **Oatts, Charles & Co.** [3/3] set up new business.

Oatts, Charles & Co. [Entry 3/3]
1892–1893
Glasgow
1892–93	178 Buchanan Street

PTD 1893. Originally working with **Oatts, John** [1/3], and then partner in **Oatts & Runciman** [2/3].

Oliphant, Robert
1854–1855
Glasgow
1854–55	240 George Street

Also Bookseller, Stationer, and Letterpress Printer.

Orr, J.C.
1857–1869
Cupar
1857–69	8 Bonnygate, and
	Burnside Printing Works

Listed Slater 1867 as Publisher and Lithographer. John Cunningham Orr, former partner in **Whitehead & Orr** and proprietor of *Fife Herald*. Achieved distinction as publisher of artistic works, but these were mostly produced by lithographers in Edinburgh. No examples of Orr's own lithographic work have yet been traced. Severe financial problems led to his eventual bankruptcy in 1869. 1870: Following a legal judgement, proprietorship was regained by the **Tullis Press**. See A.J. Campbell, *The Cupar Presses of: Whitehead & Burns, John Cunningham Orr, William Ritchie, W. Bayne, John Arnott* (Fife Bibliography: The Presses of Fife, 2) (Buckhaven, 1992).

Park, James C.
1866–1874
Glasgow
1866–70	52 W Nile Street
1870–73	8 Cambridge Street
1873–74	180 Hope Street

Engraver and Lithographer. Slater 1867 and PDT 1872.

Paterson, H. & Co.
1869–1883
Paisley
1869–71	5 Cumberland Court
1871–83	8 High Street

Paisley Directory 1869 lists as 'Lithographer' only. Also listed in PTDs 1872, 1876, and 1880.

Paterson, James

1860–1864

Edinburgh

 1860–64 43 Bristo Street

Lithographic Printer and Engraver.

Paterson, John

1852–1892

Glasgow

 1852–67 19 Ronald Street

 1867–92 31 Argyle Street

1892: Retired after 40 years trading. Listed PTDs 1872–1893.

Paterson, John S.

1823–1825

Montrose

Teacher of Art at Montrose Academy from 1821 to 1826.

Art-T Drawings on Stone for *Views of Scenery in Angus & Mearns*. 30 views in 6 parts planned for publication at three-monthly intervals (Montrose, John Smith, *c.*1824–*c.*1826). Ten of these views were printed by **Forrester and Morison**, Edinburgh. Some of the views originally planned for inclusion were irretrievably damaged in production. As a result, publication was much delayed and the remainder of the work was transferred to printers in London, primarily Charles Hullmandel.

Paterson, R. H.

1838–1839

Glasgow

 1838–39 7 Queen Street

Previously listed as Letterpress Printer only.

Paterson, Thomas

1824–1855

Glasgow

1824–26	26 Nelson Street
1826–27	17 Trongate
1827–28	17 Trongate and 51 Nelson Street
1828–29	169 Trongate
1829–30	17 and 169 Trongate
1830–36	169 Trongate
1836–38	46 Ingram Street
1838–39	169 Trongate
1839–41	16 Hutcheson Street
1841–42	not trade-listed
1842–48	124 Brunswick Street
1848–49	59 Hutcheson Street
1849–52	52 Ingram Street
1852–55	73 Hutcheson St. and 68 Glassford Street

Also an Engraver from 1847. Achieved some distinction for his fascia board which bore Senefelder's portrait. This was displayed at each of his many successive addresses. Listed Pigot 1825 and 1837.

Pattison, William C.

1844–1848

Glasgow

 1844–46 32 Nelson Street

 1846–47 38 Nelson Street

 1847–48 33 Nelson Street †

Publisher and Printer. Published the *Practical Mechanic and Engineer's Magazine* from October 1841 to September 1847. This illustrated journal may be seen in the Science and Technology Department of the Mitchell Library, Glasgow. Although shown as 'Publisher and Printer' in POD 1844, was first trade-listed as Lithographic Printer in 1847.

† *Gray's Directory* 1847 still lists at No 38.

Paul, James B. [Entry 1/3*]

1866–1892

Glasgow

 1866–72 20 Buchanan Street

 1872–75 62 Buchanan Street

 1875–92 96 Buchanan Street

Adv: Advertised as Lithographer, Engraver and Draughtsman in PODs between 1866 and 1872, and Slater in 1867. Not listed as lithographer in PTDs. Probably connects with **Paul, J. & T. & Co.** [2/3] The listing Paul, James also appeared in POD 1900, but unlikely to be same, as initial B. was omitted.

Paul, J. & T. & Co. [Entry 2/3]

1893–1895

Glasgow

 1893–95 90 Mitchell Street

Probably connects with **Paul, James B.** [1/3]. Listed PTD 1893. From 1895 business was continued by **Paul, T.** [3/3].

Paul, T. [Entry 3/3]

1895–1896

Glasgow
1895–96 90 Mitchell Street
Formerly **J. & T. Paul & Co.** [2/3] at same location. Listed POD 1895.

Peacock, Edmund [Entry 1/3]
1859–1863
Edinburgh
 1859–63 57 Nicolson Street
'Engraver, Lithographer, and Show-ticket Writer.' Slater 1860 lists as 'Lithographer only'. 1863: Entered partnership **Peacock Brothers** [2/3].

Peacock Brothers [Entry 2/3]
1863–1868
Edinburgh
 1863–66 1 Milne Square
 1866–68 27 South Bridge
Lithographic and Copperplate Printers, and Engravers. Formerly **Peacock, Edmund** [1/3], now entered partnership with brother. When partnership ended in 1868, **Peacock, Edmund** [3/3] continued the business.

Peacock, Edmund [Entry 3/3]
1868–1890
Edinburgh
 1868–88 35 Cockburn Street
 1888–90 4 Hunter Square
Lithographic and Copperplate Printer, and Engraver. Former partner in **Peacock Brothers** [2/3]. Listed in PTDs 1872, 1876, 1880, and 1885.

Peck, William & Co. [Entry 1/3]
1831–1838
Edinburgh
 1831–33 24 Greenside Place
 1833–35 16 Greenside Place
 1835–38 6 George Street
Lithographic Printer only. Listed in Pigot 1837. 1838: Took son James into partnership, trading as **Peck, William & Son** [2/3].

Peck, William & Son [Entry 2/3]
1838–1846
Edinburgh
 1838–46 6 George Street
Formerly **Peck, W. & Co.** [1/3]. POD for 1846 lists William and James Peck separately at same address, ap-parently anticipating planned retirement of William when partnership ended. Business was continued by his son, **Peck, James** [3/3].
Art-T-M 1838: Print: 'View and Plan of Parliament Square', artist: McAuley, A. 1845: 'Plan of the Cemetery Grounds on the Estate of Dalry' by Robert Bell [RHP.205/2].

Peck, James [Entry 3/3]
1847–1854
Edinburgh
 1847–53 6 George Street
 1853–54 23 St Andrews Street
The 'Son' of **Peck, W. & Son** [2/3]. Continued the business following the death or retirement of his father. It is possible that this is the same **James Peck** who in 1859 established a lithographic printing business in Glasgow.

Peck, James
1859–1867 or 1886 †
Glasgow
 1859–60 43 Argyle Street
 1860–61 118 Union St. and 246 West Bath Street
 1861–62 246 West Bath Street
 1862–66 364 West Bath Street
 1866–67 204 Dumbarton Road †
 1867–70 no directory entries
 1870–72 82 West Nile Street ‡
 1872–78 33 W Cumberland Street
 1878–85 178 Buchanan Street
 1885–86 205 Hope Street
It is possible that this was **Peck, James** previously of Edinburgh.
† In POD 1866/7 Peck was shown as a draughtsman only at this address. This may have been an indication of his on-coming retirement as a lithographer.
‡ This, followed by three years in which he was unlisted, casts some doubts as to whether the Peck, James who re-appeared in the PODs from 1870 was the same, or per-haps a relation. Listed Slater 1860, but not in PTDs.

Pentland & Son
1861–1862
Glasgow
 1861–62 45 John Street
Engravers and Lithographers. Previously partner in **For-rester & Pentland** at same address.

Pollock, James & Co. [Entry 1/2]
1857–1859
Glasgow
 1857–59 24 Howard Street
1859: Entered partnership **Pollock & Paterson** [2/2].

Pollock & Paterson [Entry 2/2]
1859–1867
Glasgow
 1859–65 42 Argyle Street
 1865–67 31 Argyle Street
Formerly **Pollock, James & Co.** [1/2]. Listed as 'Lithographer and Engraver' in Slater 1860 and PODs, but as 'Lithographer only' in Slater 1867.

Powell & Auld
1867–1872
Edinburgh
 1867–72 30 Hanover Street
Listed Slater 1867. Lithographic and Letterpress Printers specialising in legal and general work.

Pritty, Francis [Entry 1/2]
1844–1866
Glasgow
 1844–66 36 Argyle Arcade
Engraver, Lithographer, Copperplate Printer. Listed Slater 1860 and 1867. Former partner in **M'Donald & Pritty**. Took over business at same site. 1866: Title changed to **Pritty, Francis & Son** [2/2].
Adv: Slater 1860.

Pritty, Francis & Son † [Entry 2/2]
1866–1886
Glasgow
 1866–77 36 Argyle Arcade
 1877–81 44/45 Argyle Arcade
 1881–86 44/45 Argyle Arcade and
 29 Buchanan Street
Engravers and Lithographers. Formerly **Pritty, Francis** [1/2], now in partnership with son. The firm was not listed in PDT 1885.
† It seems that due to space limitations, the '& Son' was omitted in POD listings for 1871 and from 1873 to 1879, wrongly giving impression that son had left the business. The full title was however listed in PTDs for 1872, 1876 and 1880.

Rae & Macaulay
1847–1848
Glasgow
 1847–48 120 Buchanan Street
A short-lived partnership of John Rae and A. Macaulay. 'Lithographers, Engravers and Ornamental Printers.'

Ramage, James
1849–1862
Edinburgh
 1849–54 39 South Bridge Street
 1854–56 Boroughlochhead Cottage
 1856–62 30 Rankeillor Street
Trade section of POD 1849 lists as Engraver only, but as Lithographer and Draughtsman in alphabetical Section. Slater 1860 lists as 'Lithographer' and 'Engraver'. Trained as lithographic artist with Cogars & Co. It is virtually certain that this is the same James Ramage who in 1861/2 became manager of illustrative work at **Thomas Nelson & Sons**. Previously he had acted as one of their sub-contractors for lithographic work. It is also possible that this may have been the Ramage who produced prints of military costumes, described as 'fakes' in R.G. Thorburn, *Introduction to the Index to British Military Costume Prints* (London, 1972). These were adaptations taken from popular sets produced by firms such as Ackermann and Spooners. Ramage was also the artist for views of 'Edinburgh from the Calton Hill' and 'Edinburgh from the Castle' engraved *c.*1865 by J. Bishop and T. Brown.
Art-T-O-Mil? Title page in *The Coronal* and illustrations in *Tales for all Seasons* by Fanny Forester and *The Cousins*, all published in 1850 by Thomas Nelson & Sons. 1852: Lithograph of the 'Wellington Statue' with address 39 South Bridge, Edinburgh.

Rankin, J. & J. [Entry 1/2*]
1840–1842
Glasgow
 1840–42 66 Trongate
It seems likely that financial difficulties forced the firm into equally unsuccessful partnership of **Rankin & Turnbull** [2/2].

Rankin & Turnbull [Entry 2/2*]
1842–1843
Glasgow
 1842–43 65 Jamaica Street

Probably formerly **Rankin, J. & J.** [1/2], although connection unconfirmed.

Reid & Ness
1865–1869
Glasgow

 1865–69 16 St Enoch Square

Slater 1867: Lithographic and Letterpress Printers and Engravers. 1869: Following dissolution of partnership, firm continued as **Ness Brothers**.

Reid, John
1867–1874
Edinburgh

 1867–68 21 South College Street
 1868–69 4 Brighton Street
 1869–70 6 Brighton Street
 1870–72 107 West Bow
 1872–74 12 Blackfriars Street

'Lithographer, Engraver, and Ornamental Printer.' Listed Slater 1867 and PTD 1872.

Renfrew, J. & D.
1870–1871
Glasgow

 1870–71 20 Dixon Road

Rhind, William
1858–1859
Edinburgh

 1858–59 12 Royal Exchange

From 1855 to 1857 this address was occupied by the artistic lithographers **Macpherson, A. & J.**, and from 1862 to 1865 by **Schenck, Friedrich**. Rhind appears to have abandoned lithography from 1860, when he set up business as an Letterpress Printer and Engraver at 66 Nicholson Street. Probably related to lithographer Thomas Rhind, first listed in PTD 1872.

Riley, Alexander
1861–1872
Glasgow

 1861–71 34 Turners Court
 1871–72 39 Maxwell Street

Also wood-type manufacturer. From 1866 listed under 'Lithographers' in POD as 'Riley, Alex, Joiner'.

Ritchie, Hugh H. [Entry 1/4]
1843–1847
Edinburgh

 1843–47 7 Leith Street

POD 1843: 'Engraver, Lithographer, and Copperplate Printer'. 1847: Moved to new location and entered partnership as **Ritchie, H. & A.** [2/4].

Art-P-O 'A Plan of a House & Garden' published in 1844 by John Jeffers Wilson of Kirkcaldy.

Ritchie, Hugh & Alexander [Entry 2/4]
1847–1850
Edinburgh

 1847–50 10 Hanover Street

Formerly **Ritchie Hugh H.** [1/4]. Engravers, Copperplate Printers. When the partnership ended, **Alexander Ritchie** [3/4] started business at new address.

Ritchie, Alexander [Entry 3/4]
1850–1874
Edinburgh

 1850–74 19 South St David Street

Former partner in **H. & A. Ritchie** [2/4]. Listed Slater 1860, 1867, and PTD 1872 as Lithographic Printer and Engraver. Produced a variety of artistic work, and in 1874 took his son into partnership as **Ritchie, Alexander & Son** [4/4].

Art-T-P-M-Mil-O 'Plan of Craigend Estate' from survey in 1841 by J. Livingstone [RHP.503/1]. 'Plan of Lerwick 1849' (survey date.) c.1860 Tinted lithograph, 'Leith Engine Works'. 1861: 'Peace Society' (group.) 1860: 'Royal Volunteer Review in the Queen's Park, Edinburgh by Her Majesty the Queen 7th August 1860'. c.1870: Plan of 'Ardnamurchan (Peninsula, Argyle)' [RHP.3305].

Ritchie, Alexander & Son [Entry 4/4]
1874–20thC
Edinburgh

 1874–76 19 St David's Street
 1876–20thC 51 York Place

Formerly **Ritchie, Alexander** [3/4], Lithographic & Letterpress Printers, Engravers. PTDs 1872–1900.

Art-M-Mil 'Royal Review of Scottish Volunteers by H.M. the Queen in Holyrood Park on 25th August 1881' (Scottish United Services Museum, Edinburgh). 1886: 'Plan of Devon Common, Inverkeithing, Fife' [RHP.3316]. 1886: 'Estate of Crawford Priory, Culross,

Fife' [RHP.3313/1]. 1890: 'Penicuick Estate Plan, showing feus and leaseholds' [RHP.1958].

Robb, George

1867–20thC

Aberdeen

1867–70	20 Correction Wynd
1870–77	115 Union Street
1877– 20thC	13 Adelphi (and No. 14 in 1895)

Engraver, Lithographer and Stationer. Listed PTDs 1876, 1880, 1893 and 1900.

Robertson, John [Entry 1/2]

1820–1823

Edinburgh

1820–23	13 South Union Place

John Robertson was an enterprising and outstanding lithographic printer who, during his career, worked with a number artists of considerable distinction. Originally on his own, and then in partnership with Walter Ballantine, he appears to have achieved a remarkable number of 'firsts' in the history of Scottish printing. Widespread research indicates that he was the first professional lithographic printer to be listed in the directories of Scotland, and the scenes of Perthshire drawn by David Octavius Hill, which Robertson printed in 1821, is generally recognised as the earliest series of views to have been produced in Scotland by the lithographic process. In 1823 Robertson entered partnership as **Robertson & Ballantine** [2/2].

Art-T-M 1821: Lithographed fifteen of the thirty views in *Sketches of Scenery in Perthshire* drawn upon stone by the distinguished artist David Octavius Hill, and published by Thomas Hill, of Perth (see PLATE 4 opposite). The remaining fifteen views were printed by Charles Hullmandel, London (Abbey, *Scenery*, 509). 'Plan shewing Proposed Lines of Railway from Coalfield of Mid Lothian to Rivers Tweed & Leeder', from a survey in 1821 by Robert Stevenson. This is the earliest known map printed in Scotland by the lithographic process (copy in National Library of Scotland, Newman 590).

Robertson & Ballantine [Entry 2/2]

1823–1828

Edinburgh

1823–25	20 Greenside Place †
1825–28	18 Greenside Place

Formerly **Robertson, John** [1/2] now in partnership with Walter Ballantine. Listed Pigot 1825. During a visit to the firm in August 1823, the renowned artist and wood engraver Thomas Bewick was persuaded by John Robertson to draw an image on stone. It was the only lithograph known to have been produced by Bewick (see below). The firm was important as early artistic lithographic printers of a variety of topographical views, portraits and maps. The rare series of four views entitled *Scotia Delineata*, Part I, referred to below, was published in 1824. In spite of the reference to Part I on the upper cover of the folio, no evidence has been found of the existence of any other parts. A copy of the work, may be seen in the National Library of Scotland, FB.l.238. In May 1998 another copy of *Scotia Delineata* fetched £2100 when offered by Bonhams, Knightsbridge in the auction of Part 1 of the famous Winkler Collection of lithographs. Described as 'printed in two colours and finished by hand', it is almost certainly the earliest series of two-colour prints produced in Scotland by the lithographic process. Interestingly, this particular folio contained five views, and included a vivid impression by William Turner de Lond of the 1824 conflagration in Edinburgh. However, this additional view is not thought to be part of the original *Scotia Delineata* folio. In 1824 the firm also produced what is the earliest known lithographed plan of the City of Edinburgh (see below). For reasons unknown John Robertson disappeared from the Edinburgh directories after 1828, but with the sudden ending of the partnership **Ballantine, Walter** [2/2] continued the business.

† This address confirmed by inscriptions on 1824: 'Plan of Edinburgh and Strangers Guide'.

Art-T-P-O-M 21 August 1823: 'The Cadger's Trot' drawn directly onto stone by the distinguished artist Thomas Bewick during a visit to the firm. A rare print, of which only 25 copies were run-off. The scene, depicting a travelling hawker on horseback, may be found in Newcastle City Library, Charnley and Robinson Collection, Vol. 1. Unusually, the inscription 'Sketched by TB at Edinburgh 21 Augt.' appears as a mirror image, suggesting that Bewick added this before Robertson had had an opportunity to instruct him of the need for reversal when writing on stone. 1823: 4 views in *Scotish* (sic) *Scenery Drawn from Nature upon Stone by John Knox* (see Glasgow lithographers **Watson, John** and **Wilson, Hugh** for other views in this important series). 1823: 'The River Tay and adjacent grounds between Castle Menzies and Bolfracks' from a survey undertaken by Jas. Jardine [RHP.963/2]. c.1823: Portrait: 'Mr Denham' (of the Theatre Royal, Edinburgh) by G. M. Mather. 1824: Plan and Measurement of McNab Estate by James

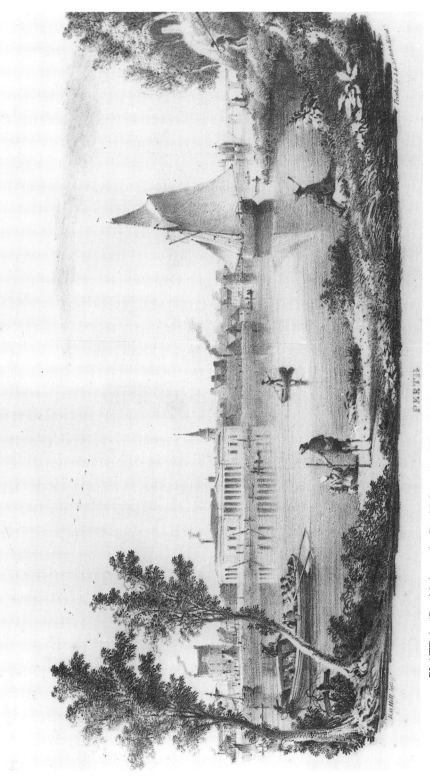

PLATE 4. 'Perth' drawn by David Octavius Hill and lithographed by John Robertson of Edinburgh for Hill's *Sketches of Scenery in Perthshire* (Thomas Hill, Perth, 1821), which is generally believed to have been the earliest series of views printed in Scotland by the lithographic process. Reduced from 193 x 405 mm. (Reproduced by courtesy of Perth Museum and Art Gallery, Perth and Kinross Council, Scotland.)

Robertson [RHP.961/1]. 1824: 'Plan of Edinburgh and Strangers Guide'. 1824: *Scotia Delineata*, Part I, a series of four views inscribed 'Edinburgh, Robertson & Ballantine Lythographia, 1824.' (299 x 485mm). 1824: A series of six views of the Great Fire of Edinburgh on 15/16th November drawn at the scene by William Turner de Lond. Remarkably, the inscription on the scene entitled 'View of the Great Fire of Edinburgh. 1824' shows that it was printed just two days later, on 18 November. This tragic fire started in the establishment of the distinguished engravers, **James Kirkwood & Son**. 1825: Portrait of 'Lord Moncrieff' by the artist William Bewick.

Robertson, John [Entry 1/2]
1847–1848
Glasgow

 1847–48 20 St Enoch Square

Born in Lanarkshire in 1810 and therefore unlikely to be connected with **John Robertson** of Edinburgh. In 1849 moved to a new location and entered the partnership **Robertson, J. & W.** [2/2].

Robertson, J. & W. (& Co. †) [Entry 2/2]
1849–1883
Glasgow

 1849–50 68 Glassford Street
 1850–52 20 Hutcheson Street
 1852–60 36/38 Dunlop Street
 1860–67 221 Buchanan Street
 1867–83 3 Bath Street

Formerly **Robertson, John**, Glasgow [1/2]. Now joined in partnership with William Robertson. Engravers and Lithographers. Listed Slater 1860 and 1867, and PTDs 1872–1880. Census of 1871 shows firm employing 6 men, 1 boy and 15 girls.

† '& Co.' from 1877.

Art-O-M-Adv Printers of Valentine cards. 1852: 'New Map of Glasgow', for Kyle's *Description of Glasgow*, advertised by Morrison Kyle in *Glasgow Herald*, 2 August 1852.

Robin & Logan [Entry 1/3]
1852–1853
Glasgow

 1852–53 107 Buchanan Street

Lithographers and Engravers. Robin believed to have been former partner in **Barr & Robin**. When partnership ended in 1853, **Robin, Thomas** [2/3] continued the busi-

ness. Logan thought to be **Logan, William** who started his own business in 1855.

Robin, Thomas [Entry 2/3]
1853–1855
Glasgow

 1853–55 107 Buchanan Street

'Lithographer and Engraver'. Former partner in **Robin & Logan** [1/3]. 1855: Joined partnership **Robin & Lindsay** [3/3].

Robin & Lindsay [Entry 3/3]
1855–1862
Glasgow

 1855–62 3 Buchanan Street †

Lithographers and Engravers. Formerly **Robin, Thomas** [2/3]. The firm engraved a pictorial map of Glasgow, which they published in 1855 as part of a guide to the city, but no examples of their lithographic work have been traced.

† In 1862 the firm was succeeded at this address by **Miller, J. Davis**.

Rodger, Alexander
– 1846–post-1867
Montrose

 –1846– 47 High Street
 –1860–67+ 62 High Street

Engraver and Lithographic Printer.

Adv: Although the firm advertised in the *Angus & Mearns Directory* 1846, this was an isolated publication; no other relevant directories of that time have been traced to determine the firm's duration. Listed as letterpress printer in Slater 1860, 1867. Not listed PTDs 1872–1900.

Rollo, William L.
1861–1868
Edinburgh

 1861–62 36 Niddry Street
 1862–66 257 High Street
 1866–68 5 St James Square

Listed in PODs as Letterpress Printer only, 'Burghs Reference Newspaper', 'Law and General Printers'. Slater 1867: 'Lithographic and Letterpress Printer'.

Ross, Hugh G. (& Co. †) [Entry 1/2* ‡]
1849–1859

Glasgow

1849–52	126 Queen Street
1852–54	62 Queen Street
1854–57	118 Union Street
1857–59	30 Montrose Street

Lithographer, Engraver, and Letterpress Printer. POD 1858 lists Ross, J. H. at last address, but this is believed to result from printing error.

† '& Co.' added to title in 1855.

‡ In 1866 **Ross, Hugh G.** [2/2] re-appeared in PODs at a new location. Believed to be the same, but unconfirmed.

Ross, Hugh G. [Entry 2/2* †]

1866–1888

Glasgow

1866–70	43 Holmhead Street
1870–71	94 North Frederick Street
1871–88	53 Holmhead Street

Lithographic Printer and Engraver. Also listed as Letterpress Printer from c.1875. Listed in PODs as Ross, H.G. but confirmed as Hugh G. Ross.

† Believed to be same as **Ross, Hugh G.** [1/2] (1849–1855). If so, possibly employed by another firm during interim period 1858–66. Listed PTDs 1872 and 1876 but not Slater 1867.

Ross, J. H.

1858–1859

Glasgow

1858–59	*30 Montrose Street*

Entry in POD 1858 believed to result from printer's error. Should be **Ross, Hugh G.** [1/2 *].

Rowan, Alexander

1859–1864

Glasgow

1859–64	18 Hutcheson Street †

Lithographer and Engraver. Formerly in partnership with Alexander Boag as **Boag and Rowan** at the above address.

† The classified listings show Rowan at No. 13 in POD 1859, and at No. 81 in POD 1860. It is probable that both of these addresses are misprints, and that Rowan remained at the original address, as shown in Slater 1860.

Russell, William

1847–1848

Glasgow

1847–48	46 Gordon Street

Lithographer, Engraver and Letterpress Printer.

Ruthven, James

1842–1844

Edinburgh

1842–44	4 Bank Street

Lithographic and Letterpress Printer. Formerly in partnership **Forrester & Ruthven**, having originally started as a Letterpress Printer at 23 New Street in 1836. Believed to be related to the important manufacturer of printing presses, John Ruthven of Edinburgh. Possibly gaining experience in the printing-trade before joining the family business.

Schenck, Friedrich F.R.S.S.A. [Entry 1/6]

1842–1850

Edinburgh

1842–50	9 Greenside Place

Emil Ernst Friedrich Theodor Schenck, *b.* Offenbach 1811, *d.* Edinburgh 1885. Following education at University of Marburg, trained as artist and lithographer in Munich and Paris. 1840: Brought, with lithographic printer W. Wahler, to Edinburgh by **Samuel Leith**. In 1842 he married Jane, daughter of the Orcadian poet and author, David Vedder (see *DNB*). In the same year he left Leith's business and set up own lithographic establishment, which included an atelier to encourage both professional and amateur artists to draw on stone. Presented several papers and demonstrations on progress of lithography to Royal Scottish Society of Arts, and was later awarded Gold Medal for contribution to development of lithography in Scotland. This included introduction of cross-line system of registration, demonstrated at R.S.S.A. meeting in February 1848. Considered by authors Bigmore and Wyman to be 'second to none in production of chalk portraiture'. In 1848 entered 'informal partnership' with lithographic artist Louis Ghémar, as **Schenck & Ghémar** [2/6]. In 1850 entered partnership **Schenck & Macfarlane** [3/6].

Art-T-P-M-Mil-O-C-Inv-Tre-ms-Adv 1843: Tinted lithos in J.D. Forbes, *Travel through the Alps of Savoy* (Edinburgh, 1843); a 2nd edition, Edinburgh, 1845, was listed in Abbey, *Travel*, 62. *c.*1844: Portrait: 'Professor Sir R. Christison', artist: W. Stewart. 1845: Frontispieces and several plates for Vols. 1 & 2 of *Registrum Episcopatis Aberdonensis*, published by Spalding Club. 1846: 'Plan of Grounds of Murdostoun,

Lanark' (Glasgow Archives). 1847: A bookplate, 'Scottish Institution for the Education of Young Ladies', artist Fr. Schenck. *c.*1847: 'Aurora Borealis' by W.H. Townsend. *c.*1845: Artistic advertisement (see PLATE 5 opposite), in 'Album of Kenneth MacLeay', National Gallery of Scotland.

Schenck & Ghémar [Entry 2/6]
1848–1850
Edinburgh

 1848–50 9 Greenside Place

The combined names of Schenck & Ghémar appear on a number of prints for which Ghémar was the lithographic artist, and in connection with an invention concerning lithographic drawing techniques submitted jointly by Schenck & Ghémar to the Royal Scottish Society of Arts in August 1849. This 'partnership' was an informal arrangement, the title of the firm remaining unchanged as **Friedrich Schenck** [1/6]. Louis Joseph Ghémar (*b.* Lannoy 1820, *d.* Brussels 1875) was a highly accomplished and versatile artist, who also worked in oils and watercolours. He continued with the firm after the commencement of the **Schenck & Macfarlane** [3/6] partnership in 1850, and is believed to have returned to Belgium around 1856.

Art-T-P-Mil-Inv-ms *c.*1848: 'The House of John Knox', 'drawn and lithogd. by L. Ghémar.' *c.*1848: Portrait of the Perthshire fiddler 'Neil Gow' (after Henry Raeburn), artist: Louis Ghémar. *c.*1849: 'View of Anstruther', after painting by J. Stark, artist: Louis Ghémar. *c.*1848: 'Royal Midlothian Yeomanry Cavalry', one of a group of lithographed plates listed under Entry no. 358 'Mercer Grant's Scottish Yeomanry Cavalry' in *Index to British Military Costumes 1500–1914* (Army Museums Ogilby Trust, London, 1972). Following a quotation submitted in 1848, Schenck & Ghémar were commissioned by Sir William Drummond Stewart to produce a folio size book illustrating *The Chapel of St Anthony the Eremite, at Murthly, Perthshire*. This magnificent building was designed by the distinguished architect James Gillespie Graham, and decorated internally with paintings by Alexander Christie A.R.S.A. Built at enormous cost on Sir William's property, the Chapel was first used for worship on 1 November 1846. In reviewing the illustrations, the London *Art Journal* commented 'The latter are executed in chromolithography, and are very fine specimens of this art; the large plate shewing the altar and altar-piece of *The Vision of St Constantine* is one of the richest examples of coloured printing we have ever seen.'

Apart from one illustration, completion of this work by Schenck & Ghémar actually coincided with the change in partnership, so that when it was privately published in 1850, it was under the Schenck & Macfarlane name. Copies of this important work are held in the National Library of Scotland (two copies: BCL.C43 and BCL.C50) and the Royal Institute of British Architects, London.

Schenck & Macfarlane [Entry 3/6]
1850–1871 †
Edinburgh

 1850–61 19 St James Square
 1861–71 14 & 19 St James Square

Lithographic Printers, Engravers from *c.*1855, and Letterpress Printers from 1866. Listed Slater 1860, 1867, PTD 1872. Formerly **Schenck, Friedrich** [1/6]. Now in partnership with *William Husband Macfarlane*. The firm achieved considerable distinction for the quality and variety of its artistic work. In 1857 Schenck wrote the entry for 'Lithography' in the *Encyclopaedia Britannica*, 8th edition. When the partnership was dissolved in 1859, Friedrich Schenck [4/6] re-established his own business.

† William Macfarlane continued at the same address, retaining, by agreement, the existing Schenck & Macfarlane title. However, due to restrictions in the dissolution agreement, William Macfarlane produced a number of works between 1859 and 1871 in which the inscription of the firm's title was abbreviated to *Macfarlane, W. H.*; examples will be found under *Macfarlane, William Husband*. In 1871 Macfarlane entered partnership with William Erskine as **Macfarlane & Erskine**.

Art-T-P-M-O-Tre-ms *c.*1850: Chromolithographed a series of six panoramic views from the Scott Monument, Edinburgh, artist: James Gordon *junior*. 1851: Portrait 'Thomas Faed' (later R.S.A., and R.A. 1862) by Belgian artist, Louis Ghémar. *c.*1851: 'Rev. John Brown', artist: Wilhelm Trautschold. 1852: 'View of St. Andrews from the West Sands' after John Beugo. 1852: Illustrations in David Vedder, *Story of Reynard the Fox*, drawn by Gustav Canton of Munich. MS letter of appreciation dated 25 October 1852 from Sir Edwin Landseer to Schenck & Macfarlane. 1856: 'Plan of the Burgh of Portobello' from survey by Archibald Sutter C.E. [RHP.2812]. 1860/1: Portrait: 'Rev. William Mackelvie D.D. of Balgeddie' drawn on stone by C. Schacher. 1871: Portrait of 'James Paterson' (writer of text for *Kay's Portraits*) from his *Autobiographical Reminiscences*, to which further reference is made under **Macfarlane & Erskine**.

PLATE 5. Trade advertisement believed to be the first published by Friedrich Schenck of Edinburgh, *c.*1845. Reduced from 240 x 197 mm. (National Gallery of Scotland, Kenneth MacLeay Album, D4874, f.16 verso.)

Schenck, Friedrich F.R.S.S.A. [Entry 4/6]
1859–1866
Edinburgh
1859–62	50 George Street
1862–66	12 Royal Exchange

Listed POD 1860 and Slater 1860 as Lithographer and Engraver. Formerly senior partner **Schenck & Macfarlane** [3/6]. Now largely specialising in artistic work, especially chalk portraiture in collaboration with artist, Otto Leyde. 1862: Following serious financial difficulties, moved to 12 Royal Exchange. 1866: Entered partnership **Schenck & Son** [5/6] at new address.

Art-T-P-M c.1859: Portrait 'Robert Burns', artist: Otto Leyde. 1860: 'Sir Thomas MakDougal Brisbane' from an 1848 painting by Sir John W. Gordon. 1860: Print 'The Memorial of the Grand Review of the Derbyshire Volunteers in Chatsworth Park' drawn on stone by J.A. Warwick after James Gordon. 1860: 'View of Thurso, from Oldfield', artist: W. Warner Scott. 1860: 52 maps in *Black's General Atlas of the World* (Edinburgh: A. & C. Black, 1860). 1862: Plan of the Grounds at Scrabster Harbour, Thurso, by W. Bell [RHP.1731]. c.1864: 'Facsimile of the National Covenant of Scotland of 1638 in its original form'. Printed in black and terracotta (National Library of Scotland). 1865: Views of 'Kennoway Den' and 'Leven' in Part 6 of Thomas Rodger, *The Kingdom of Fife* (Cupar, 1865).

Schenck, Friedrich & Son [Entry 5/6]
1866–1868
Edinburgh
1866–67	11 Hanover Street
1867–68	8 S. St Andrew Street

'Artist-Lithographers'. Formerly **Schenck, Friedrich** [4/6], now in partnership with his son Frederick. Listed Slater 1867. The partnership ended in 1868 to enable Frederick to pursue art studies under the direction of Clark Stanton R.S.A. (He later achieved distinction, firstly as a designer and modeller in the Potteries, and, from 1888, as an architectural sculptor in London. His many works included the sculpture 'Peace' on *The Scotsman* building). 1868: **Schenck, Friedrich** [6/6] continued the business.

Art-P-ms Portraits of 'Archbishop C. Swinton' by artist, James R. Swinton (c.1867), and in 1867 '15th Baron Elphinstone' by Colin Smith. MS 17 Dec. 1867 – Estimate for portrait of 'Donald Horne of Langwell'.

Schenck, Friedrich F.R.S.S.A. [Entry 6/6]
1868–1875
Edinburgh
1868–70	8 S. St Andrews Street
1870–74	11 Lothian Street
1874–75	3 Castle Street

Formerly in partnership **Schenck & Son** [5/6]. Friedrich Schenck's last traced work was in 1875. He retired in the same year, and at his home in Castle Street took to teaching German and French, and writing, which he continued until his death in 1885.

Art-T-P-O-M c.1870: 'Fac-simile of the National Covenant of Scotland in its original form, with the autographs of the principal leading personages' published by John Henderson, Edinburgh. Lithographed on Vellum 851 x 634mm. 1870: Portraits: 'Dr Knox.' 1871: 'James, Lord Moncrieff' 1875: 'Charter of King David II, 1356', 'The Charter of King Robert II, 1372', and 'The Charter of King James II, 1454, under the General Index to the Acts of the Parliaments of Scotland 1875'.

Schoenberg, Louis
c.1825–1833 †
Aberdeen
c.1825–33	10 Belmont Street
1833–34	83 Union Street †
1834	Moved to London
1835	19 Great George St., London

Following immigration, settled in Aberdeen where he combined lithography and copperplate printing with teaching of languages. Moved to London in 1835, where he established lithographic business. Listed by M. Twyman, *A Directory of London Lithographic Printers 1800–1850*; I. Beavan, '19th Century Book Trade in Aberdeen' (Aberdeen University Ph.D. thesis, 1992).
† Appeared as teacher only at this address

Art-T-M-Inv 1825: A view of 'King's College, Aberdeen' published as frontispiece in *Aberdeen Censor*, vol. 1. 1836: Map: 'Bealadangan. 1836. Being a Plan of the Upper and Lower Passes of Bealadangan in the County of Galway, showing the improvements made in the year 1836' (House of Commons Papers, Session 1837, vol. 33, p.277). Schoenberg was also credited with the invention of 'acrography', a process for making relief blocks.

Scott, Alexander [Entry 1/3]
1850–1852

Edinburgh

 1850–52 11 S. St Andrew Street

Originally an Engraver and Copperplate Printer, Scott was listed as a lithographer when he acquired the highly distinguished engraving and lithographic business of **James Kirkwood & Son**. In 1852 Scott entered partnership **Scott & Ferguson** [2/3].

Art-M 1850: 'Plan of Property bounded by Queen Street and Hill Street, Edinburgh' [RHP.267].

Scott & Ferguson (& Burness †) [Entry 2/3]

1852–1900 ‡

Edinburgh

1852–60	11 S. St Andrew Street
1860–68	63 Princes Street
1868–76	14 N. St Andrew Street
1876–84	18 Clyde Street
1884–89	18 Clyde Street and
	2 N. St Andrew Street
1889–96	14/16/18 Clyde Street
1896–1900	14/16/18 Clyde Street
	(Morrison & Gibb Limited
	Tanfield, and 11 Queen Street)

Following his succession to the business of **James Kirkwood & Son**, **Alexander Scott** [1/3] entered the successful partnership of Scott & Ferguson. The firm is known to have engraved a number of artistic bookplates in the 1850s. Listed Slater 1860, 1867 and PTDs 1872, 1876, 1880, 1885, and 1889. A firm briefly trading in Glasgow, 1872–1873, as **Scott & Ferguson** [3/3] was apparently intended as a branch of the Edinburgh-based business.

† PTD listing for 1893 shows **Scott & Ferguson & Burness**. Although this title is not listed in the PODs, the firm of **Burness & Co.** occupied the same address, and it appears that the two firms had amalgamated.

‡ Between 1896 and 1900 both Scott & Ferguson and Burness & Co. were acquired by Morrison & Gibb, who achieved great distinction as book-printers in the 20th century.

Art-Mil-M 1882: Chromolithographed illustrations of uniforms in R.C. Dudgeon, *History of the Queen's Light Infantry Militia* (Blackwood). 1884: 'Plan of Estate of Cromar', revised from O.S. map by Lindsay, Jamieson & Haldane [RHP.4105]. 1897: 'Plan of Dundee Harbour' from the survey by G.C. Buchanan [RHP.3008]. 1897: 'Plan of Blacklaw' (Marnoch, Banffshire) [RHP.4135].

Scott & Ferguson [Entry 3/3*]

1872–1873

Glasgow

 1872–73 14 North Street

Apparently intended as a branch of **Scott & Ferguson** [2/3], Edinburgh, whose address was also included in POD entry. Presumably unsuccessful, as discontinued within the year. Not listed PTD 1872.

Scott, David

1883–*c*.1895

Peterhead

 1883–89 Peterhead Sentinel Office

 1889–*c*.95 14 St Andrews Street

1866: Took over *Peterhead Sentinel*. Earliest traced example of lithographic work 1883. PTDs 1889, 1893.

Art-P-O n.d. Portrait: 'Arthur Rankin' by J. G. Murray. 1887: Illustrations in *Grass of Parnassus from the Bents o' Buchan*.

Scott, John

1854–1868

Glasgow

 1854–68 145 Argyle Street †

Previously listed as an Engraver and Copperplate Printer at 15 Hutcheson Street in 1835, 10 Jamaica Street in 1840, and as an Engraver and Letterpress Printer at 74 Argyle Street in 1846. 1854: Moved to 145 Argyle Street, where he succeeded to the lithographic business of **Kerr, James**. In 1868 Scott was succeeded at this address by **Stewart, John**.

† Slater lists at 3 St. Enoch Lane in 1860, and 1 St. Enoch Lane in 1867: probably additional addresses, not in PODs.

Scott, Malcolm

1839–1841

Glasgow

 1839–41 3 St Enoch Square

Scott, Walter

1868–1872

Glasgow

1868–69	93 Hill Street, Garneth
1869–71	7 Argyle Street
1871–72	253 Argyle Street

Engraver and Lithographer.

Seaton, J. & R. [Entry 1/2]
1852–1856
Glasgow
 1852–55 4 Dunlop Street
 1855–56 no directory entry
Also Engraver. 1855: R. Seaton appears to have left business. 1856: Business re-established under new title of **Seaton, John & Co.** [2/2].

Seaton, John & Co. [Entry 2/2]
1856–20thC
Glasgow
 1856–59 61 Miller Street
 1859–73 14 Maxwell Street
 1873–79 22 Ann Street
 1879–98 83 Dunlop Street
 1898–20thC 43 Mitchell Street
Also Engraver. Added Letterpress from c.1880. Previously **Seaton, J. & R.** [1/2]. Slater 1860, 1867, and PTDs 1872–1900. 1889: 'Colour printers'.

Selanders, David
1852–1853
Glasgow
 1852–53 24 Hutcheson Street
Engraver and Lithographer.

Shearer, Andrew
1869–1876
Glasgow
 1869–76 31 Argyle Street
Engraver and Lithographer.

Shirreffs & Nicol [Entry 1/2]
1858–1860
Aberdeen
 1858–60 56 Broad Street
'Lithographers, Engravers and Ornamental Printers.' In 1860 Shirreffs was listed simply as 'Precentor of South Parish Church'. In 1861 **Alexander B. Shirreffs** [2/2] established his own business.
Adv: *Aberdeen Directory* 1858 and 1859.

Shirreffs, Alexander B. [Entry 2/2]
1861–68
Aberdeen
 1861–68 2 Longacre

'Lithographer.' Former partner **Shirreffs & Nicol** [1/2]. Abandoned printing trade in 1868, and was subsequently engaged in clerical work.

Sim, Alexander [Entry 1/2]
pre-1866–1873
Inverness
 <1866–c.69 9 Church Road
 c.1869–73 41 Bridge Street
Engraver & Lithographer. 1866 is earliest directory traced for Inverness. Listed PTD 1872. 1873: Took son into partnership trading as **Sim, Alexander & Son** [2/2].

Sim, Alexander & Son [Entry 2/2]
1873–1877
Inverness
 1873–77 4 Bridge Street
Engravers, Lithographic Printers, Stationers. Formerly **Sim, Alexander** [1/2]. Listed PTD 1876.
Adv: Business offered for sale in *Inverness Advertiser*, 6 March 1877. Advertisement 30 March 1877: Business purchased by **Milne, Sim**.

Simpson, David Cumming (& Co.†)
1866–1889
Edinburgh
 1866–77 29 Elder Street
 1877–78 7 & 8 York Lane
 1878–83 6, 7 & 8 York Lane
 1883–86 26 Montrose Terrace
 1886–87 57 York Place
 1887–89 8 St James Place
Previously Engraver only since 1860, now added Lithography. Listed Slater 1867, PTDs 1872, 1876, 1880, 1885.
† '& Co.' from 1886.

Skene, James
1820 and 1823
Edinburgh
 1820 126 Princes Street
 1823 126 Princes Street
b. Rubislaw, Aberdeen 1775, *d.* Oxford 1864. A barrister by profession. Although an amateur, James Skene was also, arguably, the finest artist of ancient and historic topographical scenes in Scotland. By 1820 he had already produced more than 100 drawings, when his close friend and fellow barrister, the renowned poet and writer

Walter Scott, suggested that they collaborate in the production of a series of views drawn on stone by Skene, with descriptive text to be provided by Scott. The work was to be published under the title *Reekiana*. In August 1820 Skene sent his first experimental print to Scott. Although Scott was highly enthusiastic, the project was delayed when Skene was forced to live abroad, due to the ill-health of his wife. On his return in 1823, Skene drew further views on stone, which were printed by an unknown lithographer. At this point the project was abandoned, due partly to Scott's historic financial crisis and partly to the withdrawal of support from the publishers in the face of competitive publications. Had this project been launched in 1820 as originally planned, it would have been the earliest series of lithographed views to be published in Scotland, and, due to the distinction of the collaborators, greatly prized.

Art-T 1820: Experimental print, title unknown. 1823: 'Haddo's Hole' and 'Cardinal Beaton's Palace', both originally drawn by Skene in 1818, and 'Regent Murray's House' drawn in 1821, all printed by an unnamed lithographer in 1823.

Skene, William
1868–1886
Aberdeen

1868–70	74 Union Street
1870–79	21½ School Hill
1879–81	236½ George Street
1881–84	36 Gallowgate
1884–85	106 Gallowgate
1885–86	26 Queen Street

Engraver, Lithographer and Ornamental Printer. Listed PTDs 1876, 1880, but not 1885.

Sloane & Drummond
1861–1867
Glasgow

1861–62	41 Albion Street
1862–67	118 Union Street

Also Engraver from 1862. Listed Slater 1867.

Smart, Robert C.
1840–1864
Edinburgh

1840–64	20 Elm Row

Previously Engraver and Copperplate Printer at this address from 1830. Listed Pigot 1837. Listed Lithographer in POD 1840, also in Slater 1860.

Smeal, James G.
1866–1874
Glasgow

1866–69	190 Trongate
1869–72	28 St Enoch Square
1872–73	40 Union Street
1873–74	36 Renfield Street

Slater 1867: Lithographic Printer and Writer.

Smellie, William
1867–1885
Glasgow

1867–70	118 Union Street
1870–72	45 Gordon Street
1872–74	6 Hope Street
1874–75	11 Dundas Street
1875–85	74 Glassford Street

Lithographer and Engraver. Listed PTD 1872 only.

Smith, Andrew
1834–1841
Glasgow

1834–35	153 Trongate
1835–37	17 Trongate
1837–40	19 Saltmarket
1840–41	17 Nelson Street

Lithographic Printer and Engraver. Listed only as lithographer in Pigot 1837.

Smith Brothers
1859–1860
Glasgow

1859–60	20 Union Street

Smith Brothers
*c.*1865–20thC
Kilmarnock

*c.*1865–72	30 King Street
1872–84	30 King Street and Croft Street Hall (Printing Works)
1884–20thC	30 King Street, and Market Lane, and Braefoot (Printing Works)

Lithographers, letterpress printers, engravers, paper rulers and bookbinders. Enterprising and successful business. Listed Slater 1867, and PTDs 1872–1900.

Adv: The firm advertised capability in artistic work and heraldry in PODs 1884 and 1887.

Smith Brothers [Entry 1/4]
1854–1857
Edinburgh
 1854–57 25 North Bridge
'Window Ticket and Showcard Printers, Engravers, Lithographers.' 1857: Partnership ended, but **Smith, Harry W.** [2/4] continued the business.

Smith, Harry W. [Entry 2/4]
1857–1865
Edinburgh
 1857–59 25 North Bridge
 1859–65 102 South Bridge
Also Engraver. Former partner in **Smith Brothers**, Edinburgh [1/4]. Listed Slater 1860. 1865: Entered partnership **Smith & Brown** [3/4].

Smith & Brown [Entry 3/4]
1865–1878
Edinburgh
 1865–67 32 Cockburn Street
 1867–68 20 & 32 Cockburn Street and
 102 South Bridge
 1868–72 Amphion Place
 1872–74 40/42 N. Back of Canongate
 1874–78 40/42 N. Back of Canongate and
 31 North Bridge
Slater 1867: Lithographic and Letterpress Printers and Engravers. Also manufacturing stationers and ticket writers. Previously **Harry W. Smith** [2/4]. Smith & Brown also listed in PTDs 1872, 1876 and, erroneously, in 1880. PODs indicate that the partnership ended in 1878 when firm was re-titled **Smith & Ritchie** [4/4] and continued at last of above addresses.

Smith & Ritchie [Entry 4/4]
1878–20thC
Edinburgh
 1878–80 31 North Bridge and
 40 North Back Canongate
 1880–81 40 North Back Canongate
 1881–20thC 71 Albert Street (Amphion Works)
Also Engravers and Letterpress. Previously **Smith & Brown** [3/4]. PTDs 1885, 1889, 1893, 1900.

Smith, J.
1843–1844

Glasgow
 1843–44 5 Brunswick Place
Previously listed in 1842 as Engraver only. Possibly the engraver (c.1835) of the view 'Edinburgh from St. Anthony's Chapel' after a painting by J.C. Brown.

Smith, John & William [Entry 1/3*]
(Also known as 'Messrs Smith')
1834–1835
Edinburgh
 1834–35 1 Thistle Street
POD 1834 lists as Lithographic Printers only. The second partner, **William Smith** [3/3], was separately listed as a 'Writing Master' at the above address. Trading ceased in 1835, when John and William joined the partnership of **Leith and Smith**. Both **John Smith** [2/3] and **William Smith** [3/3] were later to appear in their own businesses. Also note the entry for **Smith, William junior**, who was probably a relation.
Art-T 1834/5: 'Messrs Smith' lithographed the outline Views 31–42 in E.C.C. [i.e. Mrs Robert Campbell], *Scottish Scenery: Sketches from Nature*, Parts 6 and 7; for other parts see **Bell & Co.**, **Forrester & Nichol**, and **Nimmo, R. H.**

Smith, John [Entry 2/3*]
1840–1848
Edinburgh
 1840–48 30 Hanover Street
Firstly in partnership **Smith, J. & W.** [1/3], then partner in **Leith & Smith** (1835–1840). Succeeded to the business when Samuel Leith left to set up new lithographic office. Undertook variety of artistic works, and was sometimes referred to as 'the John Smith of Edinburgh'. Also shown at the address is the Writing-Master William Smith. When John Smith retired in 1848, he was succeeded at 30 Hanover Street by **Nichol, William**. **William Smith** [3/3] then established his own business.
Art-T-P-M Portrait: n.d. 'William Hunter M.D.' after Joshua Reynolds. 'Plan of Estate of Elphinstone' after a survey in 1843 by John Lauder [RHP.1247]. Map of 'Dunbar Harbour' after a survey in 1844.

Smith, William [Entry 3/3*]
1848–1881
Edinburgh
 1848–56 1 Hanover Street
 1856–81 43 Northumberland Street

William Smith first appeared as a Writing Master in the partnership **Smith, J. & W.** When John Smith entered partnership of **Leith & Smith** in 1835, William remained with the firm and may also have been a partner. In 1840, when **John Smith** [3/3] succeeded to Samuel Leith's business, William continued with the firm until John retired in 1848, and then established his own business as a Lithographer and Writing Master. PODs 1850–55 list as Lithographer and Engraver, but it appears he may have abandoned engraving between 1856 and c.1875. Listed Slater 1860, 1867, and PTDs 1876 and 1880.

Art-M 'Plan of Vale of Devon Railway, near Stirling 1857.'

Smith, Thomas (& Co. †)

1855–1884

Glasgow

1855–58	42 Argyle Street
1858–66	52 Argyle Street
1866–79	257 Argyle Street
1879–82	9 Madeira Court and 257 Argyle Street
1882–84	India Court and 22 Hope Street

Adv: Advertised in POD 1854, being listed as 'Printer' only. POD 1855: Engraver, Lithographic and Letterpress Printer. Listed Slater 1860, 1867, and Slater 1880.

† 1871: Title changed to Thomas Smith & Co.

Smith, William Adamson [Entry 1/3]

1853–1872

Glasgow

1853–56	59 St Vincent Street
1856–72	57 West Nile Street

Former partner in **Mack & Smith** 1840–53. Engraver and Lithographer. Listed Slater 1860. PTD 1872 lists as Smith, William 'Alexander', but PTDs 1885, 1889 and 1893 list as 'Smith, William Adamson', which is believed correct. 1872: Entered partnership **Smith & Hamilton** [2/3].

Smith, W.A. & Hamilton [Entry 2/3]

1872–1881 †

Glasgow

1872–81	57 West Nile Street

Engravers and Lithographers. Formerly **Smith, William Adamson** [1/2]. Listed PTD 1872, 1876, and 1880. When partnership with Hamilton ended in 1881, business was continued by **Smith, W.A.** [3/3].

† POD first lists Smith in partnership **Smith & Hamilton** [2/3] in 1874, but this partnership is previously listed in the PTD of 1872.

Smith, William Adamson [Entry 3/3]

1881–1892

Glasgow

1881–92	57 West Nile Street

Listed as Engraver and Lithographer. Previously partner in **Smith & Hamilton** [2/3]. Remembered by **Thomas Murdoch** as a conscientious and hard working craftsman, who spent more than 50 years on the bench. PTDs 1885, 1889 and 1893.

Smith, William *Jun.*

1834–1839

Edinburgh

1834–35	14 Leith Terrace	†
1835–39	17 Hanover Street	‡

POD 1834 lists as 'Lithographic Establishment'. POD 1835 lists as 'Lithographer and Engraver'. Believed related to the partners **John & William Smith**. See also entry for **William Smith & Co.**

† Address formerly occupied by **Ballantine, Walter**.

‡ Pigot 1837 conflicts with POD showing address as 17 Rose Street.

Art-M-Adv 'Plan of the Lands of the Burn and Arnhall, Fettercairn', from a survey in 1819 by George McWilliam [RHP.3712]. Advertisement in POD of 1835 suggests intended involvement in artistic engraving and lithography.

Smith, William & Co.

1858–1865

Edinburgh

1858–65	9 S St Andrew Street

Successors to **Fairbairn & Hogg**. Entries in PODs refer only to 'Printers', but Slater 1860 lists as Letterpress and Lithographic Printers. Possibly a re-emergence of **Smith, William *jun.***

Sohns, Frederick

1866–1868

Edinburgh

1866–68	60 Frederick Street

Previously Draughtsman since 1861. Engraver and Lithographic Printer. Listed Slater 1867.

Somers & Dishart [Entry 1/2]

1868–1870

Glasgow

 1868–70 52 Argyle Street

Lithographic and Letterpress Printers. After ending of partnership, **Somers, J.** [2/2] set up new business.

Somers, John [Entry 2/2]

1872–1900

Glasgow

 1872–74 90 Maxwell Street

 1874–81 75 East Howard Street

 1881–1900 47 York Street

Former partner **Somers & Dishart** [1/2]. Also Letterpress Printer. Listed PTDs 1885–1900.

Somerville & Co.

1847–1848

Glasgow

 1847–48 29 Brunswick Place and

 Crown Street, Gorbals

No further trace under this title, but may connect with **Somerville, Robert**.

Somerville, Robert

1855–1878

Glasgow

 1855–58 430 Argyle Street

 1859–60 no directory entry – moving

 1860–73 21 Argyle Street

 1873–74 62 Argyle Street

 1874–75 118 Union Street

 1875–76 17 Gordon Street

 1876–77 40 Union Street

 1877–78 45 Union Street

Not listed as Lithographer in trade section of PODs between 1857/8 and 1870, but shown as Lithographer and Engraver in Slater 1860, 1867. Also listed PTDs 1872 and 1876.

Spence, Henry

1856–1859

Glasgow

 1856–57 9 Gordon Street

 1857–58 17 Nicholson Street

 1858–59 9 Gordon Street

Listed as Lithographic Writer.

Steam Lithographing & Printing Co.

1864–1870

Edinburgh

 1864–70 11 North College Street

Slater 1867: Lithographic and Letterpress Printers. Not trade-listed in PODs.

Steel, A. & Co.

1864–1872

Glasgow

 1864–66 95 Hutcheson Street

 1866–71 79 Mitchell Street

 1871–72 82 Mitchell Street

Former partner in **Littlejohn & Steel** at 95 Hutcheson Street. Also Engraver, Embosser, and Draughtsman. Possibly connected with **Steel, Alexander**. Listed in Slater 1867, but not in PTD 1872.

Steel, Alexander

1865–1867

Glasgow

 1865–66 4 St Enochs Wynd

 1866–67 51 High Street

Also Letterpress. May connect with **Steel, A. & Co.** From c.1867 may also have been partner in letterpress printers Steel & Craig.

Stephen, Kerr

–1846–

Montrose

 –1846– 123 High Street

The *Angus and Mearns Directory* 1846 was an isolated publication, and no other directories of that time have been traced to determine the firm's duration.

Adv: The firm advertised in the 1846 *Directory* as 'Bookseller, Stationer, Lithographic and Letterpress Printing and Paper-Ruling'.

Steven, James

1850–1852

Glasgow

 1850–52 Sidney Court, 62 Argyle Street

Steven, Robert Mure [Entry 1/2]

1852–1860

Glasgow

 1852–54 16 Montrose Street

 1854–60 16 Montrose Street and 118 George St.

Engraver and Lithographer. 1860: Entered partnership with son as **Steven, Robert M. & Son** [2/2].

Steven, Robert Mure & Son [Entry 2/2]
1860–20thC
Glasgow

1860–64	15 Cochran Street and 118 George Street
1864–65	9 Cochran Street and 118 George Street
1865–73	21 Montrose Street
1873–75	30 Montrose Street
1875–77	21 Grafton Street
1877–79	30 Montrose Street
1879–83	76 Ingram Street
1883–20thC	176 Ingram Street

Formerly, **Steven, Robert Mure** [1/2]. Engravers and Lithographers. Added Letterpress c.1873. Listed Slater 1860, 1867, and PTDs 1872 to 20thC.

Stevenson, James
1850–1874
Aberdeen

1850–74	6 Queen Street

Previously an Engraver only; now added Lithographic Printing. Listed in PTD 1872, which also lists **Dakers, Alexander** at this address.

Stewart & Love
1843–1844
Glasgow

1843–44	59 Hutcheson Street

Pattern Book and Card Maker, and Lithographer.

Stewart, Adam
1867
Glasgow

1867	13 Argyle Street

Listed Slater 1867 as Lithographer. No trace of name found in any POD, suggesting project soon abandoned.

Stewart, Charles & Co.
1861–1881 †
Glasgow

1861–70	119 Virginia Place
1870–75	119 Virginia Place and 111 Ingram Street
1875–81	119 Virginia Place

Lithographers and Engravers. Listed Slater 1867, PTDs 1872, 1876, 1880 and 1885.

† Entry in PTD 1885 probably erroneous, as POD entries ended in 1880/1.

Stewart, George & Co.
1879–20thC
Edinburgh

1879–20thC	92 George Street

George Stewart (*b.* Dundee 1834, *d.* 8 November 1901) started his business life with the well-known Dundee printer and bookseller **James Chalmers**. Having come to Edinburgh in 1855, Stewart played an active role in the management of **George Waterston & Son**, becoming a partner in the firm in 1869. Due, it is believed, to the refusal of the Waterstons to allow Stewart's son to join the business, Stewart left the partnership, and in 1879 started his own business as 'Lithographers, Engravers and Manufacturing Stationers'. Listed POD 1879. Listed Letterpress in 1895. Sadly, most of the firm's archival records were destroyed in a fire at 92 George Street in the 1950s. Following successful production of notepaper with illustrated headings, the firm took advantage of the easing of the postal requirements in 1894, and became one of the first in Britain to pioneer the printing of picture postcards, firstly from process blocks, and then by lithographic printing. The company is one of comparatively few early businesses to have successfully survived the dramatic upheavals in the printing industry. Now trading as Geo. Stewart & Co., Ltd., the firm is located in Marionville Road, Edinburgh, where it specialises in high quality promotional colour printing and stationery.

Art-T-O-Adv *c.*1895: Introduced production of a wide variety of postcards, and of attractive playing cards by *c.*1900. Regular advertiser in 19th century PODs.

Stewart, John
1868–20thC
Glasgow

1868–75	145 Argyle Street †
1875–76	no directory entry
1876–77	59 Union Street
1877–20thC	33 Renfield Street

Engraver and Lithographer. Also listed as Letterpress Printer from *c.*1885.

† Succeeded **Scott, John** at this address.

Stewart, Robert
1858–1876
Glasgow

1858–76	59 Hope Street

Listed PTD 1872. Trade-listing as a Letterpress Printer in POD 1860 may be erroneous, and is not confirmed by PODs 1865, 1870, PTDs or Slater.

Stewart, William (& Co. †)
1849–1870
Glasgow
 1849–70 255 George Street
Lithographer only, specialising in production of Pattern Books. Listed Slater 1860.
† '& Co.' from 1852.

Stirrat, J.C.
1868–1870
Glasgow
 1868–70 9 Buckingham Square, Govan
J.C. Stirrat advertised his services as 'Draughtsman for' (Lithographers) under trade heading for Lithographic Printers in PODs of 1868 and 1869. It seems likely that he then became a partner in **Strathern & Stirrat**.

Stranack & Stewart
1829–1829
Aberdeen
 1829 only Chronicle Court, 10 Queen Street
Partnership appears to have failed within first year, although Stranack continued alone for a few months. The premises were jointly occupied by a business listed solely as the **'Lithographic Printing Office'**. No evidence was found of any connection with Stranack & Stewart. See Iain Beavan, '19th Century Book Trade in Aberdeen' (Aberdeen University Ph.D. thesis, 1992).

Strathern & Stirrat [Entry 1/3]
1870–1872
Glasgow
 1870–72 33 Renfield Street
Lithographers, and Engravers in metal and wood. Believed to be partnership of **Stirrat, J.C.** and **John Strathern**. In 1872 Strathern entered new partnership of **Strathern, J. & A.F.** [2/3].

Strathern, J. & A.F. [Entry 2/3]
1872–1881
Glasgow
 1872–73 33 Renfield Street
 1873–81 153 West Nile Street
Lithographic and Letterpress Printers, and Engravers in

metal and wood. Partnership of John Strathern, former partner in **Strathern and Stirrat** [1/3], and Alexander F. Strathern. Following dissolution in 1881, Alexander started new business as **Strathern & Co.**, and in 1884 John entered partnership of **Strathern & Freeman** [3/3].
Adv: Listed and advertised in PDT 1872. Also listed PTDs 1876 and 1880.

Strathern & Freeman [Entry 3/3]
1884–1897
Glasgow
 1884–97 145 to 153 West Nile Street
Lithographic and Letterpress Printers. John Strathern former partner in **Strathern J. & A.F.** [2/3]. Listed PTDs 1885, 1889, and 1893. The ending of the partnership was indicated when both Strathern & Freeman and Freeman & Co. were listed at same address in POD 1896 and again in 1897. The partnership ended in 1897, when **Freeman & Co.** continued at same address.

Strathern & Co. [Entry 1/2]
1881–1886
Glasgow
 1881–86 128 Renfield Street
Also Letterpress. Alexander F. Strathern, former partner in **J. & A.F. Strathern**. From 1888 listed as **Strathern, Alexander F.** [2/2].

Strathern, Alexander F. [Entry 2/2]
1888–1893
Glasgow
 1888–90 128 Renfield Street
 1890–91 105 Hope Street
 1891–93 118 Union Street
Also Letterpress. Formerly **Strathern & Co.** [1/2] until 1886. Now trading under own name at same address. Listed PTDs 1889 and 1893.

Sturrock, James A.
c.1870–c.1892
Montrose
 c.1870–c.76 73 High Street
 c.1876–c.92 200 High Street
James Alexander Sturrock (PTD 1889). Also listed PTDs 1872, 1876, 1880, and 1885.

Sutcliffe, John
1846–1848

Edinburgh

1846–46	13 Brown Street (moved during year)
1846–47	104 High Street
1847–48	105 High Street

Although trade-listed under 'Printers – Lithographic' in POD 1846, listing in alphabetical section shows Sutcliffe as Lithographic Artist in 1846 and Lithographic Printer in 1847.

Art-T Undated but probably 1846: 'Edinburgh from the New Cemetery' Drawn on Stone by J. Sutcliffe, after 'a Drawing from Nature' by D. Wilson. Lithographed by W. Wahler. See also notes on **Leith, Samuel** [3/3] and **M'Dowall, Grieg & Wahler**.

Swan, Joseph (& Son †)

1834–1870

Glasgow

1834–37	161 Trongate and 17 Trongate (Litho)
1837–41	21 Exchange Square and 161 Trongate
1841–42	54 St Vincent Street
1842–53	65 St Vincent Street ‡
1853–54	34 Bothwell Street
1854–58	201 Buchanan Street
1858–60	77 St Vincent Street
1860–61	100 West George Street
1861–62	76 Hill Street, Garnet
1862–63	152 Renfrew Street
1863–64	32 Dalhousie Street
1864–70	36 Dalhousie Street

In 1834, when the firm first introduced lithography, Swan was already well established as a top-class and highly successful engraver and copperplate printer. His engravings included steel plates for banknotes. Listed in POD 1835 as Engraver and Publisher of 'Lakes of Scotland'. By the mid-1840s the firm had added Letterpress Printing. Although many of Swan's engravings of topographical scenes are to be found, examples of his lithographic work are less common. Listed Pigot 1837 and Slater 1867. In addition to the many addresses listed above, the firm's lithographic and copperplate departments were sited at 22 and 24 West Nile Street. Around 1852 these Workshops were transferred to Douglas Lane, and again *c.*1855 to Wellington Street. The firm was largely involved in commercial work but also made extensive use of the lithographic transfer process to print local buildings and country seats on note-paper, which proved immensely popular.

† Listed in Slater 1860 and POD as Swan, Joseph & Son in this year only.

‡ The classified listings of Lithographers in the PODs of 1842/43/44 show the firm at 52 St Vincent Street. This may be either an additional location or an error, as it is not supported by other entries, in which the address is listed as 65 St Vincent Street.

Art-T-M-O-C-Adv: 1834: Announced introduction of lithography 'from the knowledge acquired for the last two years in Belfast' (*Glasgow Herald*, 10 October 1834). 1837: 'Plan of London Street, Glasgow divided into lots' by Robert Black [RHP.93]. In addition to Swan's embellished note-paper, the firm also produced by transfer lithography a series of educational guides to fine handwriting. Known as 'Swan's Universal Copy Books', these found a world-wide market, and contributed greatly to the firm's success.

Tait, George

1825–1844

Haddington

1825–44	12–14 High Street

1820: Bookseller and Printer. From 1822 to 1828 Tait published the *East Lothian Magazine*, which became widely supported by the young literati of the district. 1823: Appointed Merchant Counsellor to the Magistrates of Haddington. Tait was first listed, in Pigot 1825, as a Bookseller and Lithographic Printer. 1830: Published *The East Lothian Literary and Statistical Journal*. 1840: Also shown on Burgh List of Electors as Stationer and Auctioneer. Tait, who was also a competent author, died at the age of 46, in June 1844.

Taylor & Henderson

1859–20thC

Aberdeen

1859–66	83 Union Street
1866–97	17 Adelphi Court
1897–20thC	15 & 17 Adelphi Court

Engravers and Lithographic Printers. Listed Slater 1860 and 1867, and in all PTDs 1872–1900. Senior partner David Taylor, who died in 1899, was originally apprenticed to **Keith & Gibb**. His known aptitude for music suggests the possibility of a family relationship with earlier Aberdeen lithographer **Taylor, Robert** [1/2, 2/2], while Henderson may have been a relative of **Henderson, John**.

Art-M 1866: 'Plan of Estates of Candacraig & Glencarvy, Strathdon', from surveys of 1825 by G. Stephen, and 1856, 1865 & 1866 by Alexander Smith [RHP. 3719].

1867: 'Plan of the Estate of Harthill and farms of Blair and Craigsley' [RHP.4114].

Taylor, Robert [Entry 1/2]
[Deaf and Dumb Institution]
c.1824–1832
Aberdeen
 c.1824–32 53 School Hill

Teacher at **Deaf and Dumb Institution** where he introduced and practised lithography. In 1832 Taylor set up his own business as **Taylor & Co.** [2/2].

Art-M 1832: Lithographed a sketched map 'The Road from Aberdeen to the Mill Of Dunnet' for the *New Deeside Guide*, published by Lewis Smith.

Taylor & Co. [Entry 2/2]
1832–1841
Aberdeen
 1832–40 142 Union Street
 1840–41 128 Union Street

Taylor, Robert, Lithographic Printer, formerly with **Deaf & Dumb Institution** [1/2]. 1841: Now also listed as a Music Saloon (see below). Thereafter abandoned lithographic printing and entered partnership as Taylor & Brown, Music Sellers. See Iain Beavan, '19th Century Book Trade in Aberdeen' (Aberdeen University Ph.D. thesis, 1992).

Adv: 1840: Advertised in *Aberdeen Directory* as 'Printing from Stone', and advised change of address. 1841: Advertised in *Bon-Accord Directory* as 'Music Saloon and Lithographic Establishment'.

Tennent, J.J. & P.R.
1853–1858
Edinburgh
 1853–57 4 North Bank Street
 1857–58 5 North Bank Street

Previously listed in POD 1850 as P.R. Tennent, Wholesale Stationer, 51 North Bridge. John J. and P.R. Tennent, Stationers and Lithographers.

Thomson, Robert [Entry 1/2*]
1859–1861
Glasgow
 1859–61 3 West Nile Street

Believed to be the Thomson who entered into brief partnership of **Thomson & Brydale** [2/2] in 1861. Not listed in Slater 1860.

Thomson & Brydale [Entry 2/2*]
1861–1862
Glasgow
 1861–62 120 Buchanan Street

Believed formerly **Thomson, Robert** [1/2]. This brief partnership ceased trading within the year; no further trace of either partner found thereafter.

Thomson, W.R.M. & Co.
1869–1876
Glasgow
 1869–72 20 Buchanan Street
 1872–75 62 Buchanan Street
 1875–76 96 Buchanan Street

Tinsley, James
1854–1871
Glasgow
 1854–71 19 Ronald Street

Tod, John
1860–1861
Perth
 1860–61 25 High Street

Listed Slater 1860.

Tod, Walter L.
Edinburgh
1850–54
 1849–50 30 Hanover Street
 1850–52 25 North Bridge
 1852–54 20 North Bridge

Lithographer and Engraver.

Tullis Press
1840–1849 and
1870–1879
Cupar
 1840–49 6 Bonnygate and
 Burnside Printing Works
 1870–79 8 Bonnygate and
 Burnside Printing Works

A highly successful commercial printing press, originally established c.1800 and later becoming printers and publishers of the *Fife Herald*. Lithography was introduced by George Smith Tullis, who succeeded his father, Robert, as Printer to the University of St. Andrews. Following the 1840 bankruptcy of **William Gardiner**,

George Tullis fulfilled Gardiner's original publication commitment by completing the last seven parts of the monthly magazine of science and literature, *Gardiner's Miscellany*. When George Tullis died in 1848, his brother, William, sold the business to the partnership of **Whitehead & Burns**, but retained the property. After a series of changes in structure, the business was acquired by **Orr, J.C.**, but following Orr's gradual decline into bankruptcy in 1869, Robert Tullis regained proprietorship. In 1879 Tullis transferred the business to **Innes, John**. PTDs 1876 and 1880. See A.J. Campbell, *The Tullis Press, Cupar* (Fife Bibliography: The Presses of Fife, 1) (Buckhaven, 1992).

Art-T-O 1840: Illustrations in F. Huber's *Observations on the Natural History of Bees* (Cupar, 1840). 1841–42: Illustrations in Parts 6–12 of *Gardiner's Miscellany*. 1847: Title page and four lithographed plates in Rev. Charles Lyon, *The Ancient Monuments of St. Andrews* (Edinburgh & St Andrews).

Turner, James (& Co. †) [Entry 1/3]
1831–1871
Edinburgh
1831–70	1 Lothian Road
1870–71	27 Lothian Road

Lithographic Printer. Listed as Letterpress Printing and Engraving from *c.*1850. Recognised as a quality commercial printer, but surprisingly few examples of lithographic work have been traced. 1871: Title of firm changed to **Turner, James junior** [2/3]. Listed Pigot 1837 and Slater 1860, 1867.
† '& Co.' from 1837.

Art-T-P-M-Adv 1843: 'Plan of Stranraer'. 1851: Portrait 'The Reverend T. Barclay D. D.', 'Drawn on Stone by John Irvine A.R.S.A.' (Shetland Museum, Lerwick). The firm advertised regularly in PODs.

Turner, James *Jnr* [Entry 2/3]
1871–1876
Edinburgh
1871–76	27 Lothian Road

Lithographer, Engraver, Letterpress Printer. Formerly **Turner, James & Co.** [1/3]. Following move to new premises, the son succeeded his father. Listed as 'Jnr.' in PODs, but in PTDs 'Jnr' was dropped after 1872. The firm reverted to the original title **Turner, James & Co.** [3/3] in 1876.

Turner, James & Co. [Entry 3/3]
1876–20thC
Edinburgh
1876–82	27 Lothian Road
1882–87	9 Lothian Road
1887–20thC	103 Lothian Road

Lithographer, Engraver, and Letterpress Printer. Formerly **Turner, James *Jnr*** [2/3]. Although correctly listed in PODs, the change to '& Co.' was not recorded in PTDs until 1889.

Tweed, John
1867–1872
Glasgow
1867–72	11 St Enoch Square

Adv: Advertised in PODs for 1870/1 and 1871/2. May be same as John Tweed who later operated as Letterpress Printer *c.*1875–*c.*1895.

Valentine, John & Son [Entry 1/4]
1837–1840
Dundee
1837–40	4 Overgate

Following the *c.*1825 failure of his textile business, John Valentine set up a new business engraving wood blocks for printing on linen †. He was later joined by his son James, who having previously trained as an artist, soon directed his talents to learning the art of engraving on copper and steel. The firm's involvement in the paper printing trade commenced when, at the age of 19, James appeared in partnership with his father, when the business was first listed in the *Dundee Directory* of 1834 as John Valentine & Son, Engravers and Copperplate Printers, at Narrow of Murraygate. Three years later they introduced lithography, being listed at 4 Overgate in the *Dundee Directory* of 1837, but at 3 Overgate in *Pigot* 1837. In 1840, father and son split up and established separate businesses in the same street trading as **Valentine, John** [2/4] and **Valentine, James** [3/4].
† No trace of John Valentine or his wood block business could be found in any *Dundee Directory* prior to 1834 when he took his son into partnership.

Valentine, John [Entry 2/4]
1840–1850
Dundee
1840–45	131 Murraygate
1845–46	123 Murraygate

1846–50 152 Murraygate

Formerly senior partner in **Valentine, John & Son** [1/4]. When the partnership split up in 1840, John Valentine retained the stamp-cutting and lithographic printing business. In 1850 John Valentine, passing the lithographic business to his son **Valentine, James** [3/4], confined his own business to stamp cutting at a new address, 78 Murraygate. He later emigrated to California, where he died.

Valentine, James [Entry 3/4]

1840–1850 † (Not Lithography)
1850–1879 ‡ (Engraving & Lithography)
Dundee

1840–45	98 Murraygate
1845–58	100 Murraygate
1858–78	23 High Street
1878–79	154 Perth Road

b. June 1815, d. June 1879 in Dundee, formerly the 'Son' in **Valentine, John & Son** [1/4]. In the period 1840-1850 he was Engraver, Letterpress Printer and Stationer. In 1850 he took over the lithographic business from his father, John. He also took an early interest in portrait photography, installing a studio in the premises at 100 Murraygate. His business card and other examples of his engraving work may be seen in the Lamb Collection at the Dundee Central Library. Although John Valentine had founded the original business, it was his son, James, who was responsible for the ultimate success and growth of the firm. When James's son, William D. Valentine, joined the firm in 1863, he also took an active interest in photographic work. Later in this period the firm achieved considerable success from the production of pictorial cards. When James Valentine died 19 June 1879 at the age of 64, the title of the firm changed to **Valentine, James & Son** [4/4].

Art-O-Adv Pictorial Work. Advertised in POD Dundee, 1860: 'Commercial and Fancy [work]' .

Valentine, James & Son [Entry 4/4]

1879–20thC
Dundee

1879–87	154 Perth Road
1887–20thC	152 & 154 Perth Road

Formerly **Valentine, James** [3/4]. Following the death of James Valentine, the business was managed by the partnership of his sons, William D. and George. In 1886 they were joined by William's son, Harben. Resulting from prolonged experimentation with the collotype and photo-chromic processes, the firm became internationally known for the quality of their view and greetings cards. The firm was not listed under 'Lithographers' in PTDs 1872–1900, suggesting that in later years the process was confined to in-house use. It was a sad loss to Scotland when, in spite of structural and management changes, this historic firm, more recently known as Valentines of Dundee, finally ceased trading in October 1994.

Note. Part of the background information in the Valentine entries was obtained from an unfinished history of the business kindly provided by Hallmark Cards, Henley-on-Thames, into which the business of Valentines of Dundee was finally absorbed. Written by the founder's great grandson, Harben Valentine, and referred to as a 'History of Valentines', the work covers the period from the arrival of the family in Dundee in 1750 and their entry into the paper printing trade in 1834, through to 1918. The 'History' is undated, but in the opening line Harben comments 'The firm has now been established for fully 114 years'. The reason for the unfinished state of the work is unknown, but may well be explained by Harben Valentine's death in 1949. The firm's photographic and other archival material, including Harben's 'History of Valentines', is now held in St Andrews University Library, Department of Special Collections.

Art-O Lithography used extensively to superimpose colours on collotyped pictorial and greeting cards.

Vallance & Co. [Entry 1/2]

1827–28
Glasgow

1827–28	106 Gallowgate

Lithographic Printer. No initials indicated, but believed to be **John Vallance** [2/2], who re-appeared in Paisley in 1830.

Vallance, John (& Co. †) [Entry 2/2]

Paisley
1830–32

1830–31	19 Inkle Street
1831–32	255 High Street

Lithographic Printer and Druggist. Believed previously located in Glasgow as **Vallance & Co.** [1/2]. In 1832 Vallance lithographed and published a three-volume work entitled *Notes of Sermons by Rev. J McL. Campbell* (the British Library holds all three volumes; the only other known copy is of Vol. 3, held in a private collection). Totalling some 1,300 pages, drawn in script upon stone, this was a truly remarkable achievement of marathon pro-

portions. The work contains a note that it was undertaken to raise funds to reimburse the shorthand writer who took the notes. Vallance appears to have given up printing in 1832, for the Glasgow POD for 1833 lists his business as 'Drug Warehouse, 133 George Street'. Thereafter he is believed to have moved to Liverpool, where he died.
† '& Co.' from 1831.

Veni, George [Entry 1/2]
1861–1869
Edinburgh
 1861–69 227 High Street
Lithographic Printer and Ticket Writer. Slater 1867. It is probable that he died in 1868/9, as business was then continued by **Veni, George, Mrs** [2/2].

Veni, George (Mrs) [Entry 2/2]
1869–1873
Edinburgh
 1869–73 227 High Street
Formerly **Veni, George** [1/2]. The change in title suggests that Mrs Veni succeeded to the business following the death or retirement of her husband. Listed PTD 1872.

Walker, Grassie & Co.
1892–20thC
Elgin
 1892–20thC 100 High Street
Formerly **Black, Walker & Grassie** at same location. Listed PTDs 1893 and 1900.

Walker, Hugh
1869–1872
Glasgow
 1869–72 190 Trongate
Listed as Lithographic Printer only.

Walker, Thomas
1858–1859
Glasgow
 1858–59 42 Union Street
Lithographic Printer and Engraver.

Wallace, John
1868–1869
Edinburgh
 1868–69 11 Melbourne Place
Listed in POD 1867 as Lithographic Draughtsman.

Wallace, Robert & Co.
1861–1862
Glasgow
 1861–62 114 Candleriggs
Possibly connected with long established letterpress firm of Robert Wallace & Co., of 42 Rose Street, Edinburgh (1860), which continued until the late 19th century.

Warburton, Seaton
1845–1856
Edinburgh
 1845–47 79 Princes Street
 1847–52 37 Frederick Street
 1852–55 50 George Street †
 1855–56 48 Hanover Street
Engraver from c.1840. Engraver, Copperplate and Lithographic Printer from 1845.
† Address occupied from 1859 by **Schenck, Friedrich** [2/3].
Art-M 1848: 'Plan of Water courses by which water is conveyed from Short Cleugh Burn etc., to machinery and washing stations at Scots Mines Co., and Leadhills Mining Co.'. By D. Wilson [RHP.1337/1–2].

Wark, William *junior*
1855–1856
Glasgow
 1855–56 62 Queen Street
Engraver and Lithographic Printer

Waterston, George & Son [Entry 1/3]
1865–1877 †
Edinburgh
 1865–74 56 Hanover Street
 1874–77 56 & 60 Hanover Street
Lithographers, Engravers, Stationers. Listed PTDs 1872 and 1876. Originally founded in Cowgate by William Waterston in 1752, as a wax chandlery. When William died in 1780, his second wife, Catherine, née Sandeman (1755–1850), not only continued but expanded the business. In 1786 she married Robert Ferrier, but, following his death in 1805, managed the business in partnership with her son George Waterston I (1778–1850), under the title Ferrier & Waterston. About 1828 a stationery department was added by George Waterston II. Thereafter the first classified listing as 'Lithographers' appeared in the POD of 1868 when the firm was described as 'lithographers, engravers and stationers'. However, the

firm's history shows that artistic involvement originally commenced when George Waterston III joined the firm in 1864 and introduced lithography in 1865. The firm employed four highly skilled artists including Charles Doyle, father of the author Conan Doyle, and brother of the distinguished *Punch* illustrator Richard Doyle. On 26 October 1869 the firm announced that their manager, **George Stewart**, had become a partner in the business, but the title was to remain unchanged. However, this decision was reversed in 1877, when the business title changed to **Waterston, George, Sons & Stewart** [2/3].

Art-O 1871: Tinted illustrations in R.O. Cunningham, *Notes on the Natural History of the Strait of Magellan* (Edinburgh, 1871). *c.*1870: 'View of Banff'.

Waterston, G. Sons & Stewart [Entry 2/3]
1877–1879
Edinburgh
 1877–79 56 & 60 Hanover Street
Lithographers, Engravers & Stationers. Previously **Waterston, George & Son** [1/3]. It seems that having been a partner in the firm since 1869, Stewart requested that his son be allowed to join the business. This was declined by Waterston, who may have seen it as unsettling to his plans for future succession by his own sons. As a result, **George Stewart** left the partnership, and formed his own company. The firm continued as **Waterston, Geo. & Sons** [3/3].

Art-O-T *c.*1878: Delightful colour illustrations in a quaintly-titled toybook *The Tragic and yet strictly Moral Story of how Three Little Pigs went to Market and the Old One stayed at Home*. Drawn by Charles Doyle (see Entry 1/3) 1879: *Old Edinburgh by James Drummond R.S.A.– reproduced in Fac-simile from his original Drawings now in the Collection of the Society of Antiquaries of Scotland*. This magnificent volume contains more than 100 tinted lithographic reproductions of works drawn between 1848 and 1861 by James Drummond R.S.A. (1816–1877), an artist distinguished for his drawings of antiquarian and historic subjects. Publication of the work was limited to 500 copies, of which 50 were on 'larger paper'. Copy No 380, held in the National Library of Scotland, has a paper size of approx. 18" high x 15" wide.

Waterston, George & Sons [Entry 3/3]
1879–20thC
Edinburgh
 1879–20thC 56 & 60 Hanover Street

Incorrectly listed as '& Son' in PTDs 1880, 1885; correctly listed in PTDs from 1889. Formerly **Waterston, G. Sons & Stewart** [2/3]. Between 1883 and 1969 the firm was involved in the security printing of banknotes for the Caledonian Banking Company and the Royal Bank of Scotland. The firm celebrated its bi-centenary in 1952, and is still in business in 1997, as George Waterston & Sons Ltd., in Warriston Road, Edinburgh. It continues to be heavily involved in security printing. Remarkably, after 245 years, the majority shareholding remains with members of the Waterston family, and although a small part of production, the wax chandlery business on which the firm was founded is still thriving. See *Two Hundred and Twenty Five Years – A History of George Waterston & Sons Limited 1752–1977* (1977).

Art-T-Mil-O-Ms 1881: 'Highly commended' colour illustrations in *Ancient Scottish Weapons*, drawn by James Drummond, R.S.A., introduction by Dr J. Anderson. 1888: R. Wallace, *India in 1887* (Oliver & Boyd). The firm also specialised in the production of coloured 'surgical maps'. George Waterston read a paper on 'The Morison Press, Perth' (see **Morison, David Junr**) before the Edinburgh Bibliographical Society.

Watson, Gavin
1864–20thC
Glasgow
 1864–73 88 Glassford Street
 1873–79 20 Dixon Street
 1879–98 33 East Howard Street
 1898–20thC 51 Dundas Street City
Engraver, Lithographic and Letterpress Printer. Listed Slater 1867 and PTDs 1872–1900.

Art-M Reproduction (1906) of 'Plan of the City of Glasgow/Gorbels, Caltoun and Environs' from original survey in 1782 by James Barrie of Glasgow.

Watson, George [Entry 1/2]
1859–1891
Glasgow
 1859–79 58 Ingram Street
 1879–83 58 & 64 Ingram Street
 1883–91 162 & 164 Ingram Street
Also Letterpress Printer, Bookseller, Stationer, and Librarian. Listed in PTDs 1872, 1876 and 1880. Not listed PTD 1885 or subsequently. 1891: Took son into partnership as **Watson, George & Son** [2/2].

Watson, George & Son [Entry 2/2]

1891–20thC

Glasgow

1891–94	162 & 164 Ingram Street
1894–20thC	162 Ingram Street

Lithographic and Letterpress Printers. Formerly **Watson, George** [1/2]. Firm not listed in PTDs.

Watson, James

1829 or 1832–1837

Aberdeen

1829–35	Believed to have been at 'The Lithographic Printing Office' at 10 Queen Street
1835–37	44 Upperkirkgate

Although his name first appeared in the Directory of 1833 as 'Clerk' with **Taylor & Co.**, James Watson is known to have been a lithographic printer in Aberdeen in 1832 both from a biography of his ex-apprentice **Colin Ross Milne** and from his signature on a certificate marking the end of Milne's apprenticeship. In the POD of 1836, Watson is listed as a lithographic printer at 44 Upperkirkgate – the same address as the **Lithographic Printing Office** (1829–1837). As no individual name has been associated with the Lithographic Printing Office, it is possible that James Watson was the proprietor not only from 1835 but since it was first established in 1829. See Iain Beavan, '19th Century Book Trade in Aberdeen' (Aberdeen University Ph.D. thesis, 1992).

Ms Certificate of Apprenticeship (traced in USA.)

Watson, John

1821–1827

Glasgow

1821–26	169 George Street
1826–27	230 George Street

Believed to be the earliest professional lithographic printer listed in Glasgow PODs. Watson achieved considerable recognition for his all-too-brief involvement in artistic lithography; in particular for his printing of works by the Paisley artist John Knox, and also for his pioneering efforts in printing and publishing one of the earliest cartoon journals. Sadly, production was discontinued in April 1826, and Watson ceased trading shortly afterwards. Listed Pigot 1825.

Art-T-P-O-M Lithographed 7 views which included 'Inverary Castle' and 'Arroquhar' *(sic)* in the series *Scotish* [sic] *Scenery drawn from Nature upon Stone by John Knox*, publication of which commenced in 1823 (see Wilson, H. and Robertson & Ballantine for other views). 1825–26: Produced very early cartoon journal titled *Glasgow (later Northern) Looking Glass*, for which one of the principal illustrators was London artist William Heath. An interesting example of Heath's artistic work for Watson, 'Glasgow Fair taken from the Roof of the Court House', may be seen in Issue No. 4 of the journal, published 23 July 1825. 1825: Folding frontispiece, 'Degree of Smoke' in James Cleland, *Letter....respecting the consumption of smoke in the furnaces of steam engines* (Glasgow: Khull, Blackie & Co., 1825; copy in Mitchell Library, Glasgow). c.1827: 'Glasgow Environments – Communications Map' published 1829.

Watson, John

c.1860–1872

Kilmarnock

c.1860–72	32 King Street

Listed as Lithographer in Slater 1860. Slater 1867 also lists an address in Water Lane. In 1872 Watson was succeeded by letterpress printer and lithographer, **Armour, Robert**.

Watson, Robert

1873–82

Glasgow

1873–78	66 Mitchell Street
1878–82	57 Mitchell Street

Also Letterpress from c.1878.

Watt, Philip B.

1854–1855

Edinburgh

1854–55	3 East Register Street

POD 1854: 'General Engraver and Lithographer'. Appears to have moved to London. Believed to be Philip Butler Watt, author of several articles relating to letterpress and lithographic printing. These included W.J. Adams, *A Few Hints on Colour Printing and Printing in Colour* (London, 1872); 'The Rise and Progress of Lithography in Britain', published in *The British Lithographer*, Vol. 1, Part 5 (1892); and 'Early English Lithography', *The Artist*, May 1896.

Tre-Adv Advertised in POD for 1854/5.

Watt, Thomas

1848–1852

Glasgow

| 1848–50 | 107 Buchanan Street |
| 1850–52 | 191 Argyle Street |

Engraver, Lithographer and Draughtsman.

Weatherston, Robert (& Co. ? †) [Entry 1/2]

1870–1877

Glasgow

1870–72	98 West Nile Street
1872–74	96 West Nile Street
1874–77	106 West Nile Street

Letterpress and Lithographic Printer. Listed PTDs 1872 and 1876. From 1874 Robert Weatherston shared premises at 106 Nile Street with the newly formed business of **Weatherston, William & Son**, and appears to have merged with them in 1877. This continued until 1889, when that firm ceased trading.

† The PTD for 1889 also lists 'Weatherston, R. & Co.' at 209 Hope Street. This brief entry did not appear in POD classified listings.

Weatherston, William & Son [Entry 2/2]

1874–1889

Glasgow

| 1874–78 | 106 West Nile Street |
| 1878–89 | 15 Bath Street |

Lithographic and Letterpress Printers. Appears to have merged with **Weatherston, Robert** [1/2] from 1877. The relationship between William and Robert is unknown. Listed PTDs 1880, 1885.

Weddell, Andrew

1867–1870

Edinburgh

| 1867–70 | 20 Cockburn Street |

Slater 1867: Lithographic and Letterpress Printer. POD 1867 lists as 'Printer (Smith & Brown)'. **Smith & Brown** vacated this address in 1867/8, and entry suggests that having briefly shared the premises, Weddell then succeeded them.

Wedderburn, Jemima

Edinburgh & Glasgow

c.1837–20thC

Born in 1823, Jemima Wedderburn became one of Scotland's foremost illustrators, achieving particular distinction for her water colour illustrations of animals and birds. Unlike others listed in this directory, she did not offer a lithographic printing service to the public, but was 'professional' to the extent that she would have received remuneration from the wide variety of lithographic work which she drew or engraved on stone and, during her earlier years, frequently printed herself. In the mid-1840s she worked closely with the Edinburgh artist and lithographer **Friedrich Schenck**, who is believed to have instructed her in the technique of engraving on stone and in whose atelier some of her works were printed. Several of her earlier works were produced anonymously, while on others inscriptions were restricted to the initials J.W., which changed in 1849 to J.B, following her marriage to Hugh Blackburn, when she moved to Glasgow. Other works carried her full names. Jemima died in 1909, but her story is beautifully told and illustrated in *Jemima – The Paintings and Memoirs of a Victorian Lady*, edited and introduced by Rob Fairley (Canongate, 1988). Albums of works by Jemima Wedderburn are held in the National Gallery of Scotland, Edinburgh, and in the Archives of the National Portrait Gallery, London.

Art-O-P 1845: Print: 'The Warwick Races', drawn on stone by 'J.W.' and lithographed by Friedrich Schenck. 1847: Illustrations in the books *The White Cat* and *Fortunio*, engraved on stone and lithographed by 'J.W.' (Edinburgh: Blackwood, 1847). 1857: Print: 'The Defenders of Glasgow', drawn on stone by Mrs Hugh Blackburn, after her own oil-painting, and lithographed by Schenck & Macfarlane. Sold for the benefit of the Fire Service.

Weir, James W. & Co.

1865–1866

Glasgow

| 1865–66 | 26 Argyle Street |

Letterpress and Lithographic Printers.

Whitehead & Burns [Entry 1/2]

1849–1857

Cupar

| 1849–57 | 6 Bonnygate and |
| | Printing Works at Burnside |

Partnership of James Whitehead and Walter Burns. Apart from jobbing work, the firm specialised in publications of religious and moral content. When the partnership ended in 1866, the firm became **Whitehead & Orr** [2/2]. See A.J. Campbell, *The Cupar Presses of: Whitehead & Burns, John Cunningham Orr, William Ritchie, W. Bayne, John Arnott* (Fife Bibliography: The Presses of Fife, 2) (Buckhaven, 1992).

Art-M-Adv 1851: 'Plan of the Estate of Carphin' (Creich, Fife) … 'the property of David Cook' from survey by William Horne [RHP.3362]. They advertised as 'Successors to G. S. Tullis of **Tullis Press**' and 'Booksellers, Bookbinders, Stationers, Letterpress, Lithographic & Copperplate Printers & Engravers'.

Whitehead & Orr [Entry 2/2]
1857 †
Cupar
 1857 6 Bonnygate, and
 Printing Works at Burnside
Formerly **Whitehead & Burns** [1/2]. The business continued as **Orr, J.C.**
† Partnership terminated, for financial reasons, after a few months.

Whyte, W. L. & Co.
1866–1871 †
Kirkcaldy
 1866–71 'Advertiser' Office at 294 High Street
Following the death in March 1866 of John Jeffers Wilson, the *Fifeshire Advertiser* was run by his two nephews, William Lindsay Whyte and Francis Hislop, under the title 'W. L. Whyte & Co.'. Already Letterpress Printers, the firm added a 'Lithographic and Engraving Establishment' in June 1867. This department was managed by **Archibald Beveridge** and acquired by him in 1869, utilizing the existing site until 1872. After Whyte's death in 1871, **Francis Hislop** became sole Proprietor of the *Fifeshire Advertiser* business.
† Although 'Whyte & Co. Printers and Lithographers' appears on an 1870 poster, it is possible that after 1869 he sub-contracted such work to Beveridge.
Art-O-Adv 1870: Poster advertising a concert. Announcement in *Fifeshire Advertiser*, 15 June 1867.

Wilkinson, A.
1850–1852
Glasgow
 1850–52 108 Argyle Street, Morrison's Court
Letterpress and Lithographic Printer, with separate Engraving business at 191 Argyle Street.

Wilson, David & Co.
1856–1872
Glasgow
 1856–60 7 Argyle Street

 1860–72 14 Maxwell Street
Also Letterpress Printer and Engraver. Lithography seems to have been abandoned from 1872, although the other activities continued to *c.*1886. Listed Slater 1867.

Wilson, Guthrie & Co.
1866–1898
Glasgow
 1866–67 33 West Nile Street
 1867–72 57 Renfield Street
 1872–74 no directory entries
 1875–82 Morrison's Court, 108 Argyle Street
 1882–84 34 & 36 Frederick Street
 1884–97 36 Frederick Street
 1897–98 335 St Vincent Street
Lithographic and Letterpress Printers. Not trade-listed in Slater 1867, nor in PODs 1872–1900.

Wilson, Hugh (**& Co.** †)
1822–1872 ‡
Glasgow
 1822–26 47 Argyle Street
 1826–29 43 Argyle Street
 1829–40 197 Trongate
 1840–54 191 Trongate #
 1854–72 75 Glassford Street
Artistic and progressive Engraver, Copperplate, Lithographic, and, later, Letterpress Printer. Born in 1797, Wilson entered an engraving apprenticeship with Andrew Blaikie at the Cross, Paisley, in 1810. Around 1814 he joined the Glasgow stationery and engraving business of **James Lumsden** under whose entry Wilson's earlier history will be found. At the end of 1821, Hugh Wilson acquired Lumsden's engraving and copperplate printing business, being first listed in the POD of 1822. In February 1822 he was admitted as a member of the Glasgow Philosophical Society, and on 4 August 1823 exhibited two chalk drawings lithographed at his press. It is probable that these were views drawn by John Knox, and published in the same year (see below). Strangely, it was not until 1826 that Wilson was first listed as a Lithographic Printer in Glasgow directories. Between 1829, when he moved to Trongate, and *c.*1850, he appears to have devoted much of his attention to the engraving of maps. Starting with 'Eight Miles Round Glasgow' in 1829, he went on to engrave maps of the 'City of Glasgow' in 1830, 1833, 1835, 1844, 1846 and 1848, which he published in collaboration with James Lumsden & Son. Wilson is believed to have been the first in Glasgow

to undertake colour work, and was among the first in Scotland to install a steam press. He was listed in Pigot 1837 both as an 'Engraver' and a 'Lithographer (and Chalk Drawing and Writing)'; and in POD 1839 as 'Engraver and Lithographer to Her Majesty.' He also became President of the Company of Stationers of Glasgow. Wilson again widened the scope of his work following his move to Glassford Street, becoming deeply involved in designing and engraving banknotes for the Clydesdale Bank (information kindly provided by Trevor E. Jones, of Banking Memorabilia, Carlisle, the author of vol. 3 of the trilogy *Twentieth Century Scottish Banknotes* [Carlisle, 1998]). Almost certainly due to the influence of his former employer, James Lumsden, who had founded the bank in 1838, he displaced the previous contractors, the distinguished firm of **W. & A.K. Johnston.** Remarkably, Wilson's basic design remained in use until 1949. Fifty years after starting his own business, Wilson retired in 1872, and was succeeded by the partnership of his son-in-law and grandson, **Woodrow, Alexander & Son.**

† '& Co.' from 1868.

‡ Until 1873/4 both names were listed in PODs – a 'linking' device to demonstrate continuity of the original business. Listed Slater 1860, 1867.

Thought to be attributable to re-numbering of 197.

Art-T-M-O Lithographed three of the views in the series *Scotish* (sic) *Scenery drawn from Nature upon Stone by John Knox* (see **Watson, John** and **Robertson & Ballantine** for other views). Publication of this series commenced in 1823, being modelled on David Octavius Hill's *Sketches of Scenery in Perthshire* (Thos. Hill, Perth, 1821). 1831: 17 monochrome plates in *The Leven Delineated*, a fine work with descriptive text by Charles Taylor (Glasgow: W. R. McPhun, 1831). 1857: Ornamental and coloured title page in John Bunyan, *The Pilgrim's Progress* (Glasgow: James Lumsden & Son, 1857). 1857: 'Proposed feuing plan of Helensburgh…' by William Spence [RHP.3517].

Wilson, Matthew
1844–1848
Glasgow

1844–48	22 Argyle Street

Lithographer and Engraver.

Winter, Duncan & Co.
1874–20thC

Dundee

1874–76	8, 10 Castle Street
1876–82	8, 10, 12 Castle Street
1882–87	10, 12 Castle Street and Town House Building, St Clements Lane
1887–1900	10 Castle Street and Town House Building, St Clements Lane
1900–20thC	24 Castle Street

Stationers, Booksellers, Publishers, Account Book Manufacturers, Printers, Lithographers, Paper-Rulers and Bookbinders. This firm was originally established in 1788 by **James Chalmers**, who introduced lithography in 1829. On his death in 1853, he was succeeded by his son, **Charles D. Chalmers**, who in 1870 entered partnership with former apprentice David Winter as **Chalmers & Winter**. When Winter succeeded to the business in 1874, he immediately formed a new partnership with James and John Duncan, respectively the firm's Foreman of Printing and Bookbinder. Remarkably, the firm is still in business in 1998, now operating under the title Winter & Son and located at Dunfinane Avenue, Kingsway West.

Wisher, David
1850–1852
Glasgow

1850–52	42 King Street

Listed as Lithographic Printer only. Unusually, his name is not listed in the unclassified section of POD 1850

Wood, D.
1862–1864
Edinburgh

1862–64	7 Drummond Street

Lithographic Printer only.

Woodrow, Alexander & Son
1874–20thC
Glasgow

1874–20thC	75 Glassford Street

Also Engraver and Letterpress Printer who succeeded his father-in-law **Wilson, Hugh** in 1874.

Woodrow, James
1832–1837
Glasgow

1832–37	131 Trongate

Lithographer, Engraver and Copperplate Printer.

Wright, C.L.
1886–20thC
Glasgow
> 1886–20thC 100, 102 W. George Street and
> 100, 106 Stirling Road

c.1855: Started as Letterpress Printer at 45 Union Street. 1864–86: Joined in partnership with Thomas and Samuel Dunn as **Dunn & Wright**. 1886: C.L. Wright succeeded to the business, which he continued at the same address. Listed PTDs 1889, 1893, 1900.

Wright, James
1860–1864
Edinburgh
> 1860–61 19 & 21 Niddry Street
> 1861–64 7 Hunter Square

Also Letterpress Printing, which he continued until 1867.

Wright, John (& Co. †) [Entry 1/3]
1854–1861
Glasgow
> 1854–56 14 Garthland Street
> 1856–58 Sydney Court, 62 Argyle Street
> 1858–60 120 Buchanan Street
> 1860–61 108 Argyle Street
> 1861–62 no directory entry

'Lithographic and Letterpress Printer.' In 1863 firm was continued by **Mrs John Wright** [2/3]. Also in 1863, the name **Wright, John** [3/3] re-appears at another address: possibly the same, or perhaps a son.
† Listed '& Co.' from 1856.

Wright, John, Mrs [Entry 2/3]
1863–1869
Glasgow
> 1863–69 108 Argyle Street

Continued Lithographic and Letterpress Printing business of her husband, **Wright, John (& Co.)** [1/3]. It is probable that **Wright, John** [3/3] was connected.

Wright, John [Entry 3/3*]
1863–20thC
Glasgow
> 1863–79 67 Oswald Street
> 1879–87 16 Carrick Street
> 1887–20thC 61 Bishop St., Anderston

Lithographic and Letterpress Printer. Listed Slater 1867. This could well be the same as, or son of, **Wright, John** [1/3]. May also connect with **Wright, John, Mrs** [2/3]. Under 'Lithographers', POD 1900 lists 'Wright, John, Bishop Paper Bag Mills' at last above address.

Young Brothers [Entry 1/4]
Glasgow
1854–1867
> 1854–67 128 Union Street

Lithographers, Engravers and Copperplate Printers. Listed Slater 1860. Added Letterpress by 1865. It is believed that in 1867 one brother established a separate business as **Young, A.** [2/4] while the other, **Thomas H. Young,** became a partner in **Young & Hamilton** [3/4] at the existing location.

Young, A. Entry [2/4*]
1867–1870
Glasgow
> 1867–70 45 Union Street

Unconfirmed, but believed to be ex-partner in **Young Brothers** [1/4]; now started his own business. The remaining brother, Thomas H. Young, entered partnership **Young & Hamilton** [3/4].

Young & Hamilton [Entry 3/4]
1867–1870
Glasgow
> 1867–70 128 Union Street

Stationers, Lithographers and Engravers. Believed former partner in **Young Brothers** [1/4]. When this partnership ended in 1870, **Young, T.H.** [4/4] continued at same address. 'Hamilton' is believed to be **Hamilton, A.**, who started his own business in 1871.

Young, Thomas H. [Entry 4/4]
1870–1876
Glasgow
> 1870–72 128 Union Street
> 1872–75 49 Oswald Street
> 1875–76 126 Renfield Street

Also an Engraver and Letterpress Printer. Listed PTD 1872, 1876. Former partner in **Young & Hamilton** [3/4]. Young appears to have abandoned lithography in 1876, but continued his other activities until c.1882.

Young & Smith [Entry 1/3*]
1839–1840
Glasgow
 1839–40 95 Argyle Street
'Lithographic Printers and Engravers'. 'Young' may be
same as **Young, John** [2/3*].

Young, John [Entry 2/3*]
1842–1847
Glasgow
 1842–43 62 Trongate
 1843–46 66 Trongate
 1846–47 126 Ingram Street and 5 S. Hanover St.
Engraver and Lithographic Printer. John Young may be
ex-**Young & Smith** [1/3*]. Although he seems to have
ceased trading in 1847, it is possible that **Young, John**
[3/3*] may be a re-appearance.

Young, John [Entry 3/3*]
1854–1869
Glasgow
 1854–55 297 Argyle Street
 1855–56 118 Union Street
 1856–57 1 Ingram Street
 1857–58 230 Argyle Street
 1858–59 130 Argyle Street
 1859–60 19 Bedford Street and 36 Cook Street
 1860–63 43 Nelson Street, Trad.
 1863–64 34 Nelson Street, Trad.
 1864–69 12 Robertson Street
Listed Slater 1867 as Lithographic and Letterpress Printer
and Engraver, but the address, given as 24 Howard Street,
conflicts with PODs. Judging by his predilection to
frequent changes of location, he may well be same as
Young, John [2/3].

EDINBURGH BIBLIOGRAPHICAL SOCIETY

(founded 1890)

A programme of six to eight meetings (including visits to private and other libraries) is organized every year, and members receive the *Transactions* at no additional cost and are able to purchase one copy of any *Occasional Publication* (see opposite) at a substantial discount.

The annual subscription for 1999/2000 is £15.00 for institutions and £10.00 for personal members. Enquiries about membership and purchase of back numbers of *Transactions* and other publications should be directed to the Hon. Treasurer, c/o National Library of Scotland, George IV Bridge, Edinburgh EH1 1EW.

Contributions for the *Transactions* should be submitted for consideration to the Hon. Editor, c/o National Library of Scotland, George IV Bridge, Edinburgh, EH1 1EW. Articles are invited in the fields of bibliography (in its widest sense), the book trade, the history of scholarship and libraries, and book collecting. The Hon. Editor also welcomes suggestions for the *Occasional Publications*.

EDINBURGH BIBLIOGRAPHICAL SOCIETY
OCCASIONAL PUBLICATIONS IN PRINT

David Fate Norton & Mary J. Norton. *The David Hume Library.* 1995.
Royal octavo. Pp.156, including 8pp. of plates. ISBN 1 872116 21 3. £8.00 (carriage extra) to members of
Edinburgh Bibliographical Society (limited to one copy per member), and £16.00 or $27.50 (carriage extra)
to non-members.

David Hume, well-known as a philosopher and historian, was also an avid reader and
collector of books. Unfortunately, no catalogue of his library survives. The Nortons
have traced the path of Hume's books to his brother and sister, then to his nephew, David
Hume the Younger (later Baron Hume), and finally to Thomas Stevenson, an Edinburgh
bookseller. Working from manuscript sources, including an 1840 catalogue of Baron
Hume's library, as well as letters written by Hume, the authors identify several hundred
titles that belonged to, or probably belonged to, Hume.

Brian Hillyard. *David Steuart Esquire: An Edinburgh Collector. The 1801
Sale Catalogue of his Library Reproduced from the Unique Copy in New
York Public Library, with an Introductory Essay.* 1993.
Royal octavo. Pp.88, including 46pp. of plates. ISBN 1 872116 03 5. £8.00 (carriage extra) to members of
Edinburgh Bibliographical Society (limited to one copy per member), and £16.00 or $27.50 (carriage extra)
to non-members.

Maureen Townley. *The Best and Fynest Lawers and Other Raire Bookes: A
Facsimile of the Earliest List of Books in the Advocates' Library, Edinburgh,
with an Introduction and Modern Catalogue.* 1990.
Royal octavo. Pp.163, including 21pp. of plates. ISBN 1 872116 05 1. £8.00 (carriage extra) to members
of Edinburgh Bibliographical Society (limited to one copy per member), and £16.00 or $27.50 (carriage
extra) to non-members.

POSTAL ORDERS FOR THE ABOVE TITLES should be directed to Oak Knoll Press,
310 Delaware St., New Castle DE 19720, USA, except from members, who should write
to the Hon. Treasurer, Edinburgh Bibliographical Society, c/o National Library of
Scotland, George IV Bridge, Edinburgh EH1 1EW.